Sound Art Revisited

Sound Art Revisited

Alan Licht

BLOOMSBURY ACADEMIC

NEW YORK • LONDON • OXFORD • NEW DELHI • SYDNEY

BLOOMSBURY ACADEMIC
Bloomsbury Publishing Inc
1385 Broadway, New York, NY 10018, USA
50 Bedford Square, London, WC1B 3DP, UK
29 Earlsfort Terrace, Dublin 2, Ireland

BLOOMSBURY, BLOOMSBURY ACADEMIC and the Diana logo are trademarks of
Bloomsbury Publishing Plc

First published in the United States of America 2010
This edition published 2019
Reprinted 2019, 2020 (twice), 2021

Cover design by Louise Dugdale
Cover image: Bernhard Leitner, *Sound Field 1*, 1972 © Atelier Leitner Vienna

Bloomsbury Publishing Inc does not have any control over, or responsibility for,
any third-party websites referred to or in this book. All internet addresses given
in this book were correct at the time of going to press. The author and publisher
regret any inconvenience caused if addresses have changed or sites have ceased
to exist, but can accept no responsibility for any such changes.

Library of Congress Cataloging-in-Publication Data
Names: Licht, Alan, author.
Title: Sound art revisited / Alan Licht.
Other titles: Sound art
Description: New York : Bloomsbury Academic, Bloomsbury Publishing Inc, 2019.
| Revised version of: Sound art : beyond music, between categories,
published by Rizzoli, 2007. | Includes bibliographical references and index.
Identifiers: LCCN 2019009592 (print) | LCCN 2019009705 (ebook) |
ISBN 9781501333149 (ePub) | ISBN 9781501333156 (ePDF) | ISBN 9781501333132
(hardback : alk. paper) | ISBN 9781501333774 (pbk. : alk. paper)
Subjects: LCSH: Sound in art. | Arts, Modern–20th century. | Arts, Modern–21st century. |
Sound installations (Art) | Sound sculpture. Classification: LCC NX650.S68 (ebook) |
LCC NX650.S68 L52 2019 (print) | DDC 709.04/074–dc23
LC record available at https://lccn.loc.gov/2019009592

ISBN:	HB:	978-1-5013-3313-2
	PB:	978-1-5013-3377-4
	ePDF:	978-1-5013-3315-6
	eBook:	978-1-5013-3314-9

Typeset by Integra Software Services Pvt. Ltd.
Printed and bound in Great Britain

Companion website: jayhodgsonmusic.com

To find out more about our authors and books visit www.bloomsbury.com
and sign up for our newsletters.

Contents

List of Figures

Preface

This volume is in essence a revised version of my previous book, *Sound Art: Beyond Music, Between Categories*, published by Rizzoli in 2007. Rizzoli had contracted me to write the book in 2005; it was originally going to be a catalogue, with essays by various authors, for a sound art exhibition, which had been cancelled. The publisher and editor still wanted to do a book about sound art and already had a format in mind: a body of text providing a brief history and overview of the genre, a section of artist biographies in the back, numerous illustrations, and an accompanying CD of representative recordings. I was conversant with the term "sound art," but even though I had done my own sound installations and had visited and written about other sound exhibitions, I still wasn't exactly sure what "sound art" really was. I took the project on, hewing to the designated structure, and sat down to do research.

As I soon found out, not only was there no clear-cut definition or starting point to sound art but literature on the subject was limited, at least in English (Helga de la Motte-Haber wrote several comprehensive texts about sound art in German). Douglas Kahn's *Noise Water Meat*, Christoph Cox and Daniel Warner's *Audio Culture*, Dan Lander and Micah Lexier's *Sound by Artists*, Karin v. Maur's *The Sound of Painting*, and Jim Drobnick's *Aural Cultures* were some of the few books touching on sound art without tackling it head-on, and there were a few scattered essays in old exhibition catalogues.[1] Distinguishing between experimental music and sound art was also difficult, as until the mid-1990s much of what has been termed sound art was still being created by card-carrying music composers. Discussions with colleagues like Michael Schumacher, proprietor of Studio Five Beekman/Diapason, helped me to form a viewpoint about what constituted sound art, and I began to discern its evolution and elements. Rather than examining sound art through a philosophical or theoretical lens, as many critics have done, I took an art historical approach while also coming to the subject as a practicing experimental musician myself.

Within the publisher's outline, I found I was able to structure a kind of narrative in three ways: through the main body text, which traced the development of sound art as well as containing a short rundown of music made by artists (for the sake of context); through the artists' biographies, which I decided to list by

birthdate rather than alphabetically in order to show a generational time line of sound art's progression; and through the illustrations, which went a long way in evincing parallels between contemporary visual art and sound art (juxtaposing Walter De Maria's *New York Earth Room* with La Monte Young's *Dream House* or Dennis Oppenheim's *Accumulation Cut* with Rolf Julius's *Concert for a Frozen Lake*, for example). As Rizzoli is an art book publisher, and the book was aimed at an art history audience as much as a music audience, the pictures were an important asset and constituted a photo essay in and of themselves. Although sound art does not necessarily lend itself to standard sound reproduction, given its orientation toward multichannel, spatialized sound that is often calibrated to a specific space, the accompanying CD gave a decent approximation of a range of sound art modes—an excerpt from a sound installation by Bill Fontana, classic artists' noise music by Jean Dubuffet and Mike Kelley, Steve Roden treating a Harry Bertoia chair as a piece of sound sculpture, a field recording by Bernhard Gal, and an Alvin Lucier piece whose psychoacoustic properties demonstrated the fine line between certain music compositions and sound art.

The book went out of print in 2014, but by that time it was already somewhat outdated—several artists had passed away in the interim, and other books had appeared that contributed to the ongoing discussion about sound art, particularly Brandon LaBelle's *Background Noise*, Seth Kim-Cohen's *In the Blink of an Ear*, and Salomé Voegelin's *Listening to Noise and Silence*. Not only that but in 2010 Susan Philipsz's sound piece "Lowlands" won Britain's Turner Prize, the first to do so, and there was considerable attention paid to the Museum of Modern Art (MoMA)'s first sound art survey show, *Soundings*, three years later. Sound art's profile had increased substantially since the initial publication of the book, yet Rizzoli chose not to reprint it again. Fortunately the rights reverted back to me, and I set about doing an updated edition with a new publisher.

That is the present book. In going over the previous work, I decided to reorganize it as well as update it. I folded most of the artist biographies into the main text and dispensed with some of them altogether. I also incorporated anecdotal or trivial material from the endnotes into the main text and eliminated material that I no longer felt was relevant in discussing sound art. The first book took a purist position in differentiating sound art from music and sound artists from musicians; while I am still committed to a workable definition of sound art that avoids too much overlap with experimental music, I have taken a more pluralistic view overall this time, showing how the boundaries for what people call (and in some cases, expect from) sound art have expanded in the

last twenty years, with respect to the ongoing mixed-media hybridizations that have elements of sound art contained in them. I have also made mention of sound studies, which was absent from the first edition, and greatly expanded the history of sound exhibitions. I try to give Australian sound art, which was barely touched on in the previous book, its due here.

The first edition's main text was divided into three parts: "What Is Sound Art," "Environments and Soundscapes," and "Sound and the Art World." These have been restructured into four parts. Part One, "Introduction," begins with the term "sound art" itself, tracing its earliest usages and the controversy surrounding it. I try to disentangle it from experimental music, suggesting sound works created in a non-time-based, non-programmatic way as being sound art as opposed to music, and propose a fundamental definition that can be limited to works of sound installation and sound sculpture. There is also discussion of the problems faced in exhibiting, documenting, and disseminating sound art, and the further conflicts of visuality versus aurality—the dominance of the ocular world over the aural one. All of these factor into sound art's difficulties with acceptance in both the art and music worlds.

Part Two, "Prehistories and Early Manifestations," looks at the long line of modern technologies and aesthetics that led to sound installation: the inventions of telephone, the radio, and recording, which separated sound and made it capable of being transmitted or otherwise resituated over long, even global distances; the development of musique concrète, which distorted sounds beyond recognizability into unique, independent entities; and the reintroduction of spatialization into modern composition. From there it details early sound installations from the 1950s that combined sound with architecture, and John Cage's *4'33"* is examined as a radicalization of the concert experience that became seminal for later notions of ambient sound as music as well as surround-sound installation. Luigi Russolo and Max Neuhaus are noted as pre- and post-Cage advocates of listening to what might otherwise be considered noise in the environment while sound ecology is explored as a post-Cage engagement with the sounds of nature that coincided with the rise of sound art. This in turn leads to a consideration of the parallels between the development of sound art and that of Land art in the mid-to-late 1960s, and the similarities that exist between translocations of Land artist Robert Smithson and those of sound artists Bill Fontana and Maryanne Amacher, among others. Finally, there is a lengthy survey of sound sculpture.

Part Three, "Sound and the Art World," looks at sound by visual artists and early sound exhibitions—which go hand in hand, as sound works made

by visual artists or visual works that involved sound in some way constituted the majority of sound exhibitions until the 1990s. Throughout the twentieth century, the movements of Dadaism, Fluxus, Conceptualism, performance art, and video art all made sound or music a part of their respective aesthetics. From there, we delve into the first stirrings of audio art exhibitions in the 1960s and 1970s, the rise of sound art galleries in Germany, and the citywide festival—the most expansive and effective way of presenting sound art to date. In Part Four, "Recent Sound Art," contemporary trends are reviewed, where recombinant works that blend music, sound art, musical instruments, sound sculpture, and interpersonal communication have increased. The merging of sound art and more traditional or accessible music or art forms is exemplified in works by Philipsz and Janet Cardiff, which have gained more currency in the art world. Artists with a background in DJ culture, and the relationship between ambient music and sound art in the 1990s, are also detailed, with Brian Eno and Christian Marclay being two of the better known figures who link the music and art worlds without expressly being sound artists. Sound studies' influence is measured on the upturn in sociopolitically oriented sound art works, particularly a new approach to soundscapes that favors societal development and history over nature conservancy, and the use of the voice as a means to convey identity politics and cultural heritage as well as to provide an emotional trigger. To conclude, there is a brief discussion of the newer terminology developed since sound art gained wide usage in the late 1990s, such as "non-cochlear sonic art," and some speculation about what forms its future may take.

As sound artist Steve Roden wrote me in late 2007, "Sound is not a medium that developed through a clean linear trajectory and ended as a real movement like Futurism or even Fluxus … it's a messy history that includes a lot of wonderful things. Development for most of us was piecemeal and personal, not as a group evolving together."[2] An uncontested definition and truly complete history of sound art may not be likely, for the reasons Roden mentions, but in this book I have tried to look at sound art from a variety of angles in hopes of giving it a meaningful context beyond its reputation as a vague and often misinterpreted catchphrase. Part of sound art's paradox is that it remains a genre whose works tend to resist categorization—a classification for the unclassifiable. Ultimately, I want to honor those who drew a distinction between working as a musician and working as a sound artist, but at the same time it must be recognized that sound art might only be one facet of its makers' often diverse artistic practice, which could include music and other media.

I wish to thank Greg Hainge for making the initial connection to Bloomsbury and Leah Babb-Rosenfeld for her immediate enthusiasm for bringing a new edition of the book into print and her patience and support as I labored to rework it. Amy Martin skillfully guided me through various queries regarding image reproduction and Bloomsbury's house style. I'm grateful to Meghan Brown, Luciano Chessa, Seth Cluett, Bill Dietz, John Driscoll, Janet Hicks, Maija Julius, Lawrence Kumpf, Richard Luu, Silvia Neuhaus, Hélène Panhuysen, Kathinka Pasveer, Valerio Saggini, Taleen Setrakian, Sophie Webel, and Keiko Yoshida, who all assisted in securing photo permissions, as well as the artists who allowed me to reproduce images of their work: Christina Kubisch, Bernhard Leitner, Annea Lockwood, Gordon Monahan, Liz Phillips, and Stephen Vitiello.

I have incorporated not only much of the text from *Sound Art: Beyond Music, Between Categories* but some material from my essays "Sound Art: Origins, Development and Ambiguities" (published in the journal *Organised Sound*), "The Noise of Surface" (published in the catalogue *Art or Sound*), "CBGB as Imaginary Landscape: The Music of Christian Marclay" (published in the catalogue *Christian Marclay*), "What Sound Does a Conductor Make?" (published in the catalogue *Christian Marclay: Festival*), "Navigating Time and Space in the Exhibition of Sound" (published in the anthology *Choreographing Exhibitions*), essays on William Anastasi and Alan Vega and a review of Anri Sala's New Museum exhibition *Answer Me* (all published in *Artforum*), and a conversation with Kabir Carter that appeared in *Parkett*. I wish to acknowledge Jøran Rudi, Leigh Landy, Chiara Costa, Russell Ferguson, Claire Barliant, Mathieu Copeland, Michelle Kuo, Julian Rose, Lloyd Wise, and Jeremy Sigler for their editorial work in those original pieces, as well as Isabel Venero and Eva Prinz at Rizzoli for their editing on *Sound Art: Beyond Music, Between Categories*.

Key input and advice came from Seth Cluett, Yvan Etienne, RoseLee Goldberg, Kenneth Goldsmith, James Hoff, Stuart Licht, Barbara London, Justin Luke, Aki Onda, Jay Sanders, and Keith Fullerton Whitman.

I would like to recognize the following friends and colleagues for contributing their knowledge and insights into music, art, and sound over the years: Vito Acconci, Maryanne Amacher, Oren Ambarchi, Domenick Ammirati, Cory Arcangel, André Avelãs, Tim Barnes, Bob Bielecki, Betsey Biggs, Chris Bohn, Marcus Boon, Andrew Cappetta, Kabir Carter, Howie Chen, Luke Cohen, Seth Kim-Cohen, Anthony Coleman, Tony Conrad, Viv Corringham, Christoph Cox, Jozef Cseres, Charles Curtis, Phil Dadson, Phillippe Decrauzat, Matt De Genero, Christopher De Laurenti, Lisa Delgado, Joe Diebes, Arnold Dreyblatt,

John Driscoll, Phil Edelstein, Lawrence English, Barbara Ess, Bill Fontana, Iliya Fridman, Marco Fusinato, Bernhard Gal, Alexis Georgopoulos, Grey Gersten, Carol Greene, David Grubbs, Anne Hilde-Neset, Anthony Huberman, Manuel Rocha Iturbide, Branden Joseph, Dan Joseph, Ben Judson, Jacob Kirkegaard, Jutta Koether, Liz Kotz, Ulrich Krieger, Damon Krukowski, Thom Kubli, Andrew Lampert, Zach Layton, Franck Leibovici, George Lewis, Tobi Maier, Joshua B. Mailman, Ben Manley, Miya Masaoka, Tommy McCutchon, Thurston Moore, David Newgarden, Phill Niblock, Esa Nickle, David Novak, Stephen O'Malley, Jim O'Rourke, Piotr Orlov, Tony Oursler, Raj Patel, Bruce Pearson, Tristan Perich, Britton Powell, Seth Price, Chad Radford, Lee Ranaldo, Lucy Raven, Peter Rehberg, Pedro Rocha, Steve Roden, Bruce Russell, Yusef Sayed, Michael Schumacher, Kerry Schuss, Olivia Shao, Skye Sherwin, Yoko Shioya, Michael Snow, Laetitia Sonami, Sergei Tcherepnin, Stefan Tcherepnin, Fred Tomaselli, Yasunao Tone, David Toop, Mónica de la Torre, Derek Walmsley, Ben Vida, Carl Michael von Hausswolff, Mark van der Voort, Dan Warburton, Alex Waterman, Byron Westbrook, Tom White, Helen Homan Wu, Kolby Yarnell, C. Spencer Yeh, La Monte Young, Rob Young, Marian Zazeela, and John Zinsser.

For various professional opportunities related to sound art since the publication of *Sound Art: Beyond Music, Between Categories*, I thank Tania Aedo at Labotorio Arte Alameda, Wayne Ashley at Future Perfect, Alexander Campos at the Center for Book Arts, Jay Wegman, Martin Dust, and Jonathan Durham at Abrons Arts Center, Marina Rosenfeld, Bob Bielecki, and Bill Dietz at the Bard College MFA Program Music/Sound Department, Kevin Ernste at Cornell University, Minoru Hatanaka at I.C.C. Tokyo, Eric Namour at No Signal, Rogelio Sosa at Festival Radar, Douglas Repetto at the Columbia University Sound Arts program, and Sara Roberts at California Institute of the Arts.

Special appreciation goes to my mother, Frances Licht, and my partner, Angela Jaeger, for their unstinting support.

Part One

Introduction

"Sound art" as a term

Sound art holds the distinction of being an art movement that is not tied to a specific time period, geographic location, or group of artists and was not named until decades after its earliest works had appeared. "Sound art" is a term that has been used with increasing frequency since the late 1990s but with precious little in the way of an accompanying, agreed-upon definition. Indeed, the meaning of the term remains elusive. Gallerist Bernd Schulz has written of it as "an art form … in which sound has become material within the context of an expanded concept of sculpture … for the most part works that are space-shaping and space-claiming in nature."[1] Musician, author, and curator David Toop has called it "sound combined with visual art practices."[2] The glossary of the anthology *Audio Culture* describes it as a "general term for works of art that focus on sound and are often produced for gallery or museum installation."[3] Scholar Caleb Kelly feels that "'sound art' describes a medium, much like 'oil painting'"[4]; artist Max Neuhaus likewise suggested it was as ludicrous as terming metal sculpture to be "steel art."[5] As a term, "sound art" is mainly of value in crediting site- or object-specific works that are not intended as music per se but is often a catchall for any kind of piece, be it music or an artwork, that experiments with sound.

As with many art movements, some of sound art's chief figures, who predate the appellation "sound art," are mistrustful of the label itself. What follows are considerations of the term by two artists who take sound as their primary medium: Annea Lockwood and Max Neuhaus who made what can now be seen as inaugural sound art works in the 1960s and an assessment of the uneasy fit between sound and art institutions by Christian Marclay, an artist who has moved between the art and experimental music worlds.

That none of them seem to endorse the term is illuminating; while artists frequently resist critical categorization, in this case, it also pinpoints the lack of agreement over what—and whom—"sound art" really refers to:

> Sound art. I find it a useful term, but why? I apply it to the pieces I make using electroacoustic resources, and which I intend to be presented in galleries, museums, other places in which sound is, increasingly, conceived of as a medium per se, like video, lasers, but not as performance. For example, I'm currently working on a large audio installation, *A Sound Map of the Danube*, which I think of as Sound Art. I also recently finished a commission for the All-Stars band, which it wouldn't cross my mind to call "sound art." That's the big difference for me, between music and sound art. There's some distinction to do with the conceptual, also. I think maybe what's termed "Sound Art" doesn't intend connection to the linguistic. Eventually, all styles of performance music become languages, even [John] Cage's anti-linguistic works, as people become more and more familiar with his intentions and sound worlds. Nevertheless, perhaps the term was pragmatically conjured up for/by museum curators to account for sound's acceptance into their world.[6]
>
> —Annea Lockwood

When faced with musical conservatism at the beginning of the last century, the composer Edgard Varèse responded by proposing to broaden the definition of music to include all organized sound. John Cage went further and included silence. Now even in the aftermath of the timid "forever Mozart decades" in music, our response surely cannot be to put our heads in the sand and call what is essentially new music something else—"Sound Art" ... If there is a valid reason for classifying and naming things in culture, certainly it is for the refinement of distinctions. Aesthetic experience lies in the area of fine distinctions, not the destruction of distinctions for promotion of activities with their least common denominator, in this case, sound. Much of what has been called "Sound Art" has not much to do with either sound or art.[7]

—Max Neuhaus

Well, I think it's great that there is this interest in sound and music, but the overall art-world structures are not yet ready for that, because sound requires different technology and different architecture to be presented. We still think of museum galleries as nineteenth-century galleries, like "How do we hang this on the wall, how do we light it?" But nobody knows anything about sound—how you hang a speaker, how you EQ it to the room. There isn't that kind of knowledge and expertise within the museum world. More and more museums have a lounge-

type listening room, but there are still a lot of changes that need to happen before the art world is ready to present sound as art. And, you know, it doesn't matter because there are so many ways for people to enjoy sound these days. Sound is so easily diffused, spread around through the internet, downloaded to portable Mp3 players and Walkmans, you name it. Everything is so portable and so easy to share that you don't need an art institution to tell people what to listen to. I think it is in sound's nature to be free and uncontrollable and to go through the cracks and to go places where it's not supposed to go.[8]

—Christian Marclay

"Sound Art" was first used as the title of a 1979 exhibition at MoMA curated by Barbara London, in which artists Maggie Payne, Connie Beckley, and Julia Heyward each produced a twelve-minute tape piece that was exhibited for two weeks sequentially in "a tiny video gallery."[9] In the press release, London notes that "'sound art' pieces are more closely allied to art than to music, and are usually presented in the museum, gallery, or alternative space."[10] A review by Peter Frank of the 1981 show *Soundings* at the Neuberger Museum refers to it as a survey of "the sound art phenomenon."[11] A longer-lived early example of the nomenclature is William Hellermann's SoundArt Foundation, founded in 1982, which primarily seemed to work with experimental music or "New Music," although it did organize an early show of sound sculpture and other exhibitive work at the Sculpture Center in 1984 titled *Sound/Art*. Hellermann himself was a composer and instrumentalist but also a sculptor, and had exhibited his "eyescores" graphic notations in 1976. In the show's catalogue, published in 1983, writer Don Goddard refers to "sound art" three times.[12]

The term is already controversial in 1985, as reported by Kevin Concannon in *Media Art* magazine:

During a panel at the audio art symposium at the Staten Island Children's Museum earlier this year, Robert Ashley provoked considerable noise from his fellow panelists by referring to them as *sound artists*. Two of those panelists, Liz Phillips and Doug Hollis, are considered by many to be well-established *sound sculptors* … Hollis sees himself as a public artist and a poet of sorts. Phillips responded: "I try to avoid describing what I do; I just *do* it."[13]

Strangely, Concannon goes on to wrestle with the notion of sound sculpture as something that has less to do with objects than with using sound to show "the interaction between time and place" but makes no further comment on sound art, besides that "the field of sound art in general suffers from a lack of

definition and sound sculpture fares no better."[14] The following year Concannon wrote another article, "Notes on Sound Art," which mentions an exhibition titled "Sound Art" at the Brattleboro Museum in Vermont as well as a concert series under that name in the Boston area.[15]

By 1989 a Miami festival was dubbed "Subtropics: Experimental Music and Sound Art;" a "Sound Art Australia 91" competition was held jointly by Australian & German radio, and in 1995 the term begins to crop up more frequently in the names of festivals and exhibitions (Six Exquisites International Sound Art Festival, held in Seattle in 1995, 1997, and 1999, Sounding Islands Nordic Sound Art Festival (1995), SoundArt '95 Internationale Klangkunst in Hannover). In 1993 Rene van Peer's *Interviews with Sound Artists* was published, including Fluxus artists (Joe Jones, Takehisa Kosugi, Yoshi Wada) alongside Christina Kubisch, Terry Fox, Martin Riches, and Paul Panhuysen, an early reference to these practitioners as sound artists. Only three years earlier, in the biographies section of Dan Lander and Micah Lexier's 1990 collection *Sound by Artists*, Kubisch is the sole contributor identified as a sound artist, whereas Neuhaus is an "audio artist" (as are Lander and Douglas Kahn) and Lockwood a "composer/ performer."[16]

A rash of high profile exhibitions at the turn of the century brought the term to greater prevalence while causing considerable confusion as to what it actually referred to. *Sonic Process: A New Geography of Sounds* (Museu d'Art Contemporani de Barcelona, 2002) and *Bitstreams* (Whitney Museum of American Art, New York, 2001) dealt specifically with interfaces between digital art and electronic music and included electronica groups like Coldcut and Matmos and experimental musicians like Elliott Sharp, Andrea Parkins, and David Shea; *Sonic Boom* (Hayward Gallery, London, 2000) likewise featured 1990s electronic group PanSonic alongside veteran sound sculptors like Max Eastley and Stephan von Huene and ambient composers who have worked with installations (Brian Eno, Paul Schütze, and Thomas Koner). The sound room in the Whitney's survey of modern American art, *American Century*, was called *I Am Sitting in a Room* and mixed sound works by visual artists (Dara Birnbaum, Tony Oursler, Bruce Nauman, Mike Kelley, Fluxus), Minimalist composers (Steve Reich and Philip Glass), classic experimentalists (John Cage, David Tudor, Robert Ashley, Pauline Oliveros), and spoken word recordings (Ken Nordine, William Burroughs), with Bill Fontana being the main example of an artist who creates sound installations exclusively—and he, like the others, was represented with stereo recordings rather than the multichannel system utilized in many sound installations. *Volume:*

Bed of Sound (P.S. 1, New York, 2000) similarly functioned as an overview of experimental music, rather than sound art; unfortunately offering selections to listeners on CD players with headphones or competing with each other in a large space, it managed to include some bona fide sound artists (Neuhaus, Maryanne Amacher, Paul De Marinis) but also threw in experimental pop and rock groups (Cibo Matto, Sonic Youth, the Residents, Yamataka Eye), experimental electronic composers (David Behrman, Joel Chadabe, Tod Dockstader), free-jazz musicians (Butch Morris, Ornette Coleman, Muhal Richard Abrams), and rock star Lou Reed (who deserves some recognition as an experimental musician but should not be labeled a sound artist).

 None of these shows purported to be an exhibition of sound art per se, but their curatorial picks reflect and reinforce a tendency to apply the term "sound art" to experimentation within any music genre of the second half of the twentieth century. Other early 2000s large-scale exhibitions like *Sons et Lumière* (Centre Pompidou, Paris, 2004) and *Visual Music* (organized jointly by the Museum of Contemporary Art, Los Angeles, and the Hirshhorn Museum, Washington, D.C., 2005) and the smaller *What Sound Does a Color Make?* (Eyebeam, New York, 2005) dealt with synaesthesia, the ongoing dialogue between the visual and music/sound, and the efforts of many to *illustrate* music or sound, either synchronously or asynchronously, in the age of the moving image. Color organs, animation to music by Oskar Fischinger, the Whitney Brothers, Jordan Belson, and Walt Disney's *Fantasia*, Tony Conrad's flicker films, and late 1960s psychedelic light shows are all well worth experiencing but certainly are not sound art. They are fundamentally related to dance as a scripting of visual movement to music or sound. Music videos have become a mainstream example of the codependency of image and sound and have often been criticized for branding songs with a definitive picturization, limiting the imagination's ability to come up with its own interpretation of how the music translates into associative visions (or not). In the wake of mixed-media assemblage, video art, and performance, sound has become a medium to be reckoned with in contemporary curatorial perspectives, but sound art and sound in art are not necessarily the same thing.

Proposing a definition: Sound art versus music

For the purposes of this study, we can make a very basic definition of sound art in two (sub) categories:

–An installed sound environment that is defined by the physical and/or
 acoustic space it occupies rather than time and can be exhibited as a visual
 artwork would be.
–A visual artwork that also has a sound-producing function, such as sound
 sculpture.

(Sound or music by visual artists that serves as an extension of the artist's own
aesthetic, usually expressed in other media, is again not nominally sound art but
frequently included in early museum shows devoted to sound in the art world;
see Part Three.)

Sound art often involves motion—the audient moving through an outdoor
environment, a room, or another kind of space to follow the sound; this also
differentiates it from records or concerts of music, which are commonly
listened to from a fixed position. Sound art tends to heighten a listener's sense
of place, even if it's filling it, whereas music aims to transcend its setting. Sound
art is conceived of in terms of a *listener-to-listener* relationship between the
artist and the audient, unlike music performance, where the relationship is
player-to-listener. A sound artist is more likely to be a listener of sounds in the
environment than hearing a melody in their head or looking to compose sounds
to be put together as in a music piece. Kate Lacey has written, "Sound artists
have long been driven by a mission not only to get people to listen to different
things, but to listen differently—indeed to make listeners self-reflexively aware of
themselves *as listeners*."[17] Particularly given the automation of sound installations
and some sound sculptures, sound art belongs in an exhibition situation rather
than a performance situation—that is, I would maintain, a necessary correlative
in defining the term (although one could point to Indian sand paintings, which
are erased after a day, as an example of artwork whose rejection of permanence
is similar to live music performance; and much of Akio Suzuki's sound art
work is usually done in performance, although it's as much a demonstration or
activation as a show).

Traditionally, music, like drama, sets up a series of conflicts and resolutions,
either on a large or small scale (it can be as small as a chord progression resolving
to the tonic chord or as large as a symphonic work that adheres to the narrative
arc complete with exposition, climax, denouement, and coda). This was
drastically reconsidered in twentieth-century composition, which broke down
the prevailing orthodoxies of harmony and melody and retained the durations,
but not necessarily the forms, of traditional Western classical composition. A

friend once commented that avant-garde art is now commercially viable and extremely successful, whereas avant-garde literature, music, and film are usually uncommercial and generally unsuccessful. He's right, but that is because art (in the modern age, anyway) lacks the inherent entertainment value of a narrative that those other art forms have. It doesn't have to appeal to the masses to be successful—as long as it catches one collector's (or curator's) attention, the person who created it can make a fair amount of money from it. Literature, music, and film, however, are more likely to depend on popular opinion and public demand; there is more distance between their avant-garde and commercial sectors and a different market value between commercial art and avant-garde art. This is because they're the primary sources of entertainment besides sports. And *that* is because of the potential to be engrossed by a storyline and characters, dazzled by spectacle, or have a catchy tune stuck in your head all day. If an effort in any of these disciplines fails to live up to this potential, it's largely considered to be a disappointment; in fact, it's *intrinsically* disappointing regardless of its actual aesthetic worth. Part of the reason "sound art" has become such a popular term is because it rescues music from this fate by aligning this kind of sound work with the aims of non-time-based plastic arts, rather than the aims of music (and some have seized on it as a replacement for "experimental music" in order to escape the association with science).

When "sound art" came into parlance, there was no attendant list of artists who would be identified with it, although in Germany Rolf Julius, Christina Kubisch, and Ulrich Eller were often cited as original exponents of *Klangkunst*, which itself carried a more clear-cut definition: of works, usually sound installations, that catered equally to "the eye and the ear." Eller and Julius personified this, as Eller's installations merged sound with drawings and other media while Julius at first combined photography and sound, and then paired sounds with small objects and pigments. If we talk about Abstract Expressionism, or Impressionism, or Pop art, there are artists who have become well-known exponents of these genres (however resistant those artists may be to such classifications), but often when I've given a lecture, I'll ask the audience to name a sound artist, and they usually say "John Cage," if they say anything at all. This underlines the association of sound art with experimental music; Cage is a godfather to sound art, but chiefly a composer. As Neuhaus stated above, Cage himself followed Varèse's Modernist redefinition of music as "an organization of sound" rather than a composition of melody and harmony, but what is more important is Cage's contention that music is everywhere, in all sounds—that all sounds can be

music. His statement can be taken in two ways—that all sounds can be listened to as music or that composers can use them as musical material. Therefore, he is still thinking in terms of music, itself already an established art form, with sound as a potential tool for composition as opposed to another art medium in and of itself (although he does look to visual artists such as Marcel Duchamp and Robert Rauschenberg for inspiration, as will be detailed later). At any rate, the openness to listening to any and all sounds is the point of departure for twentieth-century experimental music and sound art as well—but this commonality does not make them interchangeable. Sound art has also been applied retroactively to noise music, sampling, and various forms of musical collage—all experimental music forms of the twentieth century. Their time-based nature and orientation toward concerts and recordings delineate these genres as music rather than sound art, although noise music is often tagged as "arty" and does belong to the tradition of noise-making started by the Futurists and Dadaists as an extension of their visual art and literary activities.

Douglas Kahn has recollected (via a reminder from artist Paul DeMarinis) that "experimental music up until the early 1970s accommodated what would now be called sound art, but by the mid-to-late 70s not only had art spaces become more amenable to sound works, but musical venues and culture had grown more conservative ... and less interested towards experimentalism."[18] 1980's New Music America festival, though, programmed not only concerts but installations in various Minneapolis locales over the course of a week: Max Neuhaus in a greenhouse, Maryanne Amacher in an empty house, Liz Phillips in a pool, and even bus stops were outfitted with speakers playing experimental music. It is clear by the time the term becomes commonplace there were enough examples of sound installation and sculpture that were resistant to the normal channels of live and recorded music that a new terminology to separate them from experimental music was justified. By the mid-1990s and through until today, festivals with this kind of programming usually have "sound art" rather than "New Music" in the title, which adds to the pervasive conflation of sound art and experimental music in audience's minds.

Adding to the difficulty in separating sound art from music is the fact that many composers also work with sound installation, especially those whose work precedes the coining of the term "sound artist." The electronic composer Nic Collins recalls:

My first exhibited project (*Under The Sun*, 1976) was an installation simply because I thought it was too long and had too little human performance to be

a concert work: a long, inclined wire is plucked by a solenoid once per second, causing a loop of Teflon to jitter a few millimeters further down the wire with each shake; the wire is amplified, and the Teflon isolates different overtones as it moves along (in the same way that a light touch upon the string of a guitar at the 12th fret yields the octave harmonic.) Depending on the size of the exhibition space, it can take hours for the loop to travel the entire length of the wire, and very few visitors have remained for the duration.[19]

Composer Alvin Lucier has had several sound installations from the late 1970s onwards and also made a series of framed sheets of paper with speakers behind them called *Sound on Paper* (1985). The speakers are set to same sine tone frequency but each piece of paper responds differently (visually and audibly). It was originally made for a dance piece but also exhibited at the art festival Documenta 14 and in the *Sound Art: Sound as a Medium of Art* exhibition (2012) in Karlsruhe. "My problem is deciding what work should be installed and what should be performed," Lucier stated in a 1995 lecture. "For me it isn't a question of deciding to make sound installations and that's all I do. I'm interested in many ideas and have to figure out what's the best way to work them out."[20] Composers Eliane Radigue and La Monte Young also made sound installations in gallery spaces in the late 1960s. It is still common for composers to include sound installation as part of their practice; Cathy Lane, who self-identifies as a composer and sound artist, has tried to analyze the distinction: "I suppose I'm a sound artist when the work that I make seems to be outside the frame of the allowable of the music in which I 'grew up,' and when the world constructed around that music only has the language and necessary references to engage a small portion of what I am trying to communicate."[21] On the other hand, Max Neuhaus, who coined the term "sound installation" in 1971, left a career as a leading percussionist in the avant-garde classical world in favor of working exclusively with sound installation—and more specifically, to work with sound in a context that was *not* music. Christina Kubisch likewise abandoned composition and performance; Steve Roden and Stephen Vitiello had once played in punk bands.

Sound art also attracts practitioners from varied backgrounds and not always from either music or the plastic arts. Bernhard Leitner and Akio Suzuki worked in architecture; Francisco Lopez in ecology; Jana Winderen was a marine biologist. And sound art itself demands multidisciplinary skill sets. Michael Schumacher told me:

There's sound art, but no sound artists … there aren't so much sound artists as people from a wide variety of disciplines—music, visual art, architecture,

computer programming, etc., who make, among other things, sound art ... It also helps in seeing why sound art is different than music, or mixed media art, since the array of practitioners suggests the inclusion of the features of their respective disciplines in the underlying conception of a work.[22]

Sound sculptor Bernard Baschet has written of himself and his brother and creative partner François:

> We are musicians because we are performers and play in concert; sculptors because with our hands we shape sheets of metal into forms, and assemble iron and other metals; poets, because we attempt to create the "supernatural element"—a universe of light, shape and sound; craftsmen, because with our hands we build musical instruments, referring also to our sensoriality.[23]

while sound artist Bill Fontana declares, "My work exists one foot in and out of contemporary music, one foot in and out of contemporary art, on the edge of some science, on the edge of philosophy."[24]

Embodying the interdisciplinary nature of the genre, Joyce Hinterding's installation *The Oscillators* (1995) uses drawing, electricity, solar power, and sound. Three drawings based on the circuit diagram of a phase-shift oscillator are turned into electrical conductors by their components—pencil, paper, and silver leaf—and a solar panel, which generates the electricity. The sound travels through piezo speakers. Shown as part of the *Sound in Space* exhibition at the Museum of Contemporary Art in Sydney, Australia, mounted on a wall, the drawings in essence fulfill the function of the sound-making electronic machine they depict, while also are displayed as visual art, a distillation of the nexus of sound, science, and visual art that sound art occupies.

Problems of exhibition

Not only is finding the boundaries of sound art difficult in terms of aesthetics but exhibiting sound works is an inherently complicated process. Any exhibition requires some thought as to how to position the works, but with sound art the visitors' movement and position must especially be taken into account, as many sound art works require that the listener experience the work from many different acoustic vantage points. Vibrations are something we feel, and sound waves are often interacting with not only our ears but other parts of our body (think about how one feels the frequencies from an amplified bass drum in the

chest area at a loud rock concert). This physicality is a key difference between going to experience sound and going to look at painting, sculpture, or ephemera in a vitrine. A visitor to La Monte Young and Marian Zazeela's *Dream House*, for example, enters a room to a sonic hurricane of static, dense, high-decibel electronic tones, whose overtones seem to change with even the slightest shift of the head. If the visitor spends a long time with the piece, it may be somewhat like looking at a sculpture from every conceivable angle, but its scale has a somatic impact as well as a psychological one, due to the volume of the sound and the selection of frequencies.

In curating a show of sound works, one is not only installing sound in the space but also putting it in contact with the visitors. People commonly understand that they are not to touch artworks in an exhibition, but in a sound exhibition the artworks are always touching *them*. Attention must be paid to volume level and comfort level; instead of positioning a painting on a wall or a sculpture on a mount to afford the best view for a wide variety of spectators, in a sound exhibition one must consider the artist's wishes about volume level versus the size of the room, the average person's tolerance for sound, and the neighboring works, if any. (In the *Dream House*, the warm glow of Zazeela's magenta light environment may make the space more inviting to those put off by the intensity of the electronic sound.) Care must also be taken as to where speakers and connecting cables are placed, not only for the optimum of sound dispersion but so as not to be an obstacle.

Equally challenging, particularly for group exhibitions, are the physical properties of sound itself. Sound is permeable and tends to move through walls; it's hard to contain in a space, which is what leads to solutions like headphones. Laboratoria Arte Alameda in Mexico City, where I curated a group sound show, *Inside Out*, in 2009, is separated into several different rooms; we managed to keep each piece discrete, although we did put one work that was located in an open, central area, Manuel Rocha Iturbide's *I Play the Drums with Frequency* (2007), which vibrated a drum kit with oscillators rather than played in the usual fashion and was the loudest, on a timer so that it would only be activated for fifteen minutes on the hour, every hour. A compromise, but otherwise it would have bled into all the other pieces. This is a frequent problem with videos in art exhibitions too, where you're hearing the soundtrack from a video in other rooms in a space—so then there's this unintended "soundtrack" to the other works. It may also be a drawback in marketing sound installations to individuals; if you buy a painting or a sculpture, it's confined to the space it resides in, but a sound

installation could conceivably be heard in every part of a house, or apartment, which might not be desirable.

The converse is that besides containing the sound, a sound work's presentation should, in theory, strive to prevent extraneous sounds from entering its space. Michael Schumacher has pointed out that art galleries make no attempt to make sure other sounds are not heard (telephones ringing, etc.) but Diapason (his sound art gallery) did. Galerie Mario Mazzoli in Berlin, which specializes in sound art, had a series of rooms in its original location with doors that would allow for discrete installations of sound works. Museums and galleries are still working out effective ways to exhibit sound works. In the New Museum's *Unmonumental* (2008), which examined contemporary collage, there were separate sculptural, two dimensional, online, and sound components. The sound pieces were played over loudspeakers but not identified other than a back announcement at the piece's conclusion, which was fairly inaudible above the din of the museum's visitors. The works were reduced to anonymous background music. In P.S. 1's *Organizing Chaos* (2007), the high-volume soundtrack of Christian Marclay's video *Guitar Drag* was audible in every other room of the exhibition, providing an unwitting aural accompaniment to the rest of the show, even to other sound pieces or films or videos that had their own soundtracks (Marclay himself wisely put multiple sound sculptures in one large room as one collective, ever-changing sound environment when curating *Ensemble* at the ICA Philadelphia, also in 2007). In Jane and Louise Wilson's 2008 sound installation *The Silence Is Twice as Fast Backwards* at the 303 Gallery, the piece is heard throughout the room, even as a visitor walks past the keyboard clicking and chatter of the gallery's reception desk, surely an unwanted sonic overlay. More recently, at a 2018 Bruce Nauman retrospective at MoMA PS1, the sound of fans in his installation *Two Fans Corridor* (1970) was entirely audible in the room next to it, containg a sound installation, *Get Out of My Mind, Get Out of This Room* (1968). For all the interest in sound art, there is still often little effort made in exhibitions to distinguish it from music in a decorative mode and showcase sound works as distinct pieces.

Groupings of sound art pieces often yield cacophony (such as one show I participated in in 1996, *Constriction*, which had a variety of sound pieces triggered by motion detectors in what appeared to be an empty gallery in Brooklyn's Pierogi 2000 space) or are real-time public compilation albums, which are annoyingly time-based (I can remember sitting in a room at the 2002 Whitney Biennial and in Charlie Morrow's *Sound Cube* at the Kitchen, an alternative space in New

York, wishing I had a fast-forward button to get to certain pieces). Sound Spill, an ongoing research project and series of group exhibitions organized by curator Thom O'Nions and artists Haroon Mirza and Richard Sides, takes the overlap of sounds in a group show as a starting point and carefully selects pieces for each iteration that will complement each other sonically, rather than thematically. While headphones are anathema to sound artworks dealing with spatiality and acoustics, some pieces have been made specifically with headphones in mind. I curated an exhibition at Abrons Arts Center in 2008 devoted to these, *The Headphone Show*, exemplified by Betsey Biggs's *Burble* (2006), an interactive work consisting of a bamboo water fountain whose burbling sounds are converted to musical tones via music software. Through headphones, visitors could vary the pitches and dynamics, as well as mix in the sounds of birds and thunder.

Zeitgleich, a 1995 sound exhibition and symposium held in Innsbruck, situated three sound installations quite compatibly in an old salt warehouse. Ros Bandt, Andres Bosshard, and Bill Fontana each made installations specific to the location itself, with Bandt using recordings made on site and Fontana transmitting sounds from the salt mines in the nearby Alps; Bosshard used both methods in different areas of the warehouse. Bandt noted that her installation featured controllers that would calculate

> sound levels and densities according to the number of people in the space and their proximity to the hidden architectural speakers. This was also moderated by the overall curatorial program that gave prominence to various installations installed in the salt warehouse at various times. In this case the overall levels could be dropped or raised in relation to other sound installations in the adjoining rooms.[25]

Not only had Bandt and the curators prepared for an acoustic relationship between the installations and the visitors, but Bandt also described the arrangement of the installations as

> a spatial scenario similar to dramaturgy. Walking in from the subterranean sounds of Bill Fontana's underground microphone, the sounds of horses on cobblestones would follow you into the space as if being carried. The ecology of the miners and community was spatially collaged throughout the columns and the River Inn's water could be heard flowing on floor speakers at the same time as Andres Bosshard's Alpine recordings flew overhead in the same space. On leaving the space, the voices of the gold-mining elders, the 90-year-old Wick sisters, could be heard coming out of the high walls of the room as if the spirit of *Das Weiss Gold*, the white gold of the salt, were resident in the building.[26]

Here the placement of three separate installations made for an interrelated flow beyond a purely sonic cohabitation.

Another exemplary navigation of how to display sound art was the 2017 show *Resonant Spaces: Sound Art at Dartmouth*, curated by Spencer Topel and Amelia Kahl, which not only situated works in a typical art context but in various sites and buildings around campus and even underground. Terry Adkins's mixed-media objects, Jess Rowland's book-like paper sound works, and Christine Sun Kim's ceramics and drawings were all shown in gallery spaces and the campus museum, while Bill Fontana made use of the slatted steel structure of the Life Sciences Center, which was vibrated with recordings he made of sounds inside the center itself. Alvin Lucier buried five speakers emitting electronic tones in the amphitheater, Jacob Kirkegaard played back sounds originally recorded above and below ground in the desert in the atrium of the Physical Sciences Center, in a vertical setting across three floors, Laura Maes filled the entrance to the school of Engineering with 200 solar-powered panels that made clicking sounds, and Julianne Swartz exhibited "listening objects," designed to be encountered by one person at a time, like a book, in the school's art library. This was a well-conceived blend of site-specific sound art and art whose subject is sound, and also highlighted sound art's position between the arts and sciences. The placement of works so that they could be encountered anywhere on campus, not just in a gallery but also in a music-oriented facility, is in keeping with sound art's basic consideration of sound as an element of any indoor or outdoor environment. A college campus is all the more appropriate to underscore this distinction given the attention and enthusiasm that sound art has received from academia, much of its critical reception has not come from music or art critics but from academics, many with a specialization in philosophy (sound art has been discussed extensively in relationship to phenomenology and ontology, notably by Christoph Cox, Salomé Voegelin, Brian Kane, and Brandon LaBelle, among others).

While exhibitions have influenced what people may construe as being "sound art," documentation and dissemination of sound art works have also been an issue, as much of the work does not translate well to either stereo sound recording or photography—video is perhaps a compromise. A two-channel stereo recording excerpt of a multiple-channel sound environment, which is a multidirectional experience, is inevitably a reduction and also a transmutation into "music"— the sounds tend to read simply as drones or plink plonk, which can add to a perceived homogeneity between experimental music and sound art. Maryanne Amacher and Yasunao Tone had long resisted recording and releasing their work

because they felt its spatiality would be lost in a stereo recording, although both had released CDs by the late 1990s; Trimpin and Bernhard Leitner have not recorded their installation work at all. Neuhaus considered his installation works "unrecordable ... but, most importantly, they exist in a specific context, and they grow from that context. To take the one component that's recordable, to take that away from the context, misleads people about the nature of these works."[27] He also felt that since sound was the material he was using and not the work itself "recording this material is as silly as taking the paint off the canvas and thinking it's still the painting."[28] The time limitations of vinyl records were also counter to installations that were intended to be free of such constraints; this is less problematic for sound sculpture, which tends to be recorded more successfully but with the caveat that its visual element is missing. This dearth of recordings makes it all the more difficult to widely communicate sound art's history and landmarks, compared to visual art movements. Even if not everyone has seen the *Mona Lisa* in person, its reproductions leave its essence intact and have made it world famous; photos or videos of performance art remain as artifacts of events that were perhaps witnessed initially by only a few people and now have been seen by thousands. But there is no truly representative recording of site-specific works like the *Dream House* or Max Neuhaus's *Times Square* sound installation—you have to visit them to experience them. A photograph of *Times Square* is a photo of a sidewalk grating in Times Square, it's not going to tell you anything more about the piece than that. A photo of Susan Philipsz's sound installation *Lowlands* is a photo of a bridge or an empty gallery. Not only are the works silenced in a photograph, but there is nothing in a still image of these sound installations that will excite the viewer's imagination or give them an impetus to go visit them. Even sound installations with a visual component often fall short in a photographic documentation. There is also the question of market value when something is mass-producible; this also correlates to video art, where releasing a video art piece commercially would devalue it and erase its identity as an installation work.

However, radio has been an ally in documenting and presenting sound art, despite the obvious drawbacks of programming time limitations and stereo mixes in a radio format. This evolved out of the European model of radio as an alternative to the concert hall as a home for more experimental, long-form work. Michael Schumacher named radio as

> the European equivalent of the American alternative space, how the gallery became a venue for alternative music. In Europe, because the concert hall was much more flexible and open to new music, new music stayed in a very narrative

form that's suitable to the concert hall. Radio became the center for what we would call radical experimentation forms. The facilities were there … the format of an hour radio program gave composers the freedom, and a different way of thinking about time. A concert hall requires ten-to-fifteen-minute pieces.[29]

As early as 1974, the CBC broadcast a ten-part series, "Soundscapes of Canada," with environmental recordings by R. Murray Schafer, Barry Truax, and Bruce Davis. In Australia, "The Listening Room," a program produced by Andrew McLennan that ran from 1988 to 2003 on ABC, covered "new radio plays, audio essays, acoustic features, sound documentaries, new music, soundscapes and sculptures, audio installations, acoustic art forms"[30]—a variety of sonic forms that heavily influenced Australia's interpretation of sound art, as will be detailed in Part Three. They regularly commissioned work and provided technical assistance both in their own studios and in the field, making a radio broadcast in many instances the raison d'etre of a given sound art piece and the program itself the leading forum for sound art in Australia. In Germany, the WDR Studio Akustiche Kunst, which started out in 1963 as a forum for radio plays, developed in the direction of "Ars Acustica," commissioning and broadcasting along the same lines as ABC; director Klaus Schöning was very much aware of ABC, starting with Bill Fontana's presence there in the 1970s, and partnered with them in some cases, notably for Ros Bandt's *Mungo* (1992), recorded on location at a dried lake in the desert and then realized as both a radio broadcast and a "surround-sound theatrical performance installation," in Bandt's description, that premiered in WDR's studios.[31] Heidi Grundmann's program "Kunstradio," begun in 1987 at ORF in Austria and still extant, was another important outlet for predominantly European sound art. Beginning in 2005, RadioArte Mobile in Rome, a web radio station, initiated a Sound Art Museum, an online archive for recordings, and also hosted installations at their studios.

Visual versus aural/sound versus silence

The sense of hearing cannot be turned off at will. There are no earlids.
—R. Murray Schafer[32]

Hearing extends further than sight; sound is perceptible from any direction. Yet vision is the more dominant sense; one can tune out sounds more readily than ignore what their eyes behold. Identification is more instantaneous with

sight than with sound. While it may be true that we gather the majority of our information visually and that we are more responsive to visual than aural stimuli (as light is faster than sound—even Varèse admitted that "art means keeping up with the speed of light"[33]), it's equally true that no one is comfortable with silence any more than they're comfortable with darkness. Aural information is not only essential to survival in any environment, to hear something that may be unseen and pose a threat, but sound can also indicate aliveness, even to an anthropomorphic degree. Sound also connotes companionship; part of the appeal of radio and records is simply that a voice is speaking or singing to the audient and engaging them in some way. Likewise ambient sounds remind the listener of his own presence in a living world, rather than an empty void. Even when reading, we "hear" in our heads our own voice reciting the words. In museums, audio tours provide an aural guide even when artworks are labeled with relevant information and background. And we're always trying to find something to look at when faced with a sound that has no visual counterpart—no one listens to the radio in the dark or closes their eyes when they're on the telephone. Look around: people driving with the radio on, walking around with headphones plugged into their smart phone, creating their own soundtrack of prerecorded sound to replace the ambient sound that reality is surrounding them with. A work by Hans Peter Kuhn illustrates this need: in 1988 he was commissioned by the city of Berlin for a public sound work as a picnic, with designated food and blankets and cassette players with specially designed soundtracks for eating the picnic lunch. Of course, there's a kind of layering of sound going on, as the sounds of urban civilization that one's earbuds are drowning out have already paved over a natural soundscape.

Still, the subjective lack of control over sound in relation to sight (where of course, one can always close one's eyes) is another way that sound can be a nuisance. Noise in a gallery or museum is considered a distraction in appreciating both sound and visual art. Carsten Seiffarth, who ran the Singuhr Gallery in Berlin, has written that openings at his gallery "each with around 400 visitors in the underground water reservoirs in the Prenzlauer Berg district, shows, for example, that sound art completely goes under at such events. The sound material of an installation is drowned out by the many visitors and can, simply, no longer be heard."[34] Video art notwithstanding, while visiting a museum, painting or sculpture is customarily intended to inspire quiet contemplation; however, this has become less and less likely with museums attracting crowds. Sound artist Ed Osborn has started a website called Audio Recordings of Great

Works of Art (www.auralaura.com) in which he records the sounds made by visitors to household-name sculptures and paintings in museums around the world (the *Venus de Milo*, the *Mona Lisa*, etc.). And Conceptual artist Lawrence Wiener has commented:

> When you look at a painting in a gallery you hear somebody talk behind you about their feet hurting. You hear all the noises around you. You start to talk to other people and that is how you see art. So why not hear it as well as see it all at the same time? But it is not a *Gesamtkunstwerk*. Everything is moving along at the same time. They are all growing. There is not one dominant.[35]

Marco Fusinato took a radical approach to the issue of extraneous noise in a gallery with his installation *Constellations* (2015) in which a large white wall is constructed that bisects a gallery space with microphones hidden inside. Visitors are invited to strike the wall with a baseball bat attached by a chain, the impact causing a blast that is amplified to 120 dB. This is a sort of institutional critique, not only symbolically battering the walls of the white cube art space but also suggesting that an art space can be loud instead of quiet.

Of course, sound installation in a gallery setting makes it easy for someone to just drift in and out the way they would take a quick look to see if a painting or sculpture catches their eye and then keep moving on to the next location. As Jørgen Larsson put it, sound art theoretically demands both quiet and a time commitment from the visitor (although perhaps not stillness, as he contends, as many sound installations are best appreciated and sometimes even require a more ambulatory approach):

> Rather than an art form, sound art is a mode of experience. As a visitor to such work, one soon becomes aware of how fragile this experience is; the mere conversation or movements of other visitors, or other forms of ambient noise, can effectively cause the art to vanish. In contrast to the sense of sight, which functions just as well even when you run through a gallery, listening requires you to stand still, because the sound of one's own movements always threatens to mask other sounds. In effect, audiences are invited to partake of a slow experience that turns one's own physical presence and that of others into a kind of social acoustics. In a concert hall, the audience's temporal and spatial experience is essentially determined by the composer/performer. In sound art, the temporal and/or spatial aspect of the experience is the responsibility of each individual listener.[36]

Sound art is directed toward the individual by highlighting perceptual experience. In their essay "Defining Sound Art," Laura Maes and Marc Leman write, "Whereas a concert hall strives to bring the same acoustic experience across

to all members of the audience, disregarding their seating, most sound artworks want to achieve the opposite experience as the perception changes and depends on the viewer."[37] Neuhaus too desired an individual response with regard to space and time, putting sound in almost sculptural terms: "Traditionally, composers have located the elements of a composition in time. One idea which I am interested in is locating them, instead, in space, and letting the listener place them in his own time."[38] His *Water Whistle* pieces of the early 1970s, which were electronic sound installed in pools and only audible by submerging one's ears in water, are one example of how he went about making works geared to an individual experience yet in a space large enough to accommodate an abundance of listeners. Putting the listener in charge of the amount of time spent with a sound piece further distances sound art from music and strengthens sound art's bond with visual art, where the viewer determines how long they take to look at an object.

This insistence on the individual's response is also part of the resistance sound art has faced from the music establishment. Christina Kubisch remembers that

> in the beginning it was more the departments of visual arts which were interested in my works, because the sounds I have been offering are not a finalized, fixed composition. As it was something which the visitor has to mix himself, it was not taken for serious. Although it was not meant to be a provocation, it was frowned upon, especially in the music scene.[39]

Sound art's focus on the individual is at odds with music as a connector of people and a shared activity. Meanwhile, sound's acceptance into the art world is hampered by its immateriality; in a lecture at the 2016 Sound Art Matters conference in Aarhus, Frances Dyson points out that "sound has never been matter, and matter is associated with substance—things that 'don't matter' are 'immaterial' or 'insubstantial.'"[40] In this way sound art can also be seen as political, a kind of civil rights movement for sound, which is as ubiquitous as the visual yet in many ways subservient to it. In the 1960s Conceptual artists embraced sound partially as a way to displace or topple visual dominance, and sound sculpture's aesthetic of generating or conveying a sound from everyday objects is in some respects like giving dispossessed people a voice. Max Neuhaus told an interviewer, "People think seeing is everything. They say, 'Seeing is believing,' but in fact the eye and ear are in constant dialogue … Sound is the other half of life."[41] Bill Fontana recalls an epiphany when he was doing field recording in a tropical rain forest and encountered a solar eclipse:

During the minutes just before the moment of totality (having a duration of 2 minutes), the acoustic protocol between birds, determining who sang at the different times of day became mixed up. All available species were singing at the same time during the minutes immediately proceeding totality, as the normal temporal clues given by light were obliterated by a rainforest suddenly filled with sparkling shadows. When totality suddenly brought total darkness, there was a deep silence. This recording was seminal for my work because a total eclipse is always conceived of as being a visual experience, and such a compelling sonic result was indicative of how ignored the acoustic sensibility is in our normal experience of the world. From this moment on, my artistic mission consciously became the transformation and deconstruction of the visual with the aural.[42]

The factors of sound and time can be problematic for regular art audiences. Janet Cardiff has enumerated the obstacles involved in the reception of her audio walk pieces in answer to the question, "Is it difficult to develop a reputation in the art world when your works are site-specific and unable to circulate to multiple venues?"

One major problem is also the format because walk pieces are a bit invisible, and many of the audience members miss the pieces unintentionally. Other problems are because a lot of people have difficulty participating in an artwork that

–takes 15–20 minutes of their time, people don't want to give that much time (especially the press)
–is not traditional in its interaction as an art object i.e. it cannot just be looked at for a few minutes. It dictates the time that you must take rather than the audience having a choice which is what they are used to in relation to art. Films and linear videos have this same problem in an art museum
–uses a new format or real world materials like Walkmans and video cameras instead of identifiable art coded materials
–is not traditionally visual so people don't recognize it as art or they mistake the pieces for a didactic "tour" because of the format or miss the piece because of this or because my pieces quite often are in different sites away from the museum. One of the best aspects of this format is that when a person does commit to doing a walk they get involved for almost twenty minutes rather than the normal 20 seconds that is given a lot of works. As well the audio gives them an intimate connection with me, the artist.[43]

Public artworks can be controversial and those involving sound sometimes provoke outrage and even violence. Video artist Valie Export did one sound

piece in 1979, a "sound monument" that positioned huge loudspeakers on either side of a bridge in Graz, Austria, from which recordings of belches bellowed forth. The town reacted in a fury, and the piece had to be dismantled. During New Music America 1988 Gordon Monahan had a sound installation that was activated over Miami's elevated train's sound system at every stop, which caused widespread confusion among passengers and was shut down after two days. In an essay on public audio, Brandon LaBelle describes how John Wynne's *The Sound of Sirens*, composed of various alarms and set up in a town square in Copenhagen in 1997, was terminated by the City Council as people had become "confused and frightened" by it, and that Bill Fontana's relatively innocuous *Aerial Waters* (1998), which broadcast sounds from a lake from several bell towers in the town of Bregenz, was vandalized by a local priest who attacked a loudspeaker and receiver in one of the towers.[44] La Belle cautions:

> The question of "enriching" the listening experience is predicated on the assumption that the public is at all interested in such experience. This is not to suggest that one should not develop such work, engage with public space, and inaugurate new forms of artistic encounters, but rather that while we may concentrate on the physical and perceptual materiality of sound, it may in turn behove our auditory pursuits to appreciate and embrace sound's inherent ability to annoy, antagonize, and agitate.[45]

Even if the public is not viscerally offended by a sound artwork, they may also be simply unaffected by it. In 1973, composer and then journalist Tom Johnson went to see *Walkthrough*, a Max Neuhaus installation in the Jay St.-Borough Hall subway station in Brooklyn; Neuhaus made many public sound installations, characteristically low-volume and low-profile, which he tended to fold into an area's milieu not wanting to call attention to the work or interfere with people's daily activity, preferring them to discover the adjustments he had made to the sonic ambience on their own. *Walkthrough* constituted two electronic beeping tones whose rhythm, while mostly steady, changed slightly depending on weather conditions. Johnson asked a couple of subway employees, who would have been hearing the beeps continuously on the job, what they thought of it. Both had noticed the sound but hadn't taken much interest or realized that it was the product of an artist, and both asked, "What's it for?" When asked if he liked it, one replied, "It doesn't bother me, but it doesn't do anything for me either. Not like music. Music makes me feel something, but this doesn't make me feel anything."[46]

The lack of an emotional connection with sound art can also help explain its perennial outsider status in both the art world and the music world. It is perhaps unsurprising that the sound pieces that have attracted notice from the art world lately, such as Susan Philipsz's *Lowlands* (2010) or Janet Cardiff's *40 Part Motet* (2001), have used vocal music, a reliable communicator of emotional content, as source material, and both appeal to an appreciation of music rather than sound for sound's sake. But this is a recent development; sound art grew from the separation of sound from its source via the technological agents of microphones, transmission and recording, and the simultaneous Modernist pursuit of abstraction in both art and music. As a result, its initial phase in the second half of the twentieth century was marked by a new consciousness of hearing a full spectrum of sounds and works that conceived of sound as a vehicle for transcendence and spatial reorientation.

Part Two

Prehistories and Early Manifestations

The disjunction of sound and image

Somewhat ironically, the evolution of sound art may be ascribed in part to sound's *separation* from visual art, rather than their union. Centuries ago, sound mixed with visual art in the church. As Don Goddard has written, "motets, oratios, cantatas, requiems, fresco cycles, and altarpieces intoned or depicted the same subject matter, while architecture provided vaulted spaces for the acoustics and illusions of music, painting, and sculpture."[1] With the advent of the concert hall in the nineteenth century and the expansion of cities and secular thought, the arts began to disperse from this meeting ground. The conception of sound as an independent entity that ultimately would find its way to a genre of sound art started with the mediation and division of sound from its source through recording and radio and telephone transmission and continued through the disjunction of sound and image in cinema.

With the inventions of the telephone, phonograph cylinders, and radio in the late nineteenth century, people had their first experience of hearing each other's voices and other sounds come out of a device. In these technological disembodiments, sound takes on a life of its own and becomes untethered to its original location and, through playback, the present moment. With the telephone and radio, one could hear voices and sounds occurring in two different parts of the world at the same time. The telharmonium, an instrument that would pipe music (played on multiple keyboards) into different businesses and public areas through installed loudspeakers, using the principles of the telephone receiver and transmission, was an early forerunner of Muzak (and by extension, sound installation). That was developed in the late 1890s; by the early twentieth century, artists were already thinking of abstract avenues for radio beyond music. In 1925, Kurt Weill called for an "absolute radio" to coincide

with the "absolute cinema" (which did not tell a story but was a montage of pure images), with noises, sounds of nature, and "unheard sounds" that could be produced by the manipulation of the electronics of microphones. Futurist F. T. Marinetti began his *radio sintesi* in 1933, an early montage of various sounds from the real world. It seems fitting that one of the first sound art works made by Max Neuhaus, *Public Supply I* (1966), would be constructed out of both telephone and radio technology. Doing a live broadcast at WBAI in New York, he installed ten phone lines and mixed listeners' calls to the studio live, incorporating the feedback that occurred from the callers having their radios on. For *Drive in Music* (1967–1968), Neuhaus installed radio transmitters along a stretch of road that set up a number of sounds, heard through an AM radio in a car, which changed as one drove along (Neuhaus was apparently arrested several times during one realization of the piece in Buffalo). Bill Fontana's series of "sound bridges," where he linked different cities on different continents via satellite through the broadcast of their ambient sounds live on the radio, is even more linearly descended from the innovation of long-distance wireless radio transmission.

Just as any sound, having originated in some far-off location, was suddenly displaced when issuing forth from a radio, telephone receiver, or loudspeaker, in silent films, human activity and the world, depicted more realistically than ever before, were rendered mute. Pianists had to be brought in to break the silence (and mask the sound of the projector), while inter-titles, and even "lecturers" were brought in to explain the action to audiences. Phonograph records and carnival barkers were also used to provide sound accompaniment to films, but as film running times grew, records (which were not yet "long-playing" and only held a few minutes of sound) became impractical, and when films started screening in larger rooms it became harder to hear the barkers.[2] With the coming of sound film, film purists were dismayed at the possible end of pure cinema, in which the story was told strictly visually. The famous 1928 Soviet "Statement on Sound," by directors Sergei Eisenstein, Alexander Pudovkin, and Grigori Alexandrov, lamented the encroaching realism of synchronous sound and image, reducing cinema to little more than canned theater, and derailing the inroads made in montage. They advocated asynchronous sound, which would maintain the independence between sound and image. Eisenstein and Alexandrov collaborated on asynchronous sound films (*The General Line/Old and New* (1929) and *Romance Sentimentale* (1930)), while René Clair's *Entr'acte* (1924) used an Erik Satie composition

(originally made to accompany a ballet by Francis Picabia) called *Cinema*, which was comprised of musical segments in uniform length that did not conform to the film's edits. Dziga Vertov, who had trained as a musician and had made films out of frustration with the technical limitations of the time that prevented making audio montage to his satisfaction, was overjoyed at the prospect of sound in cinema, claiming that both synchronous and asynchronous sound were valid in the new cinema and maintaining an intricate interplay between sound and image in *Enthusiasm* (1930) and *Three Songs of Lenin* (1934).

Of course, the Soviets' fears were realized as early film sound largely consisted of little more than stiffly recorded dialogue (with actors often stuck talking around a table with a microphone hidden in a plant) and some incidental music. It's only later in the 1930s that sound film starts to show signs of sophistication, with post-synced sound created in the studio, Foley effects (borrowed from radio), and a sound mix. Orson Welles's background in radio was used to great effect in the soundtrack to *Citizen Kane* (1941), particularly a technique in recording the audio where the actors were placed at different distances from the mic, creating a sense of depth matched in the film's deep-focus cinematography. But in some animated films sound effects were used to help tell the story, synchronized with the action but not naturalistically representing it (a drum roll for running feet, for instance). In the 1950 cartoon *Gerald McBoing Boing*, the character spoke in sound effects, not words. As Walter Murch has noted, "with animated films you have to create something that gives a sound where none is present"[3]; unlike live-action films, there is no sound during the actual filming of a cartoon. (The cartoon soundtracks by Carl Stallings would become rediscovered in the 1980s experimental music scene, admired for their dexterous juxtapositions of sound effects and different genres of music that resembled the quick successions of musical quotations then fashionable in avant-garde circles.)

Recording and sound as an object

Recording was arguably an even more radical invention than photography in that the human voice was thought to be un-reproducible, whereas human likeness had been captured to greater and lesser degrees in visual art; it was the invention that Thomas Edison himself was most proud of. It was only a matter of time, in light of Modernist trends in art, before experimental techniques

were applied to documentary recordings. Walter Ruttmann created *Weekend* (1929), a "sound film without images," for radio, an eleven-minute, rapid montage of speech, noises, and music that in his view demonstrated the "procedure of photographing audible phenomena in a non-stylized manner, with the inclusion of their specific spatial characteristics," further enthusing, pre-Cage, that "every audible in the entire world becomes material."[4] Recording reaffirmed sound's invisibility, and some took advantage of recording as an opportunity to intensify, rather than compensate for, sound's imageless identity. Musique concrète, developed in France in the late 1940s and 1950s by Pierre Schaeffer (a radio engineer) and Pierre Henry, took documentary recorded sounds and processed them to the point of unrecognizability (speeding up or slowing down the tape, editing, and using distortion and other effects) so as to dissociate them from the object that made them. The sound of a violin, untreated, is identifiable as a violin, although it isn't a violin per se, in the same way that a photograph of a violin is not a violin. With Schaeffer's electronic treatments, the sound itself becomes an object in and of itself, and not an imitation—Schaeffer even referred to *objet sonore*, or sonic object.

With musique concrete, sound and image again become an issue in so-called acousmatic listening. As defined by Schaeffer, acousmatic listening is "listening to sound without any visual clue to its source."[5] The term derives from the disciples of Pythagoras who heard, but never saw, his lectures delivered from behind a curtain. Schaeffer made an analysis of four modes of listening that preceded acousmatic listening: Ecouter (listening with attention paid to the source of the sound) Ouir (hearing in the basic sense, without discrimination) Entendre (listening to certain aspects of the sound itself) and Comprendre (attaching meaning to the sound once its identity is established). Acousmatic sound then facilitates *l'écoute réduite* (reduced listening), where the external factors in Ecouter and Comprendre are eliminated, putting the perception of sound itself as the only objective. Despite Schaeffer's nuanced attention to listening, and the fact that musique concrète is not performed by instrumentalists, it is still in the player-to-listener mode, since its composers are aware of the audio source material in its raw state before its transformation; the composer has a whole prior stage of listening that the audience is not privy to before receiving the work. Schaeffer, in fact, ultimately became discouraged when he couldn't distance sounds far enough sonically from their original source for his liking and felt he could not escape musical form and break

through to pure sound. In sound art, the citing of a sound's source is often integral to the work, and the degree of listening as postulated by Schaeffer often varies accordingly, particularly if there is an accompanying visual component or whether it is a public art work or in an art institution. Nevertheless, in its insistence on reconfiguring sounds to be taken on their own terms and advancements and advocacy of heightened listening, musique concrète stands as an essential link between music and sound art, and between sound and the art world, as the 1944 premiere in a Cairo art gallery of a pre-Schaeffer example of tape music, Halim El-Dabh's *Expressions of Zaar*, a piece derived from manipulated recordings of women's voices in an Egyptian healing ceremony, seems to attest.

The other value of recording was its capacity for repetition not only by replaying a recording over again but by creating tape loops in which the machine would play a given section of tape over and over without interruption, which contains the seeds of sound installation. This was anticipated by Schaeffer early on in his 1948 *Five Studies of Noises* using locked grooves on record discs rather than tape. Previously, the idea of continuous repeats could only be realized through physical repetition, a notoriously extreme example being Erik Satie's *Vexations* (1893), a piano piece that reiterates the same melody, with two different harmonizations, 840 times. A performance of the piece organized by John Cage in 1963 at the Pocket Theatre in New York lasted eighteen hours and forty minutes, and another performance in conjunction with the 1981 exhibition *Soundings* also lasted eighteen hours; Richard Toop's performance at Arts Lab in London in 1967 lasted twenty-four hours. Toop remarked "the piano was in the outer foyer, where there was an art exhibition, so that the music became a real 'musique d'ameublement.' [i.e. "Furniture music," Satie's own term for music that stays in the background of a social gathering, rather than the foreground of a recital] People walked round the piano, talked, sometimes stopped and listened."[6] Satie scholar Stephen Wittington has likened it to art rather than music:

> The static, undramatic nature of *Vexations*, reinforced by repetition, gives it the character of a "sound object" (objet sonore), while the "flatness" of the music suggests a two-dimensional surface … the pallid harmonic colour of *Vexations*, the absence of strong contrast and the large-scale repetitive structure based on the small-scale alternation of similar elements, suggest an analogy with the "pale and hieratic" frescoes of the Middle Ages or antiquity which Satie so admired.[7]

Vexations' epic repetitions afforded room for contemplation associated with visual art and not usually possible with time-based music; its integration with the aforementioned exhibitions underlines this perspective. Cage's revival of the piece coincided with artists' investigation of repetition as a way of testing the limits of the reception of time-based forms. Choreographer Yvonne Rainer, in discussing her 1961 solo work *The Bells*, said that dance "was at a disadvantage in relation to sculpture in that the spectator could spend as much time as he required to examine a sculpture, walk around it, and so forth—but a dance movement—because it happened in time—vanished as soon as it was executed."[8] Her solution was to repeat seven movements, in varied sequence, direction, and parts of the room, over seven minutes—"in a sense allowing the spectator to 'walk around it.'"[9] Bruce Nauman's eight-minute 1967–68 film *Dance or Exercise on the Perimeter of a Square (Square Dance)* shows him stepping to the rhythm of a metronome from each station of a square constructed of tape on his studio floor; we see him from every angle over the course of the process of moving around the perimeter of the square. A visual artwork manages to freeze a moment in time as an image; installations that use loops or drones are an attempt to sustain a sonic moment indefinitely to inspect details (as you would with a work of art). There is no fixed time duration in appreciating a visual art object; however, for a sound installation, even if it's seemingly static, it may take an extended period of time to fully understand everything the piece has to offer and to absorb the structure the sound artist has intended.

Bill Fontana has written: "Sounds that repeat, that are continuous and that have long duration defy the natural acoustic mortality of becoming silent."[10] The use of echo and delay to elongate a sound's time duration is a basic technique to serve this dual purpose of time extension and opposing silence (and, on a subliminal level, lengthening life itself). You can only hold a note vocally for a short period of time until you *run out of breath;* psychologically, this could be part of the equation of silence with death. And in some cases, architecture itself afforded an extreme echo that could sustain a given sound to an almost perpetual degree. In an interview, sound artist and architect Bernhard Leitner notes a sense of infinity in the acoustics at the Taj Mahal:

> The Taj Mahal contains a huge empty domed space above the crypt. The mass, the weight of the walls, the shape and dimensions of the dome (twenty meters in diameter, twenty-six meters in height), and the extremely hard and polished surfaces (the interior of the dome is entirely made of marble) sustain a tone for up to twenty-eight seconds. In this space, a simple melody played on a flute will

interweave with itself, going on and on to become an almost timeless sound. The room never ends. Even without sound time is inherent in this space. The silence is tension-filled. The space finds its meaning in an unearthly, infinite silence.[11]

Akio Suzuki is a sound artist who has pursued echoes as an aural method of mapping space. In the "self-study event" *Searching for Echo Point*, he first actualized an idea of throwing sounds into nature and then following them and playing with the echo. To this end, in the 1970s, he fabricated and performed on the instruments Suzuki-type glass harmonica (later re-christened De Koolmees) and Analopos, an echo instrument made of a spiral cord and two metal cylinders. The sonic effect has been compared to two mirrors facing each other. In the piece *Oto-date*, performed at the first Sonambiente festival in Berlin in 1996, he charted a map locating thirty different points of special audio interest (chosen for their echo density) in the city and placed markers at each one. He also performed *Oto-date* in other areas, using explosive sounds (from dynamite to a bamboo slit drum) to gauge the echoes.

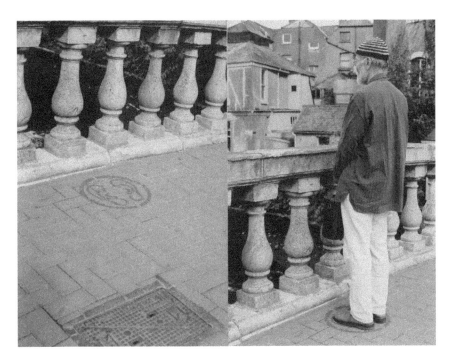

Figure 2.1 Akio Suzuki, *Oto-date*, Cork, 2005. Photo by Keiko Yoshida.

Sound and space

Every sound has a space-bound character of its own. The same sound sounds different in a small room, in a cellar, in a large, empty hall, in a street, in a forest, or on the sea.

—Bela Belazs[12]

Recording removed music and sound not only from time (by documenting its moment of creation for replay and via tape loops, or slowing down and speeding up tape) but from a designated performance space as well. Brian Eno points out that recording took music away from site specificity, as you could bring a recording of the symphony into your home as opposed to having to go to the concert hall.[13] Pianist Glenn Gould gave up performing concerts in the mid-1960s because he thought that records would replace the concert hall. This was partly due to an egalitarian attitude on his part; at home, everyone had the best seat in the house, and in playback "the listener is able to indulge preferences and, through the electronic modifications with which he endows the listening experience [presumably the bass and treble or equalization controls on a home stereo] imposes his own personality upon the work. As he does so, he transforms that work, and his relation to it, from an artistic to an environmental experience."[14] In this way Gould unknowingly interprets albums as a kind of interactive sound installation. Not only could home listeners enjoy the piece of music at any time, but through volume and equalization on a hi-fi system they effectively become an executive producer. One reaction to record players' capability of turning any living room into a concert hall, and consolidating the nineteenth-century restriction of sound to one central location, was new implementations of site specificity and spatiality in the composition and presentation of concert music.

A key characteristic in sound art is its interest in articulating a preexisting space through sound or fine-tuning a sound in a space. Long before sound art though, there was often a deeply ingrained understanding of sound's relationship to architectural and natural spaces. Bill Viola has written of Gothic cathedrals:

When one enters a Gothic sanctuary, it is immediately noticeable that sound commands the space. This is not just a simple echo effect at work, but rather all sounds, no matter how near, far, or loud, appear to be originating at the same distant place ... Chartres and other edifices like it have been described as "music frozen in stone."

Ancient architecture abounds with examples of remarkable acoustic design—whispering galleries where a bare murmur of a voice materializes at a point hundreds of feet away across the hall or the perfect clarity of the Greek amphitheaters where a speaker, standing at a focal point created by the surrounding walls, is heard distinctly by all members of the audience.[15]

In modern times architecture has been less preoccupied with acoustics. "Sound as a medium is still lost a lot in our culture," sound artist Bill Fontana has said. "Architects hardly think about it. We design space visually and don't think about the relationships between sounds that exist in spaces."[16] Viola notes that modern acoustics have been developed to combat unintelligibility due to the reverberations in modern room design, which he considers ironic because "the acute reverberation in the Gothic cathedral, although a result of construction and not specific intention, was considered an essential part of its overall form and function."[17] And Bernhard Leitner has noted the effect of room acoustics on human health:

> What is true for music applies to any acoustical stimulus: the sound quality of a room affects the nervous system. Heart, breathing, and blood pressure, which are largely beyond conscious control, are affected. And psychosomatic implications should also not be underestimated. In other words our entire physical and mental well-being is affected by the sound of a room. Because modern architecture has underestimated if not completely ignored these phenomena, it certainly has caused substantial damage. In this context we must, however, point out that we have great difficulties talking about the way we hear a room, the way we come to terms with "audible" space. We simply lack the terminology. In this respect our visually-oriented language fails us.[18]

The use of spatiality in Western European music composition goes back to the sixteenth century, when composers like Giovanni Gabrieli were writing works to be performed in churches by multiple choirs. Gabrieli wrote in particular for St. Mark's Cathedral in Venice, which boasted two choir lofts and two organs facing each other (also an early example of site-specific composition). Leitner cites another even more complex example from the seventeenth century:

> In 1628 the Salzburg cathedral was inaugurated with the performance of a spatial/musical composition by Orazio Benevoli, for which fifty-three instruments and twelve choirs were distributed throughout the interior of the cathedral in order to emphasize its acoustic effects through the ensemble playing of different groups, through echoes and dialogues, or through a general tutti. The resulting

monumental spatial effect was achieved in an altogether different way from that used in the nineteenth century where one simply projected an increased volume of sound into the space from a single place, the podium. Likewise, in court ceremonies small groups of musicians were distributed all around the room in such a flexible way that they could change places at short notice and thus create different spatial effects as well as meanings.[19]

One exception to the nineteenth-century practice that Leitner mentions is Mahler's *Third Symphony* (1896) where there is one section in which the brass plays offstage; another example of offstage brass is found in Berlioz's *Requiem* (1837). In the early twentieth century, George Ives and Henry Brant composed pieces for multiple bands or orchestras to be played outdoors. Ives, father of the composer Charles Ives, had two marching bands play two different tunes while marching through a town park, starting at opposite ends. Ives would listen for the differences in sound in relation to each band's position at any given time. He would also have his son listen as he played cornet from across a pond, later immortalized by Charles in his composition *The Pond (Remembrance)* (1906). Charles would use spatiality to some degree in the orchestration of pieces like *The Unanswered Question* (1908), but it was Brant who took spatial composition for acoustic instruments to its twentieth-century apogee. In *Antiphony I* (1953), five orchestras are spread throughout the stage and auditorium. Brant went on to compose over one hundred spatial pieces (needless to say, these do not translate well to stereo recordings).

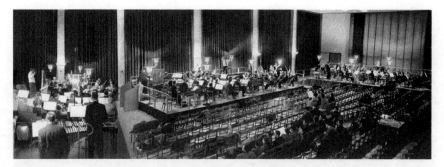

Figure 2.2 Rehearsal for the world premiere of *Gruppen* by Karlheinz Stockhausen with the Cologne Radio Orchestra under the direction of Stockhausen, Bruno Maderna, and Pierre Boulez, Cologne, Germany, March 24, 1958 © Archive of the Stockhausen Foundation for Music, Kuerten, Germany (www.karlheinzstockhausen.org).

The musique concrète crowd was already conceiving of spatialization in the early 1950s. At Pierre Schaeffer's suggestion, Jacques Poullin invented a device called *pupitre d'espace* ("space desk" or "space control"), which utilized induction coils to move sounds around in space. Edgard Varèse had even earlier wished for "a sense of sound projection in space by means of the emission of sound in any part or in many parts of the hall."[20] Karlheinz Stockhausen is often associated with spatial music, for a series of compositions he dubbed *raummusik* ("music in space"). He has maintained, "From the very beginning I've thought about where the instruments would have to be placed, I didn't want to simply have an automatic spacing of sound."[21] *Gruppen* (1955–1957) for three orchestras comes two years after Brant's *Antiphony I*, but Stockhausen's piece involved "moving timbres … a chord is moving from orchestra to orchestra with almost exactly the same instruments (horns and trombones) and what changes aren't the pitches but rather the sound in space,"[22] whereas Brant's music emphasizes contrasting a variety of musical styles (in the footsteps of Ives). *Carré* (1959) was for four orchestras and four choirs surrounding the audience. In 1956, Stockhausen composed *Gesang der Jüngling*, a landmark musique concrète piece that incorporated singing, tape loops, and electronics, spreading five loudspeakers throughout the auditorium. The electronic piece *Kontakte* (1960) dealt with the speed of sound moving from one speaker to the other. This prefigures the sound installations of Hans Peter Kuhn: in *Blue* (1997) Kuhn moves sounds recorded in a factory among several speakers at hyperspeed, while an installation at New York's Chelsea Piers also moved sounds between nine outdoor towers at a rapid pace. Stockhausen also thought of putting musicians on swings to make the sound move and conducted workshops at Darmstadt of "walking and running music" where singers and instrumentalists made movements. In *Ensemble* (1967), a four-and-a-half-hour performance as part of one of his seminars in Darmstadt, at the program's end the musicians continued playing in open roofed cars or open car windows and met again 20 miles outside of town. Stockhausen also took movement of the audience into account: "You have to compose differently when you know that the listeners are coming and going."[23] In *Sternklang* (1971), five groups of musicians were separated by bushes and trees. The sound changed for the listeners as they approached each group, who would then walk over and listen to another. Stockhausen's ideas about motion and music performers and audiences foretell many of the measures adapted in conceiving how sound installations function and are to be encountered, e.g., Neuhaus's *Drive in Music*, where the listener/driver controlled the speed at which the sounds were heard.

Iannis Xenakis also composed acoustic and electronic pieces requiring instruments or multiple speakers positioned at various points in the hall: *Terretektorh* (1965) "for 88 instruments scattered throughout the audience"; *Nommos Gamma* (1967) for ninety-eight instruments similarly dispersed; *Kraanerg* (1968) for four-channel tape and orchestra; and *Persephassa* (1969) "for six percussionists circling the audience." He also had spatialized arrangements for outdoor works including *Persepolis* (1971), with 100 loudspeakers distributed among the ruins of Darius's palace in Iran, and *La Legend de Er* (1978), first performed at the opening of the Centre Pompidou as a seven-channel tape piece.

It should be remembered that while the spatialized multiple-channel sound diffusion of modern classical composition is likewise utilized in much sound art, these works are still time-based and remain in the Modernist classical format of "an organization of sounds," even if they have a "moment-to-moment" structure (as in Stockhausen) as opposed to traditional compositional forms or a seeming narrative arc. By and large the pieces were composed with concert or radio programming, and possibly even album side lengths, in mind, with appropriate durations in the fifteen- to twenty-minute range. Several concert spaces have been developed to accommodate spatialized composition. In the performance space of the Centre Pompidou's Institut de Recherche et Coordination Acoustique/Musique (IRCAM) "the wall consists of hundreds of panels that can be flipped around to get the acoustic that you want, and a ceiling that can be lowered." Radio France operates the Olivier Messiaen Concert Hall with a spatial sound system ("an orchestra of loudspeakers") designed by musique concrète composer Francois Bayle, who dubbed it "acousmonium." The Institute for Music and Acoustics at the ZKM Center for Art and Media in Karlsruhe, Germany, completed the Klangdom (Sound Dome) in 2006, with fifty speakers controlled by software called Zirkonium for flexible spatialization. The Experimental Media and Performing Arts Center (EMPAC), which opened at Rensselaer Polytechnic Institute in 2008, claims their "convex walls and other shaped surfaces allow performers or loudspeakers to be anywhere in the hall, redefining the notion that music comes only from the stage." Since the 1960s, San Francisco composer Stan Shaff has operated the Audium, a "theatre of sound-sculpted space," where he plays his own spatialized works through 176 speakers dispersed throughout the main room.

The experiments in spatialization in the concert hall had also taken place in the cinemas: in 1953, Fox introduced CinemaScope, which originally was not only a new chapter in cinematography but also a sound process in which four sound

tracks played on three speakers behind the screen (for onscreen sound) and one "surround" speaker (for off-screen sounds and/or voice-over narration). Todd AO sound, introduced in 1955 with *Oklahoma* (the same year that Stockhausen began composing *Gruppen*), utilized six tracks on five speakers and as many as nineteen "surround" speakers spread throughout the theatre. This may have been done in the name of spectacle and perhaps to compete with television— the same could perhaps be said of spatialized sound-equipped concert halls, although in relation to home stereos instead of TV sets—but adding a visual surely enhanced the prospects of a thoroughly immersive experience achievable through spatialized sound.

Early sound installation

Alongside the resurgence of spatialization in modern music composition, some visual artists were thinking even more radically about redefining how sound is experienced in space and time. In a note included in his *Green Box*, Marcel Duchamp proposed the idea of "Sculpture Musicale," "sounds lasting and leaving from different places and forming a sounding sculpture which lasts."[24] Laszlo Moholy-Nagy imagined "sound waves issuing from unexpected sources— for example, a singing or speaking arc lamp, loudspeakers under the seats or beneath the floor of the auditorium."[25] Piet Mondrian envisioned a new kind of concert hall for Neo-plastic music where, as Douglas Kahn put it, "people could come and go freely without missing anything because the compositions would be repeated just like in movie theaters."[26] These equally point the way toward sound installations, the first of which can be found in the 1950s, involving musique concrète.[27] Composer Mauricio Kagel's *Musica para la torre* (*Music for the Tower*, 1954) was four hours (by some accounts, 110 minutes in others) of musique concrète played through loudspeakers attached to the forty-meter high steel tower "torre alegorica" by architect César Janello in San Martin de Mendoza Park, Buenos Aires. The same year Nicolas Schöffer made a fifty-meter high "spatio dynamic tower with sound" (*tour spatiodynamique cybernetique et sonore*) with musique concrète by Pierre Henry for the First Salon Batimat, Paris, as part of the International Exhibition of Public Works at Parc de Saint Cloud; he made a second tower in Liege, 1961, with music by Henri Pousseur.[28]

Other early sound installations also included a visual component. In Varèse's *Poème Électronique*, realized at the Brussels World's Fair in 1958, an eight-minute

tape piece of bells, sirens, treated voices, and piano traveled in various routes through 350 loudspeakers spread throughout the Philips Pavilion designed by Le Corbusier (with the help of Iannis Xenakis), a kind of twentieth-century secular version of writing music for a cathedral space; the music was synchronized to a film of still photographs. Xenakis's tape piece *Concret PH*, made from the sound of burning coal, was also played through the system. The two pieces were replayed at regular intervals to hundreds of visitors throughout the day for the duration of the exposition. Xenakis later composed a twelve-channel tape piece, *Hibiki Hana Ma*, that was played on a loop through 800 loudspeakers at the Osaka World's Fair in 1970. Composer Eliane Radigue, a first-generation Minimalist composer with roots in musique concrète (she studied with Pierre Schaeffer and was a former assistant of Pierre Henry's) also had a sound installation located inside a stairwell at the Osaka World's Fair and made a sound environment with tape loops for a sculpture by Marc Halpern in the Salon des Artistes Décorateurs at the Grand Palais of Paris in 1969. As she describes it, "[Halpern] had made a sculpture out of a glass block with moving elements inside. Inside the base, there were loudspeakers that diffused three tracks with different durations—each was about nine minutes long—that played endlessly and that desynchronized from each other progressively. The music was thus evolving on its own."[29] This is an early example of a sound installation with static elements that recombine in an ever-changing way.

In 1962 a former Stockhausen student, La Monte Young, also known as a pioneer of Minimalism, had an even more radical idea of an endless music—a "Dream House," where sustained drone tones would sound round the clock, in a room or multiple rooms, on a permanent basis. Young talked about sustained tones over long durations as allowing the listener to "get inside the sound,"[30] and the Dream House, by extension, made the prospect of actually *living* inside the sound feasible. He put it into practice privately, using oscillators, in his own home and had temporary *Dream House* installations in galleries and arts centers in the late 1960s and 1970s. Young paired the sound with Marian Zazeela's light environments and seemingly static mobile constructions that produced shadows as the only evidence of their almost imperceptible movement in air—a perfect correlative to sound's frequency relationships, which were fixed but audibly elusive as visitor changed position, even minutely, within the space. Often the intervals were derived from Young's compositions, and frequently he and other musicians would perform a composition, which like Indian ragas would feature improvisation on a chosen set of pitches, within a Dream House sound

environment. Dia Art Foundation commissioned a full-scale *Dream House* in 1975, which became a reality at 6 Harrison Street in New York City in 1979. There were several sound environments of single chords running at once in different rooms in the six-story building, with chords mixing in hallways and alcoves as well. This lasted until 1985, when funding ran out. Young ultimately opened a *Dream House* loft space to the public two nights a week in his building in Tribeca. Here the sound installation was titled *The Romantic Symmetry* and consisted of twenty-two sine tones. Young has noted that "by slowly walking around in the space the listener can create sequential harmonic progressions of different frequency components and harmonic fragments," beside the shifts in perceived volume of frequencies in the space that occurs with head movement.[31] This would mark the *Dream House* as more of a musical experience than other sound environments (Neuhaus once remarked that he considered it "a very long piece of music"[32]), although if it is ultimately a music piece, it's one that has a dual identity as a site and implies a suspension of time rather than adhering to a duration.

Radigue and Young had made installations with the objective of perpetual music, in collaboration with visual artists; other artists were using sound as a surveying tool for the installation room itself without the equilibrium of a visual element. Bernhard Leitner began experiments with using sound to define architectural space in the late 1960s, calling the resulting configurations "sound space instruments." He programmed loudspeakers according to sequence, intensity (crescendos and decrescendos), and speed of motion. In his "Sound Space Manifesto" (1977) he wrote:

> A line is an infinite series of points. Space can be defined by lines. A line of sound is produced when sound moves along a series of loudspeakers. Space can be defined by lines of sound: the lines delineate the configuration of space and simultaneously make it a specific expressive experience. Non-linear movements of sound between two or a larger number of loudspeakers accentuate points in space: they mark out space physically and simultaneously give it an expressive shape.[33]

Sound Cube (1968, realized 1980) had a set of speakers on six walls sending sounds traveling through the room, making aural lines, circles, and planes; *Sound Tube* (1972) put speakers on the floor, above and to the sides of a room, so that the visitor walking through the installation would feel encircled by sound, as if in a tunnel. In *Sound Field IV* (1995), ten loudspeakers are placed on the floor covered with stone slabs, keeping the sound low to the ground and giving

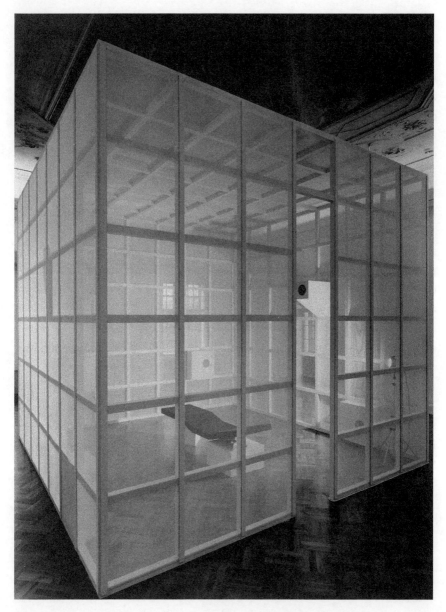

Figure 2.3 Bernhard Leitner, *Sound Cube* (1968/1980). Courtesy the artist.

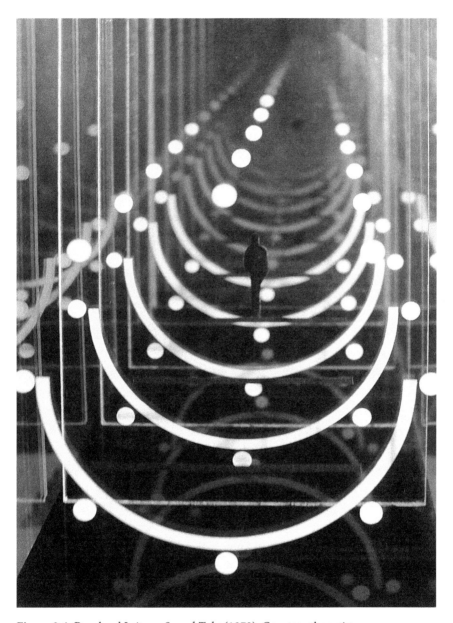

Figure 2.4 Bernhard Leitner, *Sound Tube* (1972). Courtesy the artist.

the listener the sensation of wading through sound waves. Leitner also tried building space with sound: in *Tonkuppel* (*Sound Dome*, 2005), he created an aural arch to "replace" a dome in a Berlin church that had been destroyed in the Second World War, filling an open truss with trombone sounds.

Max Neuhaus experimented with putting different sounds in rooms that had the same dimensions and look, in *Two "Identical" Rooms* (1989) and *Three "Similar" Rooms* (1990), illustrating the effect that sound can have on the perception of a given space. *Two "Identical Rooms"* had contrasting sounds, one "like a fluid" the other "a texture of very dense clicks which seems to be suspended above your head when you walk into the space."[34] "The sounds," Neuhaus wrote of *Three "Similar" Rooms*, "form textures which envelop each space, not so much as something to listen to, more something one is immersed in."[35] In *Two Sides of the "Same" Room* (1990), he put nearly identical sounds in a room divided in two, which nonetheless produced differing psychological reactions, one space feeling open, the other claustrophobic.[36] *A Large Small Room* (1993) also played with the eye and ear's registering of scale, putting a reverberant sound characteristic of a large space into a small antechamber and a more minute, contained sound into a big room—which "suddenly seemed to have shrunk," as Doris von Drathen reported.[37] For an untitled 1979 sound installation in a four-story stairwell at the Museum of Contemporary Art in Chicago, Neuhaus mined the space's own resonances and likewise created a "sonic structure which … remains more of a presence than a sound."[38] Art historian Carter Ratcliff commented that the Chicago installation was easily mistaken for "the sort of gratuitous noise that buildings often create—the unintended side-effects of some necessity (perhaps a ventilation unit), noticeable but not distracting for more than an instant. Surely some who make their way through this stairwell never hear Neuhaus's Chicago piece as a work of art."[39] For Neuhaus sound was a means rather than an end in his installations, used to amplify the visitor's sense of space (he felt it transformed space into "a place," to be more precise). Critic Tom Johnson's observation that "thinking back on my own experiences with Neuhaus works, I generally recall the situations more vividly than the sounds"[40] seems to confirm Neuhaus's success in realizing this intent.

Liz Phillips also used sound as a perceptual tool, but in a more interactive way, to spotlight people's movement within a space. A sculptor with no musical background, in the 1970s and 1980s she made many installations using radio frequency capacitance fields and her own home-brewed synthesizer. The visitors' physical presence would trigger and then shift the sounds as they walked around

the room or touched the copper plates or ribbons used to enhance the fields. The sounds were pitched and often sounded like electronic music but there was no objective of music-making: "I would not have used electronic sound if not for sensors," she told an interviewer in 2016. "I had no interest in making a piece that was composed from beginning to end and making people sit down and listen to it … I was interested in sound because it surrounded you and it was physical. Sound was a way to describe activity."[41] Her conjoining of sound and movement somewhat naturally led to collaborations with dancers, most notably the Merce Cunningham Dance Company, and a 1977 installation at a pedestrian mall at City University Graduate Center, *City Flow*, operated on a grander scale, harnessing all the passerby movement and combining a live feed of traffic noise from 42nd St. outside as well as the traffic. For Phillips, the people making contact with the sounds are not performers but conduits; as she explained in the video art journal *Radical Software* in 1971, " in the space people could act as individual systems within a larger system. To build sound structures I use electromagnetic fields where people actually become electronic components in the circuit."[42] For all its reliance on electronics, the outdoors also provided a point of reference for Phillips's work; as reviewer Tony Reveaux noticed in Phillips's 1987 installation *Graphite Ground*:

> Nature—more than technology—was its closest metaphor for me. It reminded me of times in the woods when I would approach wildlife. A frog or cicada would quiet as I came near, but birds and squirrels sounded their territorial alarms as I invaded their spheres. North American hunters above a valley could accurately read the identities and track the movements of other humans and game by those subtle changes in the terrain's soundscape.[43]

Phillips's work expresses a defining dynamic in sound art's classic modes by mapping the space of a specific indoor room through sound while also suggesting the properties of an outdoor environment. Joyce Hinterding, an Australian sound artist from a later generation who also works with electromagnetic environments, compares the sound of her piece *The Oscillators* to cicadas and notes that "the work's tendency to elicit the powerful sensation of observing nature is interesting in light of the fact that many people do not tend to think of electrical synthesis as a natural process. A kind of challenge takes place: the challenge to see what we might call the synthetic world as part of what we might call the natural world."[44]

Repetition, the resonance of a particular interior space, and recording itself coalesce in Alvin Lucier's classic piece *I Am Sitting in a Room* (1970). While not an

installation, it documents a process of recording and playback within a space in order to demonstrate that space's acoustics. A tape of Lucier's own voice reciting an explanation of the mechanics of the piece is played back and re-recorded in a room repeatedly. "What you will hear, then," his narration states, "are the natural resonant frequencies of the room articulated by speech." Over the course of fifteen minutes, the space's acoustic properties gradually overwhelm the original vocal until it is broken down into tones. Lucier noted the differences in recordings of the piece made in different rooms, telling an interviewer "every room has its own melody hiding there until it is made audible."[45] Although it takes the form of a piece of music, with a beginning, middle, and an end, and is sometimes categorized as a process piece with contemporaneous works like Steve Reich's phase piece *Come Out* (1966) in which two tape recorders playing an identical tape loop go out of phase with each other until finally re-syncing up, it's really a study in acoustics. While Lucier does not call himself a sound artist per se, the aesthetic of foregrounding a space through sound is so essential to sound art that *I Am Sitting in a Room* can, paradoxically, be considered a defining example of the form. Tellingly, its premiere took place at the Guggenheim Museum in March 1970.[46] Lucier had already turned his attention to sound in space in his previous piece *Vespers* (1969), which asked blindfolded performers to "articulate the sound personality of the environment" in a darkened room. The piece requires using handheld echolocation devices called Sondols that produce short pulse sounds that echo in the space; the echoes would alert the performers to their surroundings. As in Neuhaus's installations, the sounds in *Vespers* are a means to an end in the perception of space, rather than an end in itself.

Environments: Country/city, indoor/outdoor

Sound art developed, in the late 1960s, as an environmental art, its spatialization derived not just from musique concrète and modern classical composition but from real-world rural and urban soundscapes, encompassing both natural and man-made sounds. This coincides with a dawning ecological awareness at the time, which simultaneously impacted the art world in the Earthworks/Land art movement, but also reflected the increase of noise in the twentieth century and its embrace by both the musical and art avant-gardes.

Sound ecologist and composer R. Murray Schafer has described the meticulous listening found in rural environments:

When man lives mostly in isolation or in small communities their ears operated with seismographic delicacy. In the rural soundscape sounds are greatly uncrowded … for the farmer, the pioneer, or the woodsman the minutest sounds have significance. The shepherd, for instance, can determine from sheep bells the precise state of his flock.[47]

He adds that before outdoor lighting at night man used hearing his horse's hoofbeats during nocturnal travel to determine whether he was still on the road and the degree of pavement to determine his proximity to a city. Ancient/country/night soundscapes were much like "hi fi" sounds, able to be distinctly heard "because of the low ambient noise level" whereas city sounds are "low fi" and are "masked by broad-band noise … in order for the most ordinary sounds to be heard they must be amplified."[48]

It is these soundscapes, and the highly concentrated listening within them, that became the model for indoor sound installation, rather than the normal infusion of music into an auditorium. The concert hall traditionally served as a kind of sanctuary for music away from the everyday sounds of the outside world, yet the boundaries of the concert hall itself were questioned before the advent of recording. Schafer has discerned a tradition of the concert hall as "a substitute for outdoor life." He notes that "imitation of landscape in music corresponds historically to the development of landscape painting," first in the Flemish Renaissance masters and later developing into a separate genre in the nineteenth century.[49] The spread of art galleries in urban areas accounts for the trend, Schafer writes, as the paintings function as "windows" to an increasingly inaccessible natural world. "An art gallery is a room with a thousand avenues of departure, so that once having entered, one loses the door back to the real world and must go on exploring."[50] Music too turns "the walls of the concert hall into windows, exposed to the country," and he cites Vivaldi, Haydn, Handel, Schubert, and Schumann, noting the approximation of a hunting horn in Haydn's *La Chasse* and other works, horns being particularly representational of the freedom of the outdoors.[51]

John Cage (who said he preferred a walk in the woods to going to concerts) ushered an integration of nature into the concert hall more directly. Cage had already looked to nature (or more precisely, "an imitation of its manner of operations") as a paradigm for indeterminacy in music composition, and he virtually brought the sounds of the outdoors into the premiere of his notorious "silent" piece *4'33"* (1952). Cage was deeply interested in silence; he had considered submitting three or four minutes of silence for broadcast

by Muzak in the late 1940s, and an oft-recounted visit to Harvard's anechoic chamber in 1951 yielded the epiphany that there is no such thing as silence when he distinctly heard two sounds, one high, one low, which turned out to be his nervous and blood circulatory systems. *4'33"* instructs a performer to sit at a piano and only open and close the keyboard lid at specified intervals, rather than play the instrument. In doing so, the other sounds of the concert hall, indeterminate of course and ordinarily either diminished or obscured by the music, or ignored by an audient, would come to the fore. By silencing a concert stage Cage is directing both the audience and the performer to pay attention to whatever sounds occur in room during the allotted performance time. Nothing has been "composed" or "played." This subverts a concert situation to showcase Cage's own belief in the value of listening to any and all sounds of daily life, and by taking the sound off the stage—not by spreading instruments throughout the room or spatializing electronic sounds through speakers but in letting the incidental sounds of the immediate surroundings constitute the piece itself— he establishes a separation between music and what would eventually become the environmental quality of sound installation. By specifying an exact running time *4'33"* perhaps shows the influence of recording, but its duration is arbitrary (indeed determined by chance operations); the piece is about place rather than time, as sound art would be. *4'33"*'s world premiere in 1952 took place at Maverick Concert Hall, a wooden, barn-like space in a forest near Woodstock, NY—Cage himself noted that the sounds of wind and rain were audible during the performance. With *4'33"* Cage designates himself as a listener experiencing sounds of a given environment rather than composing them himself, whose role as a composer is to direct the audience's attention to sounds that are already there. The "player" seated at the piano is listening as much as the audience is. Again, this lays the conceptual groundwork for the listener-to-listener relationship that much sound art is predicated on. *4'33"*'s inherent resistance to being recorded in a "definitive" version, both because of its extreme quiet and reliance on indeterminate conditions of whatever space it's performed in, also relates to sound art's similarly awkward position to documentation via recording.

Post-Cage composers, perhaps unaware of the bucolic setting of *4'33"*'s debut but intrigued by the idea of reimagining what is and isn't an extraneous sound, became interested in placing music alongside natural sounds in outdoor environments. For Michael Nyman, the silences in Cage protégé Christian Wolff's early pieces

are openings which let the sounds of the environment mingle with and perhaps even obliterate the composed sounds. Cage tells the story of a performance Wolff gave where the sounds of traffic and boat horns coming through the open window were louder than the piano sounds. Someone asked him to play again with the windows closed to which Wolff replied "that it wasn't really necessary, since the sounds of the environment were in no sense an interruption of those of the music." As Wolff remarked (of the early experimental music in general) "the work is at once itself and perspicacious."[52]

Others set up an interchange between music and a natural setting. In 1969, Stockhausen staged an outdoor concert in the Giacometti courtyard (with Joan Miró sculptures) at museum of the Maeght Foundation at Saint-Paul-de-Vence, in which musicians sat on roofs, ramps, and in the courtyard, integrating sounds from frogs, cicadas, and other animals. After three hours, each musician started to walk off, still playing, into the forest. At 2 a.m. there was "a twenty-minute-long dialogue with car horns. I [Stockhausen] started it but then all the people who hadn't left began making horn music with each other; and as one after the other drove off, they exchanged sounds for miles down the road."[53] Stuart Marshall made a series of little-known outdoor sound works in the early 1970s; in one, *Golden Hill*, sound sources are placed in trees but the "listener" is meant to avoid hearing them—if he does hear them he is instructed to make a signal. David Dunn also started making outdoor performances in the early 1970s, including *Nexus 1* (1973) scored for three trumpets in the interior of the Grand Canyon and *(espial)* (1979) for solo violin and three tape recorders in the Anza-Borrego Desert in California. In *Entrainments 1* (1984) he played a single oscillator tone in a forest, which initially drew ire from a blue jay. Dunn recorded the bird's response then replayed the recording back into the woods and re-recorded that and played it back, repeating the process over a series of months. Eventually the sound attracted wildlife that would stop to listen to the sounds. Of course, whether his and his equipment's presence is actually welcome in the creatures' natural habitat is open to debate, but this attempt to recast sound as an interspecies phenomenon, on a one-to-one level, is significant. Schafer's *Music for the Wilderness* (1979) placed twelve trombonists around a lake; Rolf Julius had an early piece in which he played a tape of piano sounds beside a frozen lake (which was cut short by police as it was "disturbing the peace"). He also made outdoor installations, including putting speakers in quarries in Finland.

However, it is the *listening* to ambient sounds outdoors that is a key inspiration in sound art. Sound ecology, a movement that roughly parallels the

Figure 2.5 Rolf Julius, *Concert for a Frozen Lake*, January 1982. © estate rolf julius.

development of sound art chronologically, is based on this and addresses issues of noise pollution and urban versus rural soundscapes. R. Murray Schafer has led the quest, founding the World Forum for Acoustic Ecology (formerly the World Soundscape Project) and writing a seminal text, *The Tuning of the World* (1977). Schafer and compatriots like Hildegard Westerkamp and Barry Truax made dozens of recordings of different soundscapes across the globe, coming to the conclusion that the noise of the modern world is often at odds with the environment and urging that limits be set on ambient sound levels in industrialized societies. Westerkamp made soundwalks at local destinations in Vancouver, exploring a particular area's soundscape and began reporting on them via a radio show, *Soundwalking*, on Vancouver Cooperative Radio, where she contextualized them with on-air commentary. Westerkamp and Truax also pioneered soundscape composition, a variant of musique concrète in which field recordings were electronically processed to some degree but fundamentally left recognizable. Truax has noted soundscape composition simulates a journey, or motion, through a landscape. Westerkamp also believed in creating a kind of dialogue with the soundscape when making an "environmental composition," taking into account the rhythms and pitches

that are already present and asking "which sounds can you produce that add to the quality of the environmental music?"[54]

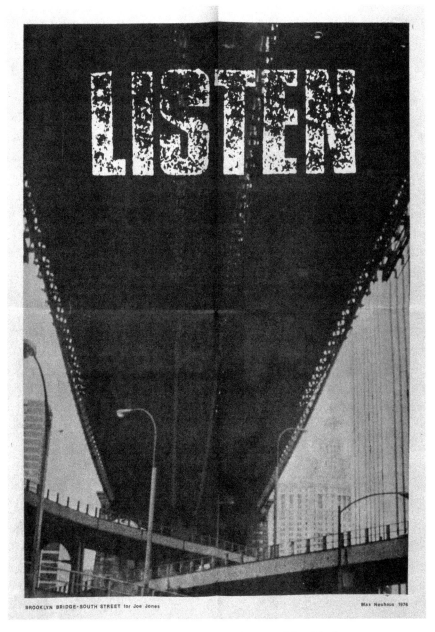

Figure 2.6 Max Neuhaus, *Listen* poster, 1976. Courtesy Silvia Neuhaus.

Environmental soundscapes are significant in sound art's progression from music. Ambient sound in its raw form is a kind of found object, which, if then placed in an ongoing exhibition setting, is the aural counterpart to the Duchampian readymade that Cage was enamored of. While Cage encouraged nonhierarchical listening to sounds (and silence) as music, he still worked with prescribed scores, indeterminate though they may be, to be performed in concert with an audience, not as a freestanding installation that would attract visitors. One of Cage's frequent performers, percussionist Max Neuhaus, played a version of Morton Feldman's *The King of Denmark* in the stairway of the Arts Club of Chicago that incorporated the traffic sounds from outside, but he also took a step further: between 1966 and 1968 he organized "six sound orientated pieces for situations other than that of the concert hall," dubbed *Listen: Field Trips Thru Found Sound Environments*. Audience members were asked to meet at a concert hall, then had their hands stamped with the word "listen" and were led by Neuhaus, without making any commentary, on listening walks through city streets. The first iteration took place in Neuhaus's own East Village neighborhood, starting with the "spectacularly massive rumbling" of the Con Ed power station on 14th St. In another instance participants were put on a bus to the NJ Power and Light Power Plant. (Neuhaus even wrote an op-ed for the *New York Times* in 1974 criticizing the emerging issue of urban "noise pollution.") Inverting *4'33"* by asking an audience to meet and listen to sounds outside the concert hall instead of inside, in essence, Neuhaus was treating one's daily surroundings as a sound installation, soliciting visitors and serving as a guide, although setting an agreed-upon time for the trip still adhered to concert protocol rather than that for galleries, museums, or public art.

Neuhaus's trips were mainly excursions into city sound environments rather than rural ones and also harken back to one of Cage's predecessors in celebrating the value of "unmusical" sounds, the Futurist Luigi Russolo. Russolo was the first important noise thinker, who disparaged music as "a fantastic world superimposed on the real one."[55] Prompted by fellow Futurist F. T. Marinetti's "Zang tumb tumb" (1912), an onomatopoeic work based on wartime sounds heard first-hand on the First World War front, and long before Cage extolled making music with noise, Russolo declares in his famous "The Art of Noises" manifesto of 1913: "We have had enough [of Beethoven et al.] and we delight much more in ... the noise of trams, of automobile engines, of carriages and brawling crowds." He notes the development of classical musical toward more complicated harmonies that include dissonance and that "this evolution of

music is comparable to the multiplication of machines ... musical sound is too limited in its variety of timbres ... we must break out of this limited circle of sounds and conquer the infinite variety of noise-sounds."[56] He considers noise "pleasing": "We want to give pitches to these diverse noises, regulating them harmonically and rhythmically."[57] He calls for the invention of instruments to make a noise-sound orchestra—in other words, a domestication of noise. He has also identified machinery as sound-producers, which foresees sound sculpture, especially Jean Tinguely's noise machines. One of Russolo's scores is *Awakening of a City* (1913) for his own noise-making machines, *intonarumori* (noise intoners), individually categorized as "howlers, boomers, cracklers, scrapers, exploders, buzzers, gurglers, and whistles." He later developed a noise harmonium that was considered for production as an accompaniment to silent films, but when "talkies" appeared soon after its invention, those plans fell apart.

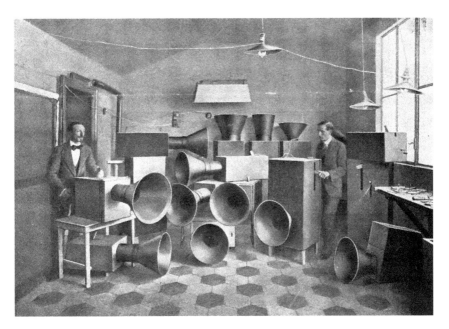

Figure 2.7 Luigi Russolo and his assistant Ugo Piatti with the *intonarumori*, 1913. Courtesy Valerio Saggini.

Other artists and composers were also interested in the idea of infusing noise into compositions. Piet Mondrian called for a new music with "a new order of sounds and non-sounds (determined noise)" in two essays from 1921 and 1922, "The Manifestation of Neo-Plasticism in Music and the Italian Futurists' Bruiteurs"

("bruiteurs" were *intonarumori*) and "Neo-Plasticism: Its Realization in Music and Future Theater." Karin v. Maur notes that George Antheil, the avant-garde composer, "dreamed of urban orchestral machines whose sounds would 'shoot obliquely into space.'"[58] But while he did employ a siren in his *Ballet Mechanique* (1924), Antheil nonetheless denied that he was copying machine sounds elsewhere in the piece. An obscure French composer, Carol-Bérard had in 1908 composed *Symphonie des forces mécaniques* (*Symphony of Mechanical Forces*) that employed motors, electric bells, whistles and sirens, alongside chorus and orchestra.[59]

La Monte Young found equal inspiration between natural sounds and machine sounds, listing his influences as "the sound of the wind; the sounds of crickets and cicadas; the sounds of telephone poles and motors; sounds produced by steam escaping such as my mother's tea kettle and the sounds of whistles and signals from trains; and resonances set off by the natural characteristics of particular geographic areas such as canyons, valleys, lakes, and plains."[60] He used to sing or whistle along with motors in his high school's machine shop (which ultimately developed into his saxophone playing, at first, and later his singing, against drones). While early pieces like *Four Dreams of China* (1962) reference both natural and man-made sounds (in the work's intervals, which Young said came from the sounds of power plants and telephone poles,[61] and in the titles as well, with names such as *First Dream of Spring* and *Second Dream of the High-Tension Line Stepdown Transformer*), this became more apparent as he began working with Tony Conrad and John Cale's amplified strings. In his 1966 essay "Inside the Dream Syndicate," Conrad wrote: "Although the stiff man does turn a latter-day ear to the music of the machine, the earlier Japanese cricket keepers and reed cutters just as easily liked the upper partials."[62] He goes on to discuss the fine-tuning of pitches and harmonics from noise in the highly amplified violin and viola drones he and Cale played in the group:

> Noises are not *ever* pitchless, to say the least ... machines suggest the patterns potentiated by manipulation and selection of high harmonic-content timbre complexes, but infinitesimal control has to be used to get the precisely wanted range of interrelations ... Ours is the first generation with tape, with proper amplification to break down the dictatorial sonority barriers erected by the master instruments of the cultures. It is no longer necessary to press upon groaning mechanical instrumentation to produce the terrific power and sonority necessary for dealing with partial complexity and without shattering the all-important sound—the throbbing reverberance that has fixed musical attention on consonance and formal design.[63]

Cale has stated that by putting electric guitar strings on his viola in the group, he got "a drone [that sounded] like a jet engine!"[64] The group also tuned to the sixty-cycle hum found in everyday home electricity. In his essay *Dream House* Young says "50 Hertz AC (derived from 220 volt power line frequency) will be used as the standard to which all other frequencies are related and tuned since it functions as the underlying drone of the city and all AC-powered equipment."[65] While this relates to the microtonal just intonation system the group was using, it also shows an awareness of hidden or otherwise discounted electrical sounds of the city (much later delved into extensively by Christina Kubisch in her electrical walks) and tapping into a constant, pervasive sound source.

So, if noise is or can be listened to as "music," what is, well, noise? Edgard Varèse said, "noise is any sound one doesn't like."[66] Cage shrugged off the distinction, relegating what would commonly be denominated as noise to an expanded concept of silence: "Silence is all of the sound we don't intend. There is no such thing as an absolute silence. Therefore silence may very well include loud sounds…the sound of jet planes, of sirens, et cetera"[67]:

> I wouldn't dream of getting double glass because I love all the sounds. The traffic never stops, night and day … at first I thought I couldn't sleep through it. Then I found a way of transporting the sounds into images so that they entered into my dreams without waking me up. A burglar alarm lasting several hours resembled a Brancusi.[68]

During a discussion with Young about his love for the hum of transformers at a power plant growing up, interviewer Edward Strickland complained that the little one for his doorbell drives him nuts. Young replied, "If you can walk up to it, listen, and leave, it's one thing. If you've got it as an annoyance in your house and you can't get rid of it, then it's a headache."[69]

Even more diplomatic are Bruce Odland and Sam Auinger, who have created several sound ecology-minded installations that turn the sounds of an urban environment into music. Using a "tuning tube," they filter real-time sounds from the location into harmonics, often fed into an interior listening space as well as back out into the environment, in effect juxtaposing the inner harmonic activity of the area with the raw material of its ambience to facilitate listening in tandem. They call it "music of the human hive," a reflection of human activity; melodious and pretty, in effect they are anti-Russolo and maybe even anti-Cage, in that the sounds themselves have to be scrubbed down to reveal a musical essence, rather than being appreciated as "noise" prima facie. By contrast, Emekah Ogboh's series of untreated field recordings of his native Lagos, *Lagos Soundscapes*

(2008–), offer the city's onslaught of sounds as a multilayered composition in and of itself while also documenting various changes Lagos has undergone. "Hawking, for example, has been banned on most of the newly renovated roads, but hawkers are a major part of *Lagos Soundscapes*," Ogboh told an interviewer. "With plans for the government BRT buses to expand to all the bus routes, it is only a matter of time before danfo buses [share taxis] disappear completely … This means that the verbal mapping (the bus route calls of the conductors) will gradually disappear."[70] Unlike Odland and Auinger, Ogboh is not trying to rehabilitate the city's din but to capture it in a nonjudgmental way. In some cases he has made installations of the Lagos recordings, noting that "the work has been described as noisy and obtrusive, especially in some quiet European cities where it has been installed. In Cologne, someone broke one of the loudspeakers of the installation and the police were called in because the sounds were felt to be a nuisance."[71] This idea of relocated sounds is an essential element of sound art and goes back to the late 1960s and the parallel translocations of Land art, or Earthworks.

Sound art and Land art

Like noise, dirt is unwanted depending on the context; soil is fine for letting trees, flowers, and vegetables to grow outside, but people generally don't want it in the house, just as they close windows, especially in urban environments, to keep out the noise. However, just as noises found their way into twentieth-century music, dirt became incorporated into painting. George Braque started mixing sand in pigment in 1912, Andre Masson in 1927, and then Jean Dubuffet in 1940s.[72] Robert Rauschenberg made *Dirt Painting for John Cage* (1952–1953) "which sprouted real plants and initially was periodically watered," according to art historian Suzaan Boettger.[73] The 1960s Earthworks movement, or Land art, brought this interest in dirt to new lengths. Claes Oldenburg's *Placid Civic Monument* (1967), a hole dug in New York's Central Park, is considered the first Earthwork; from there it spread to Robert Smithson's *A Nonsite (an indoor Earthwork)* (1968) where he put sand from a site in Pine Barrens, New Jersey, in a gallery and continued the work as a series by putting outdoor soil from various locations in gallery installations. Hans Haacke grew grass in a museum in 1969's *Grass Grows*; the same year he made *Fog Flooding Erosion*, in which he flooded grass with outdoor sprinklers, resulting in soil erosion (and a lot of mud).

Like Cage admitting the sounds of nature into the concert hall as opposed to composing music in homage to nature, Earthworks adopted a similar position in relation to landscape painting, and its outsized outdoor works more specifically brought sculpture to a new conceptual scale that could encompass miles of geography. Smithson's assertion that the world is a museum (see below) has a certain congruity with Cage's panoramic vision of everyday sounds as music; sound's ubiquity dovetailed with the Earthworks belief that art could be environment rather than object. The possibility of sonic transmission over long distances introduced by radio and telephone is likewise compatible with Smithson and Dennis Oppenheim's translocations.

Walter De Maria is a pivotal figure here. In the late 1950s, he was artistic director for mixed-media events at San Francisco Art Institute, a series produced by La Monte Young.[74] He befriended Young and both moved to New York in the early 1960s. De Maria was a drummer and played informally with Young, as well as in an early version of the Velvet Underground. He had already started formulating the idea of working with land as art, as evidenced by the pieces *Art Yard, Beach Crawl*, and *On the Importance of Natural Disasters* collected in *An Anthology* (1963) edited by Young and Jackson MacLow. DeMaria's *Two Parallel Lines* (of chalk, running for a full mile in the Nevada desert, proposed in 1962 but not realized until 1968) resembles Young's 1960 *Composition 1960 #10 to Bob Morris* ("Draw a straight line and follow it") and illustrates how Land art was able to take Conceptual art premises to monumental realizations. He recorded an album in 1968 called *Drums and Nature*, belatedly released on CD in 2000, which features him drumming on top of cricket sounds on one side and ocean sounds on the other. A similar recording serves as the soundtrack to his film *Hard Core* (1969) in which he and fellow Land artist Michael Heizer enact an Old West cowboy gun duel while the camera does endless 360-degree pans over the Nevada desert landscape. De Maria also did Young the good turn of introducing him to Heiner Friedrich, who would go on to found Dia Art Foundation and become the leading sponsor of both artists (as well as Max Neuhaus). In this respect, De Maria's *Earth Room*, a gallery space filled with two feet of dirt, first realized in Friedrich's gallery in Munich in 1968 and later at Dia in New York, could be compared to Young's *Dream House* (also mounted by Friedrich in Munich and New York) as a "sound room," although visitors could not walk around in the dirt the way they could among the sound waves of Young's environment. Still, the parity of their aesthetics cannot have been lost on Friedrich.

Bruce Nauman made two (unrealized) Earthworks that incorporated sound: *Untitled Piece* from 1969 instructed drilling a hole a mile into the earth and placing a microphone inside, which would feed into an amplifier and speaker in an empty room, and *Amplified Tree Piece* (1970) called for drilling a hole into a large tree and putting a microphone inside. Doug Aitken's *Sonic Pavillion* (2009), situated at the Inhotim Cultural Institute in Brazil, actualized drilling a hole a mile long into the earth and set up microphones to amplify the sound of the earth's movements, sending the signal to eight loudspeakers in the pavilion itself. Aitken later incorporated microphones into the foundation of his own home, transmitting the sounds of his immediate subterranean environment to speakers set up in the house.[75] Max Neuhaus's installation *Times Square* (1977–1992/2002–present), an anonymous, soothing drone set under a sidewalk grating in a triangle between 45th and 46th street in midtown New York at its most frantic, is an urban version of the idea of embedding sound in the ground. (Although it's inaccessible to the public, the actual ventilation chamber whether the installation's speakers are located was, according to Neuhaus, an acoustically interesting structure, making it a kind of dual sound installation that articulates a resonant architectural space as well as seeping into a outdoor environmental soundscape.)

There are many other correspondences between Earthworks and sound art. Smithson's celebrated 1967 *Artforum* article "A Tour of the Monuments of Passaic, New Jersey," in which he takes a bus out to his hometown to view a bridge, pipes, a sand box, parking lots, etc., as monuments, or "ruins in reverse," is reminiscent of Neuhaus's contemporaneous listening trips, Westerkamp's *Soundwalking*, or Suzuki's *Oto-date*, although Smithson's tone is distinctly ironic, and his commentary and documentation of the journey differentiate it from Neuhaus's enterprise. Trevor Wishart's sound work at the Jorvik Viking Centre museum in York (which recreates a lost Viking language and the historic natural sounds of the museum's site during the Viking era), Hans Peter Kuhn's installation at the closed steelworks Völklinger Hütte (of sounds recorded when it was still in operation), or Ron Kuivila's Mass MoCA installation (recreating sounds of the factory it once housed) are reminiscent of Alan Sonfist's *Time Landscape* (1965), which took an abandoned lot at Houston and La Guardia Streets in New York City and planted indigenous forested plants, and reconstituted rock and soil formations from centuries before. Walter Marchetti's *Chamber Music #19* is played by walking around a gallery floor that is covered with 20,000 pounds of salt, which brings to mind Dennis Oppenheim's 1968 piece *Salt Flat*, in which he put a rectangle of 1,000 lbs. of salt in a New York

parking lot. Oppenheim's 1969 *Gallery Transplant* series (the floor plan of a gallery in the Andrew Dickson White Museum in Ithaca drawn in the ground using dirt and snow at a bird sanctuary, also in Ithaca) coincides with Annea Lockwood's *Piano Transplants* (1969–1972), which were inspired by the then new heart transplants of Christian Barnard. In this series, old pianos were burned, partially submerged ("slowly drowning," as she told interviewer Frank Oteri[76]) in a pond in Amarillo Texas (belonging to art patron Stanley Marsh III, who also hosted Ant Farm's *Cadillac Ranch* (1974), which buried ten Cadillacs nose down) or partially buried at various angles (two uprights and a baby grand in her own English garden). The buried pianos also correspond to Smithson's *Partially Buried Woodshed* (1970), which dumped twenty truckloads of earth on a disused woodshed at Kent State University, which he intended to eventually collapse under the weight of soil and for vegetation to ultimately grow in the spot. In a sense Lockwood has given a (potential) sound, almost a voice, to what could be classified as an Earthwork.

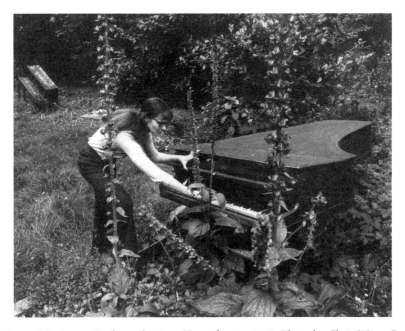

Figure 2.8 Annea Lockwood, *Piano Transplant,* c. 1970. Photo by Chris Ware. Courtesy the artist.

The translocation of Smithson's non-sites is also felt in Hildegard Westerkamp's *India Sound Journal* (which considers, as she puts it, "the deeper implications of transferring environmental sounds from another culture into the North American and European context of contemporary music, electroacoustic composition, and audio art"[77]) and Leif Brush's *Gibbs Fjord: Hexagram Wind Monitors* that beamed wind sounds from Bafffin Island in Canada to DeDeolen Hall in Holland via satellite. George Brecht's 1970 multimedia event *Journey of the Isle of Wight Westwards by Iceberg to Tokyo*, inspired by an article about the possibilities of translocating landmasses by harnessing them to icebergs, featured a performance by the Scratch Orchestra and the making of a graphic score in reaction to their playing.[78] Around the same time there was even a global musical event called Earthworks organized by the New Zealand chapter of the Scratch Orchestra, headed by Philip Dadson, in which different associates around the world recorded local conditions during the September equinox of 1971.[79] Jon Hassell's early 1970s *Landmusic Series* contained several unrealized proposals of transmitting sound from the Pacific Ocean to a desert location in Nevada and having thunder sounds emitting from speakers buried underground. Tom Johnson, recapitulating Hassell's plans in reviewing a concert of another work in the series, *Solid State*, observed that "Hassell's background is strictly musical, but it is clear that his sculptural and environmental approaches to sound have more to do with recent developments in the art world than with the mainstream of music. Consequently, many of his major outlets have been places like the Museum of Contemporary Crafts, the Albright-Knox Gallery, and the Brooklyn Museum."[80]

The translocation/transplant idea is also crucial to the work of both Bill Fontana and Maryanne Amacher. Both pinpointed particular natural and urban locations where patterns became noticeable over time and set up networks to transmit them. In these situations the sound would not correspond to the location it was transmitted to, creating a cognitive dissonance that would serve to bring to notice a sound that might be taken for granted, or not even perceived, within the context of its source. Their works looked at simultaneity at an environmental level, and Amacher's in particular brought psychoacoustic activity to the fore. Fontana claimed Duchamp's idea of the readymade as an influence in taking an ambient sound environment and relocating it, with the sound environment itself being "a musical information system full of interesting sound events."[81] An early Fontana piece, made when he was working for Australian radio making documentary recordings from 1974 to 1978, was *Kirribilli Wharf*, which turned the sounds captured from eight separate holes in the underside of a pier in

Sydney Harbor into an eight-channel gallery installation. Fontana's subsequent work in translocating sounds has been prodigious. He took the sound of steel grids on the Brooklyn Bridge and transmitted them to speakers located at the World Trade Center, the Brooklyn Museum, and the radio station WNYC in 1983, in honor of the bridge's 100th anniversary. For 1984's *Distant Trains* Fontana buried loudspeakers in a disused field near the Berlin Wall, the former site of a railway station, and transmitted the sounds of an active train station in Cologne through them. The material was also used for a radio play describing a fictional journey between Cologne and Berlin. In *Metropolis Köln* (1985) he took live sound sources from various parts of the city (a zoo, the Rhine River, a train station, a church, and a pedestrian street) and put them all in a sixteen-speaker installation in the Roncalliplatz, a plaza adjacent to the Kölner Dom cathedral. For the fiftieth anniversary of D-Day in 1994, he put Normandy beach ocean sounds in forty-eight loudspeakers installed in Paris' Arc de Triumphe (*Sound Island*) and took the sound of Big Ben and put it in the Palace of Westminster. In *Vertical Water*, during the 1991 Whitney Biennial, Fontana recreated the sounds of Niagara Falls vertically, in front of the Whitney itself. *Earth Tones* (1992) buried loudspeakers in the ground at a California ranch with loud frequency sounds from the Pacific Ocean piped in, causing the earth to vibrate with sound.

Amacher's *City-Links* series, begun in 1967, transmitted sounds from one or more distant urban environments in real time via telelinks as a continuous sound installation. The first realization was a twenty-eight-hour broadcast on Buffalo radio station WBFO in which Amacher mixed sounds live from eight separate locations in Buffalo, including the airport, main street, the Erie Canal, power plant, and an old factory.[82] From 1973 to 1978, as an MIT Fellow, she installed a microphone on a window overlooking the ocean at the New England Fish Exchange in Boston, transmitted the sound into her home studio continuously, sometimes then transmitting from her studio to exhibition spaces at MIT and in one instance, for a group show at the Institute of Contemporary Art in Boston. Amacher recalled that in doing this

> I realized that there was always a fundamental pitch, there was a whole tone of a space. So I made various installations I called *TONE AND PLACE*. When I analyzed this I discovered a low F# was coming from Boston Harbor at 91–93 Hz. I did not know exactly what was producing this tone, but that was the tone of the space, really the color of it.[83]

In *City-Links #9*, a piece made for a 1974 group exhibition at Walker Arts Center in Minneapolis, subtitled *No More Miles—An Acoustic Twin*, she

placed a microphone in a Budget Rent a Car located in an indoor arcade in Minneapolis, which was the acoustic double of the gallery space she was to occupy at the Walker: voices, footsteps, and other sounds completely matched those heard in the gallery. Visiting the gallery, you would hear the sounds produced by the installation as though people were moving and talking around you, ghost-like.

Figure 2.9 Maryanne Amacher, *City-Links #9* (*No More Miles—An Acoustic Twin*), 1974. Photo by Scott Fisher. Courtesy Blank Forms/Maryanne Amacher Foundation.

Like the sound artists using field recording in translocational installations, Smithson used rocks instead of representing rocks; in an interview he pointed out that he and his colleagues were not

> dealing with matter in terms of a back to nature movement. For me the world is a museum. Photography makes nature obsolete. My thinking in terms of the site and the non-site makes me feel there's no need to refer to nature anymore. I'm totally concerned with making art and this is mainly an act of viewing, a mental activity that zeroes in on discrete sites.[84]

Sound art could, in kind, be said to be an act of listening and in the case of field recording–based work to be focused on "discrete sites." Annea Lockwood had been recording rivers since 1966 and procured contributions from others

to create *The River Archives*, which aimed to record every river in the world. In the two-hour installation *A Sound Map of the Hudson River* (1982), she took recordings from twenty-six spots along the river from its source in Lake Tear of the Clouds the Adirondacks to its outlet in the Atlantic Ocean and combined them with interviews with inhabitants (fishermen, river pilots, a ranger, a farmer, etc.). She revisited the river map methodology idea with the installations *A Sound Map of the Danube* (2005) and *A Sound Map of the Housatonic* (2010), sequels of sorts, but in 5.1 surround sound and quadrophonic sound, respectively.

Originally trained as an ecologist and entomologist, and a teacher of ecosystem dynamics, Francisco Lopez uses natural sound sources, but is a firm believer in non-documentary field recording and in Schaeffer's acousmatic listening. In the name of "an extreme musical purism," he separates the sounds' visual component, geological, topographical, or otherwise (hence the blindfolds he insists audience members wear during his concerts) to avoid any possible connotation or referentiality. He will also blend sounds of animals or natural phenomena with industrial or urban sounds. One of his quintessential works is *La Selva* (1998), recorded in a tropical rain forest in Costa Rica. Lopez puts an equal value on all the sonic elements of the environment, from animals to rain and wind to even the sounds of plants not readily audible (plant bioacoustics); each contributes to the overall sound environment, discarding the more common bioacoustic scenario of animals' sounds foregrounded against a environmental backdrop. He also stresses that it's an artistic version of the forest, not a document of it, that recording microphones are "non-neutral interfaces" (as those that differ in brand and precision will pick up more or less sounds with varying tonal quality) and the fact that "there are many sounds in the forest but one rarely has the chance to see the sources of most of them"[85] as animals are hidden in the foliage (and the foliage itself is so dense that its own components are not easily identifiable).

Earthworks and sound art share commercial concerns; the question of how to sell Land art could also be applied to sound installations, which have yet to find a market among collectors. Neither genre deals in objects and are often site-specific. Compare sculptor/painter/architect Tony Smith's famous quote on highway landscapes as art, prompted after driving on the unfinished New Jersey Turnpike—"There is no way you can frame it, you just have to experience it"[86]— with this from Michael Schumacher, proprietor of the Diapason sound art gallery in New York: "Sound is experience, so there's no point in trying to make it into

an object as a collector's piece. So I'm trying to create situations where people come to it as experience, and value that."[87] Jennifer Licht, a Land art curator, said at the time, "Art is less and less about objects you can place in a museum,"[88] and forty years later, sound art curator Carsten Seiffarth wrote, "Sound art does not tend to be about finished works of art, that only have to be brought from a studio and staged in a museal space."[89] Still, in some ways Land art highlights the differences between sound art and visual art. There is no sonic comparison to either boring a hole in the earth or the piling of soil, but more importantly the scale of works like De Maria's square-mile *The Lightning Field* (1977) and those that are ideally viewed aerially like Smithson's *Spiral Jetty* (1970), Michael Heizer's *Double Negative* (1970), or Dennis Oppenheim's *Canceled Crop* (1969) has no equivalent in sound, where scale is ultimately based on volume level and duration rather than physical expanse. The morphological grandiosity of Earthworks that would never fit in a museum still exudes the kind of gravitas that appeals to the art market, with which a sound installation cannot compete. The photo documentation of such works is also ultimately more satisfying than the mix-downs of multichannel installations into stereo or other mediations of the sound from its intended site. The simultaneity and disjunction of translocating sounds, where a waterfall can be heard (but, crucially, not seen) in the midst of a city street, is also not completely analogous to Earthworks superimpositions like Oppenheim's *Mt. Cotopaxi Transplant* (1968), in which a volcano from Ecuador was to be placed in the middle of Kansas. Earthworks transplants have many more geological implications and do not have any electronic component—their constitution is purely organic. At the same time, sound installations are not subject to the same erosion as outdoor Earthworks, unless there is tape decay or other equipment malfunction. But sound occurs in the air, and Earthworks are based in solid ground—sound will always be perceived as the more ephemeral medium.

Conceptual artist Les Levine has written "environmental art can have no beginnings or endings,"[90] and likewise the early sound artists sought a sense of eternity, at least as an aspiration (and realized more concretely in the permanent installations of Young's *Dream House* and Neuhaus's *Times Square*). That the first generation of sound artists (Annea Lockwood, Bill Fontana, Maryanne Amacher, Bernard Leitner, Young, and Neuhaus) emerged in the 1960s and early 1970s at the same time as the Earthworks and Land artists is not purely coincidental. The ability to analyze, collect, and amplify any conceivable sound afforded by the invention of microphones and tape recorders, and the cognizance of sound's role in the environment that followed, certified sound

as a universal and elemental force, like earth, light, water, or air, and this informs the first flowerings of sound art.

Sound sculpture

In addition to sound as a means to create or outline environments, another aspect of sound art is the idea of sound being latent in any object. As ethereal as sound may seem to be, its existence is predicated on the interaction of matter. Sound is the auditory result of physical contact, whether it is water dripping from a faucet into a sink or an electronic tone being pushed through the speaker of an amplification system. Sound has a role as an indicator of presence; you can hear more of your surroundings than you can see. A musical instrument too is based on touch, fashioned with the specific intent to generate sound by causing one or more of its parts to vibrate. Customarily, the instrument is intended to supply pitches that can then be manipulated by the player. An instrument is also an extension of a human being's own innate sound-producing ability. In the case of most wind or string instruments, the instrument becomes something of a substitute for the voice, while percussion instruments relate more to the heartbeat and body movement. Any instrumentalist uses music as a second language, a form of communication and expression that is nonverbal (except for singing) but still subject to comparable notions of grammar.

The plastic arts are fundamentally an extension of sight, not speech or hearing. They are mute: there is no aural component. And the viewer is forbidden to touch the work—the engagement is strictly visual, not tactile. Silence is the general condition in which the work is observed and contemplated. It is only in the twentieth century that artists begin to conceive visual artworks that would also have a sound. Yet in some respects sound sculpture, which is not instrument-making but sculpture or a machine that is made as a visual artwork with an inherent sound-producing facility in mind, is the facet of sound art with the longest history, if not as a genre then in terms of extracting sound from objects or surfaces not intended as musical instruments. Think of lithophones—Chinese stone chimes, in which stones vibrate after being hit with a mallet to create sound; China's ancient classical music also uses stone slabs.

The science fiction writer Philip K. Dick, in one of his final interviews, told the story of Pythagoras having a sound epiphany while walking past a blacksmith's shop:

He noticed that the anvils, when hit with a hammer, the smaller the anvil, the higher pitched the sound. So the bigger anvils make a low-pitched sound and the little ones make a high-pitched sound ... Wait a minute, he says. The sound the anvil emits when struck is a musical sound. There is no difference between an anvil being hit with a hammer and a musical instrument.[91]

Cage used anvils in *First Construction in Metal* (1939), and he had begun contemplating the inherent sound properties of objects after conversations with experimental filmmaker Oskar Fischinger as early as 1936. Cage recalled:

When I was introduced to him, he began to talk with me about the spirit which is inside each of the objects of the world. So, he told me, all we need to do to liberate that spirit is to brush past the object, and to draw forth its sound ... in all the many years which followed ... I never stopped touching things, making them sound and resound, to discover what sounds they could produce. Wherever I went, I always listened to objects.[92]

In his music for the 1968 Merce Cunningham dance piece *Rainforest*, a Cage confrere, David Tudor, fed electronic sounds into inanimate tabletop objects to make them resonate. In later versions, larger objects were used, including a wine barrel, bed springs, a sprinkler, a tennis racket, a picnic basket, and the audience was welcome to walk around them. A masterpiece of sound sculpture, named for a natural environment known for its continuous sounds, it was updated in 1974 to be a kind of temporary installation, called *Rainforest IV*, and finally realized as a freestanding installation, *Rainforest V*, in 2009 by Composers Inside Electronics.[93] Also notable from the same era is Alvin Lucier's *Queen of the South* (1972), which directs its performers to

sing, speak, or play electronic or acoustic musical instruments in such a way as to activate metal plates, drum heads, sheets of glass, or any wood, copper, steel, glass, cardboard, earthenware, or other responsive surfaces upon which are strewn quartz sand, silver salt, iron filings, lycopodium, granulated sugar, pearled barley or grains of other kinds, or other similar materials suitable for making visible the effects of sound.

However, it is in the art world, rather than contemporary music, that sound sculpture as a form of exhibitive objects evolves. Dadaism is a modern source, particularly Duchamp's *A Bruit Secret* (1916) (a ball of yarn with a mysterious object inside that creates a sound when shaken), as well as Man Ray's *Indestructible Object* (1923/1958) (a metronome with a picture of an eye attached to it). Robert Morris made a self-reflexive elaboration on Duchamp's

piece with *Box with the Sound of Its Own Making* (1961), where he recorded himself building a wooden box, then pressed "play," and put the tape recorder inside the box; the tape lasted over three hours. (Intrigued, Cage reportedly visited Morris in his studio and listened attentively to the piece in its entirety.) Bruce Nauman continued in the conceptual vein with 1968's *Concrete Tape Recorder Piece*, in which a tape of a woman screaming was encased within a large slab of concrete, rendering it inoperable/inaudible (Doug Henderson did the same with an electric guitar in *stop.* (2007)). Christian Marclay made an overt homage with *Secret* (1988), in which a metal disc used to press copies of a vinyl 7" single is padlocked through its center hole, likewise preventing it from sounding. Marclay's video *Shake Rattle and Roll (fluxmix)* (2005) found him making sound with a variety of Fluxus objects by shaking them or banging them against a surface, mixing two art historical references. Jonathan Monk invoked Morris with *The Sound of Music (a record with the sound of its own making)* (2007), a vinyl LP artists multiple edition where the record contained a recording of its own manufacture.

In the mid-twentieth century, the Baschet Brothers, Harry Bertoia, and Jean Tinguely all introduce sound sculpture more decisively as a practice of making objects "for the eye and ear." The Baschet Brothers—a sculptor (François) and a radio sound engineer (Bernard, who worked at Radio Television Française, where Pierre Schaeffer had been employed and the incipient musique concrète experiments took place)—began building their own "sounding sculptures" and instruments in 1952. This effort was made to solve a problem they saw in making twentieth-century music "on eighteenth century instruments." Their acoustic "sculptures sonores" were exhibited in the 1960s at the Museum of Modern Art and traveled to the Osaka World's Fair. Ranging in sizes from small to upwards of 20 feet high, the instruments were made out of metal or glass rods that would be vibrated, often with wet fingers with other objects placed on them (glass, metal, piano wire, plastics), that interact with each other to enhance overtones and echo, and are then amplified acoustically by air-filled balloons and cones or sheets of metal. Some of the instruments also attached spring steel wires as resonators ("whiskers") that produce sympathetic vibrations and occasionally touch one another. In their time, the instruments' ability to produce synthesizer-like sounds acoustically was astonishing; more than half a century later they're reminiscent of many of Harry Partch's instruments sonically, but still among the most visually striking invented instruments ever created.

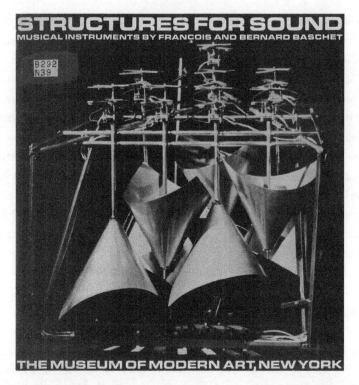

Figure 2.10 The Baschet Brothers, *Les Structures Sonores*, LP release © 1965 The Museum of Modern Art Library, New York, NY, USA. Digital image © The Museum of Modern Art/Licensed by SCALA /Art Resource, NY.

Harry Bertoia produced monotype prints and jewelry early in his career. By the late 1940s, he was working on furniture design and sculpture, working with Charles Eames and ultimately producing the now-famous welded steel mesh-pattern Diamond or "Bertoia" chair, introduced in 1952. When he was making a sculpture that emulated the form of desert grasses, a wire broke off and struck another wire, creating a resonating vibration. Thinking he could improve the sound by choosing different wires and metals, in 1960 he began producing sound sculptures or "tonal sculptures." In the tonals, multiple rods made from copper, brass, or bronze are fastened to a base, but are not rigid, and produce a spine-tingling, sizzling, mysterious rustle of sound when stroked. As with the Baschet sound sculptures, some are a just a few inches high, others as large as nineteen feet. Some of the rods are topped with cylinders, or drops, which affect the movement of the rods, depending on their weight. He also made gongs,

which are not circular like the commonly known instrument but huge block-like creations, made of silicone bronze, and "hanging bars," made of beryllium copper, which rotate and also produce a sound when touched. He produced over fifty public sculptural works, some of which are sound sculptures—these locations include Standard Oil Plaza in Chicago, University of Akron, Ohio, Colorado National Bank, a gong at the US Embassy in Oslo, Norway, Bowling Green State University, Sentry Insurance Company in Wisconsin, and the Federal Reserve Bank in Richmond, Virginia.

In 1968, Bertoia constructed a barn on his property in Bally, Pennsylvania, to house the sound sculptures. It was also used as a recording studio to record his improvisations on them. He produced over 100 sound sculptures, aided by his son Val in the 1970s, and amassed 360 tapes. He self-released eleven albums of these recordings, each including two side-long pieces, each titled "Sonambient" (a conjoining of "sound" and "environment"), and each with a different black-and-white photo of the sculptures on the front cover. He gave concerts to visitors and friends; after his death in 1978, Val and Bertoia's wife Brigitte continued this practice.

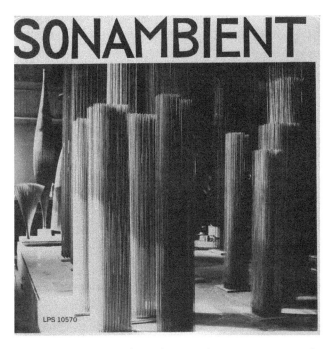

Figure 2.11 Harry Bertoia, *Sonambient*, first LP release © 1970 Estate of Harry Bertoia/Artists Rights Society (ARS), New York.

One of the most renowned Kinetic sculptors, Jean Tinguely was using 78 rpm gramophone motors in his early "meta-mechanical" reliefs. Realizing that using motors would always make his work sound-producing, he decided early on to emphasize sound, starting with 1955's *Meta-Mechanique Sonore* in which little hammers strike objects rescued from the garbage—glasses, bottles, and tins, all painted black. His *My Stars—Concert for Seven Paintings* (1957–59) consisted of wooden boards with motors, metal cutouts, and hidden sound-making objects. From a switchboard the viewer could activate the sculptures, sending an electric impulse to each work that would activate a mobile part as well as a sounding one. One of Tinguely's most infamous works was *Homage to New York*, staged in the Museum of Modern Art's sculpture garden on March 17, 1960. A gargantuan assemblage of eighty bicycle, tricycle, and pram wheels, a bathtub, a piano, a drawing machine (one of Tinguely's inventions), metal drums, an Addressograph machine, a bell, a klaxon, bottles, a fire extinguisher, a radio, oil cans, hammers, a saw and fifteen motors, all painted white, was set in motion and ended in fire as onlookers booed the firefighters, telling them to "let it burn." Tinguely made assemblages like *Gismo* and *Cyclograveur* (both 1960) out of wheels and motors that used pots and pans as sound resonators. More intricate was *Eureka* (1964), which had seven independent parts; as the piece is set in motion the volume of its movements rises and falls with its vertical motion. Besides being sculpture, these assemblages also constitute self-contained, automated sound environments.

Other sound machines include Joe Jones's music machines (assembled from broken toy instruments and motors and originated within the context of the Fluxus art movement—see Part Three), John Driscoll's *Second Mesa* (spinning robotized loudspeakers that react to the acoustics of a space), and Felix Hess's sound creatures (automatons based on studying the croaks of frogs, which "listen" with microphones and respond with electronic sounds). Martin Riches also made automated machines for flute, xylophone, organ, and viola, but with an intention to encourage composers to write for them. Stephan von Huene began making sound machine sculptures in 1964, based on the mechanics of a player piano, completing his first, *Kaleidophonic Dog*, in 1967. A kind of cabinet with a sculpted dog lying on its back, von Huene employed a pneumatic system that caused the attached drum, organ pipes, and xylophone to make sound independently. A pneumatic mechanism was also used in his *Tap Dancer* (1967) that had models of two legs that are connected to wooden blocks inside a box they stand on, as a four-minute tape loop programs the sound. Two tape loops

operated his *Washboard Band* (1967), which combined a washboard, gong, reeds, and a cowbell in a deliberate imitation of a one-man band. As opposed to player pianos or music boxes, these works don't play music pieces but simply make sounds, playing themselves as it were. Unlike some sound sculpture, there is no exploration of a latent sound in physical material; they are designed with a performative, sounding aim. Von Huene was awarded a National Endowment grant for sound sculpture in 1974, perhaps a first.

Two other Kinetic sculptors—Len Lye and Takis—have also worked with sound. Lye created several sounding sculptures starting in the late 1950s, around the same time as Bertoia. *Blade* (from the early 1970s) is a six-foot tall steel blade that bounces against a cork ball, sounding like a saw being rapidly shaken. *Storm King* (1961) and *Twisters* (1977) are more violent, erupting suddenly into hurricanes of sound from silence, but the majority of his works have the swishing sound of motion itself. Takis produced his first sounding sculptures *Signals* in the 1950s. Piano wires vibrated as they were knocked into each other by the wind. His 1963 collaboration with composer Earle Brown, *Sound of the Void*, amplified the hum of a heated cathode filament. In 1965, he inaugurated the long-lived series *Musicales*, which used a magnet to make a needle strike a string stretched across a canvas and amplified the resulting repetitive sounds.

Yoshi Wada participated in Fluxus and also studied raga singing with Pandit Pran Nath. In the early 1970s, he started experimenting with plumbing pipes, fittings, and copper tubes as horn instruments. This led to his adapted bagpipes, huge constructions (often room size) made from a long pipe with a canvas bag and an air compressor attached. David Jacobs had made a comparable device called *Wah Wah's* in 1967, using tubes and rubber, then reconfigured them as *Hanging Pieces* "capable of producing as many as 5,000 partials, beats, secondary beats, and other musical and psychoacoustic effects."[94] Another artist fascinated by organ pipes, Andreas Oldörp, has been active since the late 1980s. He has mostly worked with pipes of his own construction and has experimented with various methods of putting air into them continuously, often with gas flames and glass pipes. Seattle-based artist Trimpin's *Fire Organ* (2006) also used flame, consisting of Bunsen burners set inside Pyrex cylinders that resemble organ pipes, with a computer controlling the burners to vary the flame, which in turn makes different tones and colors.

Sound sculpture entered the electronic age with Peter Vogel and Walter Giers, who made wall pieces in the late 1960s of exposed electronic circuitry that use

speakers and other media, and are generally interactive, triggered by a viewer's presence—in Vogel's case, the viewer's shadow or conversely a sound in the room can serve as a trigger for motion in the sculpture. Howard Jones also worked with wall pieces with multiple speakers; a 1970 exhibition titled *Three Sounds* presented *Linear Relay*, in which a metronome sound is sent on a horizontal progression through twenty separate speakers and back; *Area Relay*, where a sound moved between nine speakers arranged in a square; and *Air 44*, in which white noise was diffused between seventeen speakers with minor variations in each one, to be perceived by the visitor as they walked along.[95] (Interestingly, *Three Sounds* was the final show at the Howard Wise Gallery in New York and the only one to ever sell out; Malcolm Forbes bought all three pieces.[96]) These wall works pave the way for Christina Kubisch's *Il Respiro Del Mare* (1981) in which she created a speaker-less sound system with wire reliefs on the walls, accessed by visitors when they put receivers up to their ears, one dispensing the sound of ocean waves, the other the sound of breathing, which were meant to be mixed and matched by the listener.

Paul De Marinis's *Pygmy Gamelan* (1973) was a device that would play five notes in different configurations, responding to radio waves and other electrical signals in whatever electromagnetic field it was situated in. People's movement in the room also affected its output. It was not a wall piece, but like those of Vogel, Giers, or Jones its electronic circuitry was also exposed. It was conceived both as a stand-alone exhibitive sculpture and a kind of radio (De Marinis even considered submitting it to car manufacturers for possible inclusion with a vehicle as it was the same size as a car radio). He would install several in different tunings in the same gallery space, as a kind of sound environment.[97]

Also relevant to the practice of making inanimate objects vibrate with sound is Maryanne Amacher's idea of "structure-borne sound" ("sound traveling through walls, floors, rooms, corridors") as opposed to the more customary airborne sound (the way we normally experience sound in the air), as found in her *Music for Sound Joined Rooms* series of the 1980s, for which she would spend weeks on location studying the architectural features of a building and then create sonic and visual events for each hallway, room, and staircase. Amacher described it in 1988 as "a form of sound art that uses architecture specifically, to magnify the expressive dimensions of the music. The building becomes the speaker, producing sound that is felt throughout the body as well as heard."[98] Other artists used sound transmitted through surfaces in conjunction with more direct bodily contact rather

than experienced within the air of the room. Laurie Anderson's *Handphone Table* (1978), which entailed marshaling a table and human bones as sound conductors, also gave the visitor a physical experience: the table is wired to taped sounds, which are heard/felt by placing elbows on the table and cupping hands over the ears. In Bernhard Leitner's *The Sound Chair* (1976), the listeners lay on their back in a long chair (like a dentist's chair) as sounds moved inside the chair, all along their body. Leitner was particularly interested in the body as a receptacle for sound, telling an interviewer

> I believe that is a very important fact that the body be understood as an autonomous acoustic instrument, as an integral acoustic sensorium. The hollow spaces of the body, the bones, the way the sound is transmitted in the body, how it passes through the skin, and how it is transmitted on. In this sense, the point is to open up, to allow sounds and sound motions to penetrate the body, let them resonate in the body.[99]

This sort of contact, though, is part of people's resistance to sound-based work, as Leitner realized:

> The average person is, I think, paved over in an acoustic, physical sense. He is apprehensive when sound penetrates him, resonates in him, and then vibrates out of him again. I have seen it in several of my exhibitions: that barrier of apprehension, particularly with sound-space objects where the sound touches the body directly. That demands a form of dialogue which is different to that with a painting, which one can even see in passing, in the flash of a moment. For a sound-space work, for any acoustic work, you have to make time, get into it, open yourself to it acoustically.[100]

Rolf Julius had several works that vibrated objects with sound. He attached small speakers to cobblestones in *Music in a Stone* (1982), creating the illusion that the sound is emanating from the stones themselves. He also placed speakers in bowls and flower pots, buried in gravel and dirt, and on sheets of glass coated with pigments to make them vibrate. The pigments were also meant to establish a correlation between the sound and a designated color. In another work more in the vein of Leitner and Anderson's pieces with sound touching the body, *Music for the Eyes* (1981), he applied two small speakers directly on top of a visitor's closed eyes. The title is a play on his practice of combining sound with pigments and other visual art materials but also ensuring that no visual stimuli interfere with the listener's concentration on the soft sounds emitting from the speakers.

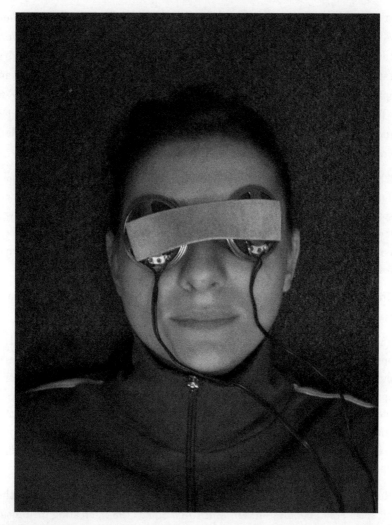

Figure 2.12 Rolf Julius, *Music for the Eyes*, 1982. Installation at Frac Limousin, Limoges, France © estate rolf julius.

Stringed sculptures: Long wires and Aeolian harps

Long string installation is a form of sound sculpture and performance that began in the 1970s. This was another area of sound art that used the dimensions of a room as a determining factor, and the overtones from the strings' vibrations also reacted to resonances within the room itself. In a late 1974 concert at the Kitchen

in New York, composer Jim Burton stretched four piano wires across the length of the space, with musicians rubbing them as they walked alongside, creating overtones.[101] Two years later, artist Terry Fox began stretching wires across a room and playing them, with resin on his fingers. Fox said:

> If you have two strings together it might be an instrument. Or if it's a monochord, because it's built like an instrument, with a sound box, bridges, and it can be tuned. But to attach a wire to something at one end and to something else at the other end doesn't make it an instrument. To me it's a sculpture, a straight piece of steel. [102]

In his 1977 piece *Music on a Long Thin Wire*, Alvin Lucier stretched an eighty-foot long wire across a room and caused it to vibrate with an oscillator situated underneath it. The piece changes considerably depending on "fatigue, air currents, heating and cooling, even human proximity" as he told Christoph Cox.[103] It was his first freestanding installation; originally it was a performed piece with musicians activating the wires but he was dissatisfied with the results. Ellen Fullman saw *Music on a Long Thin Wire* at New Music America in 1980 and began working on her own long string instruments, using multiple strings in just intonation stretched across a room to be played with resined fingers (unaware of Fox's prior works,[104] notably *552 Steps through 11 Pairs of Strings* (1976) in which he stretched eleven piano wires across his loft, played with a mallet). Paul Panhuysen's Long String Installations began in 1982 in collaboration with Johan Goedhart. A series of strings were stretched across large indoor spaces with attention paid to the acoustics of the room and the architecture (Panhuysen had also worked as an artistic advisor in urban development and met Goedhart when they collaborated on environmental design) and sometimes played by the two, resulting in thick drones with soaring overtones. Different wires, other instruments (in some instances the wires were connected to pianos), and found objects would be incorporated depending on the space. Panhuysen also had a long-running cultural center called Het Apollohius that hosted many concerts and sound art events; the Het Apollohuis record label released albums of his own long string works, as well as those by Fox and Fullman. Atau Tanaka and Kaspar Toeplitz's *Global String* installation (2000) has a real physical string connected to a virtual string on the internet. The real string stretches from the floor diagonally up to the ceiling of the space. Vibration sensors translate the analog pulses to digital data when a user vibrates the string that is transmitted to another steel string in a different location.

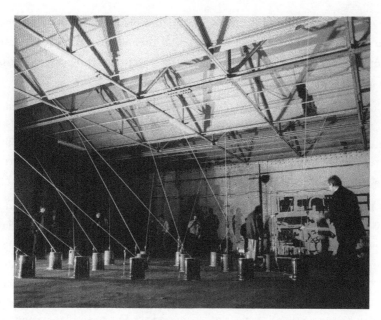

Figure 2.13 Paul Panhuysen and Johan Goedhart, *Projection*, 1987. Installation at Echo Festival 2, Eindhoven, Netherlands. Photo by Paul van den Nieuwenhof. Courtesy Hélène Panhuysen.

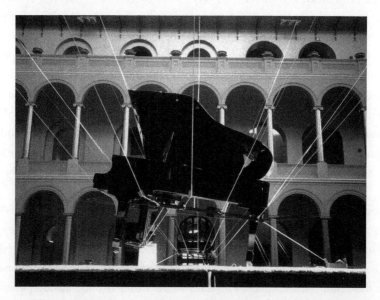

Figure 2.14 Paul Panhuysen, *Two Suspended Pianos*, 1990. Installation at the Great Hall, National Building Museum, Washington D.C. Photo by the artist. Courtesy Hélène Panhuysen.

The ancestor of these long string works is the Aeolian harp, a string instrument designed originally by the ancient Greeks in which the strings were all tuned to one note, placed on a window sill, and "played" by the wind without human interference, creating melodic interactions between the overtones (Aeolus was the Greek god of wind). In 1650, Athanasius Kircher published his book *Musurgia Universalis*, which contained his ideas for various mechanized sounding devices, including an Aeolian harp, alongside talking or singing statues and a hydraulic organ. As Ros Bandt points out, in current, large-scale Aeolian sound sculptures

> many factors come into play which influence whether there is a sound at all, and if so what is heard. Since the aerodynamic flow of the wind is constantly changing, these elements are in a constant dynamic relationship. So is the sound. The slightest change in temperature and humidity can alter the sound considerably within moments. Site orientation, the wind path and the nature of the acoustic soundscape in which the harp is situated influence the sound formation and its perception. The number and length of strings will affect the loudness and range of harmonics between the strings. The tuning of a number of strings at the same pitch will determine the density and richness of the sound and the degree of sympathetic vibration possible. The degree of tension on the string in relation to the wind's pressure is the most critical feature.[105]

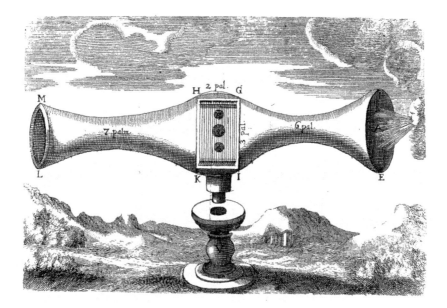

Figure 2.15 Athanasius Kircher, Wind Harp from *Phonurgia Nova* (1673). Courtesy Agosto Foundation.

Bandt has identified a trend toward Aeolian sound practice in her native Australia, noting that not only has the wind "carved the landscape for thousands of years, actively changing its geomorphic composition on a daily basis" but it has formed naturally occurring sound environments: "It stirs the spindly casuarina, Australia's native pines, until they make wonderful tones of the harmonic series in just intonation, earning them their affectionate name, the whispering pines ... So too the wind sonically activates man-made structures, albeit unintentionally. Telegraph wires and fences sing."[106] Indeed, the first sound sculpture in Australia, 1970's *The Singing Ship* by Peggy West-Moreland, Steve Kele, George Cain, and David Thomas, placed a giant Aeolian harp on a cliff marking the spot where Captain Cook first sighted Australia 200 years before.[107] Bandt's own large Aeolian harps have been semi-permanently installed in desert areas of Australia, taking advantage of the near-constant wind activity and are designed to be played either by the wind or by hand. Alan Lamb has made pieces out of the sound produced by the wind "playing" telephone wires and rigging up an organ and other contraptions to play them himself. Jodi Rose has done a series of "Singing Bridges," in which she attaches contact mics to the cables of a bridge and captures the sound of their vibration from the wind and other external factors. And Jon Rose has a long-term project of "playing" fences, which can stretch for thousands of kilometers, with bows or drumsticks, *Great Fences of Australia* (2002–)

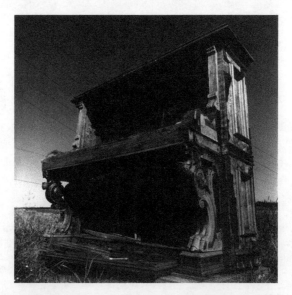

Figure 2.16 Gordon Monahan, *Long Aeolian Piano*. Photo by Thaddeus Hollownia. Courtesy the artist.

Others have modified instruments for Aeolian purposes. In Gordon Monahan's *Long Aeolian Piano* (1984–1986) installed at Holownia-Hansen farm, Jolicure, Canada, he stretched fifty-foot piano wires between two wooden bridges on a friend's property, then added an upright piano and more piano wires parallel to the original ones, this time 100 feet in length. The wind resonated the string (and in the absence of wind, still air produced low resonances). He later made a permanent installation (*Aeolian Silo*, 1990) in which piano strings stretched across the top of a silo at Funny Farm, Meaford, Ontario. Leif Brush created *Meadow Piano* in 1972, more of a grid-like structure using sensors that make aural responses to weather conditions and microphones to pick up and record insect activity. Max Eastley, too, has built Aeolian sound sculptures, not only harps but also flutes and other instruments meant to be played by the wind. Eastley, writing in 1975, also noted Ichabod Angus MacKenzie's 1934 wind instruments as being

> wind sound sculptures as we can now define them … in the U.K. Aeolian instruments have surfaced to a large extent in colleges of Art rather than in colleges of Music and in each series of final Diploma shows there seems to be a small but significant number of students who have devoted some or all of their time to using the power of the wind to move sculpture to make sound. The two main forms that this seems to take is either an extension of the tubular Chinese Wind Chimes or using a wind-operated propeller to play instruments of a conventional type rather like a Tinguely sculpture. [108]

The Tinguely reference supports the view of Aeolian works as sounding machines rather than instruments.

Numerous other works of sonic sculpture are wind-propelled. Bill and Mary Buchen, working under the joint name Sonic Architecture, have created a wind-driven gamelan for the New York Hall of Science, and *Sun Catchers* (1997) at the Arizona Science Center, where the wind rotates propellers that in turn activate mallets that strike a tone bar. They also converted a stone fountain into an Aeolian harp and made a temporary installation that used a hill's topography to create a tuning system for an enormous sound sculpture of stretched wires measuring from 20 to 250 feet (*Harmonic Compass*, 1983). Harry Bertoia's commissioned outdoor sound sculpture at the River Oaks Shopping Center in Calumet City, Illinois (1966), was meant to be "played" by the wind. Douglas Hollis's *Sound Site* (1977) had several wind-activated sound sculptures installed along the Niagara River; his permanent installation in Seattle, *A Sound Garden* (1983), has organ pipes meant to sound by the wind. Patrick Zentz has a variety of works triggered by wind motion (tuning forks, flutes, string instruments).

More elaborate works, which incorporate electronics and/or take on environmental factors in addition to the wind, suggest a further relationship between sound sculpture and the environmental concerns of Land art, focusing on the atmosphere rather than the earth. Leif Brush's *Terrain Instruments*, a series of works begun in the late 1960s, are electronic devices that turn various environmental motion sources (leaves, wind, precipitation) into sound via various metal wires strung through trees. He also has constructed "audible sculptures" like "signal discs" and "cricket chord monitors" to record the movements and weather sounds themselves. In an early 1970s installation on the roof of the School of the Art Institute of Chicago, he used galvanized steel strands, "windmonitors," and "windslicers" to channel the wind into a sound source for an ARP synthesizer. Liz Phillips's *Windspun* (1981) also used wind patterns, via weather vanes and anemometers, to trigger synthesizer tones. Felix Hess's "wind fireflies" are machines with a microphone and a flashing green light that is triggered by wind patterns; his "cracklers" subtract the light and add a speaker and an oscillator and are triggered by air pressure. This ultimately led Hess to record the air pressure itself in his home; he used specially made infrasound microphones and sped up the tape by a multiplication rate of 360, i.e., one second for every six minutes of the original recording, which was five days worth of twenty-four-hour sessions. Ordinarily below the hearing threshold but made audible as a heavy drone through his recording system, the results were released as a CD in 2000, *Air Pressure Fluctuations*.

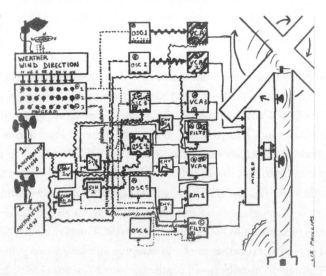

Figure 2.17 Liz Phillips, circuit diagram of the Bronx version of *Windspun* (1981). Courtesy the artist.

Recent sound sculpture and other uses of the term

A type of "silent" sound sculpture has developed in the last two decades, composed of speaker arrangements where the vibrations are visible on the speaker cones but not audible. Stephen Vitiello's *Fear of High Places and Natural Things* (2004) and *Wind in the Trees* (2005) suspend multiple speakers in a wave form, with inaudible bass frequencies making them seem to heave and percolate. Doug Henderson's *Untitled* (2004, 2006) set up a row of speakers filled with water, which rippled into symmetrical patterns caused by low-frequency sine tones. *Dead Room* (2000) by Camille Norment was a cube space outfitted with eight large subwoofers that pulsed with sub-audio bass frequencies for three-minute thirty-three second intervals, timed to fall somewhere between Cage's *4'33"* and the classic three-minute pop song length. These works suggest that vibration is at the crux of sound and need not be auditory; the speaker is there to visualize the physicality of sound rather than to project it aurally.

Figure 2.18 Stephen Vitiello, *Fear of High Places and Natural Things* (2004). Courtesy the artist.

There are also sculptures using massed groupings of speakers; whatever their volume level, these speaker sculptures radiate a physical sense of mass and scale that is not achievable in a sound installation purely through decibels, sonic density, or spatialization. Robin Minard's *Silent Music* (1994–present) vertically drapes hundreds of small piezo loudspeakers, vine-like, on a surface, emitting very soft electronic sounds. At the other end of the spectrum are high-volume, monolithic works such as Nadine Robinson's *Alles grau in grau malen* (2005), a

stationary, wall-length configuration of 200 speakers painted in forbidding black and gray and inspired by Jamaican sound trucks—the mobile DJ booths that blast reggae music. Here Jamaican dance music, Catholic funerary chants, and climactic excerpts from Hollywood film soundtracks (*The Exorcist*, *Rosemary's Baby*, and *The Matrix*) are mixed together to approximate a sonic doomsday. Robinson brings a different kind of outdoor sound experience—not an ambient soundscape but high volume, mobile music playback—indoors, and stationary, in a variation on the translocational ideas of Fontana or Amacher. Benoit Maubrey has done several installations, both indoors and outdoors, piling up recycled speakers that emit white noise radio frequencies and are also hooked up to a phone line so that people can call in and hear their voice through the sculpture. *Speakers Wall* (2011) included a portion of the original Berlin Wall alongside 700 speakers; *Temple* (2012) was modeled after the Greek temple at Delphi and contained 3,000 speakers. Shilpa Gupta made two installations out of clusters of microphones rewired to function as speakers: *The Singing Cloud* (2008–2009, with 4,000 microphones) and *I Keep Falling at You* (2010, with 1,000 microphones), both composed of recorded voices, murmuring different phrases in *The Singing Cloud* and chanting a brief song in *I Keep Falling at You*. In André Avelãs's *Earphones* (2007), 1,000 earphones are placed on the floor, 960 functioning as speakers, 40 as microphones, creating a low-volume feedback loop.

Zimoun, a sound sculptor from Switzerland, makes wall pieces and installations, each one a system employing dc motors that cause a ball or wire to strike a surface. In the wall pieces there are a grid of small cubicles that house the motorized devices, while the installations comprise rooms full of cardboard boxes, paper bags, or other quotidian objects outfitted with the motors. The motors do not work in unison—they move at different speeds, so there is an overall wash of sound rather than a steady beat, as befits the hive-like activity of the works. Once set in motion, they operate autonomously and continually. Structurally simple, as visual works they would be associated with Minimalism; the sound is dense but not varied, given that it's an accumulation of identical parts performing an identical function (although they're assembled by hand, which leaves some room for differentiation that would not be possible in factory production). Zimoun sets up a direct relationship between the sound and the visual object that produces it. His work is marked by the use of multiples—a single cardboard box made to sound with a motor would not be terribly interesting, but a room full of them transforms the space aurally, visually, and physically—in a more Spartan manner than Bertoia's barn and his sculptures

themselves, which often contain multiple rods. Zimoun often cites John Cage as an influence, but not other sound sculptors; this exemplifies how to some extent contemporary sound art keeps recycling itself by remaining in dialogue with the primary inspirations of its progenitors, rather than its own history or a sense of a movement or community.

Like "sound art," the term "sound sculpture" has proved to be quite malleable. *Sound Sculpture As*, a one-night 1970 exhibition/performance at the Museum of Contemporary Art in San Francisco, organized by its founder, Tom Marioni, featured mostly conceptual pieces like Marioni urinating in a bucket, Paul Kos's *The Sound of Melting Ice* (eight microphones surrounding two blocks of ice, producing no audible sound), Mel Henderson firing a shotgun at a projected image of a tiger, the popping of bubble wrap placed on the floor at the entrance and the elevator, a phone ringing off the hook.[109] Whereas most sound art attempts to dispel sound's temporality, Marioni theorized sound "as an element that could be used as a sculpture material which could only exist in time and was not static. To me it seemed that the sound should be the result of an action that I made."[110] Marioni later did "drum brush drawings" by drumming with steel wires on large sheets of sandpaper that would leave marks.

A case is often made for musique concrète as sound sculpture, since tape made the duration of sounds visible and physically measurable. Brian Eno has referred to tape as "malleable, mutable, and cutable."[111] Writer and sound artist Robin Minard has cited Pierre Schaeffer as one with whom "sound turned into sculptural material. Sound material was first collected and then it was manipulated. It was cut into pieces, played forward and backward, transposed and looped."[112] Tape music clearly concretized sound, yet Schaeffer's processes are more akin to experiments in film editing, where the recorded material can be manipulated in any number of ways, played backwards, juxtaposed with other images to create certain effects, double exposed, etc., than with sculpture. "Sound collage" is often applied to musique concrète and is probably the better analogy.

Records themselves are another matter. Beyond their physicality, records also have a "latent" sound in that they must be played in order for their encoded audio to be accessed. Duchamp had made "Rotoreliefs" (six "optical discs" with drawings on them, to be rotated on turntables at 33 1/3 revolutions per minute) in 1935, and Cage had incorporated turntables into his pieces *Imaginary Landscape* (1939) and *33 1/3* (1969); but more to the point, Milan Knizak made his "broken music" sculptures of two different broken records glued together in the 1960s.

Christian Marclay did the same with his "recycled records" in the late 1970s and 1980s. Both played the records at various speeds and incorporated various degrees of abuse. Marclay was active as a performer in the free improvisation scene of the 1980s and 1990s using multiple turntables to make rapid-fire juxtapositions of different forms of music and sound. He began exhibiting the records in the 1980s, first the ones he was using in performance and then ones he made that were unplayable, such as *Mosaic* (1987), where the grooves were purposely not lined up when the record parts were reassembled, and *Untitled* (1987), a record with no grooves at all.

Bill Fontana's use of the term "sound sculpture" for his sound installations affords yet another perspective. Fontana extensively utilizes field recording as way of capturing a given location's sound from every possible standpoint. Fontana has written, "In the ongoing sculptural definition of my work I have used different strategies to overcome the ephemeral qualities of sound, that seem to be in marked contrast to the sense of physical certainty and permanence that normally belong to sculpture and architecture."[113] He notes his *Kirribilli Wharf* as an example: "The percussive wave action at Kirribilli Wharf had continuousness and permanence about it. This 8 channel tape was not a recording of a unique moment, as with the total eclipse [in a rainforest, see Introduction], but was an excerpt from a sound process that is perpetual."[114] At Kirribilli Wharf the sound is already there, freestanding; it will exist before, during, and after Fontana made his field recording. It is not "played" by Fontana and is hearable in its natural state by anyone. While not automated, it occurs with a verifiable regularity, which allows for in-depth listening, rather than the type accorded to following the structure of a composition. Much sound art springs from a desire to use sound as an expression of continuity, as found in an almost systematic environmental soundscape like ones explored by Fontana. Exhibited as an installation at the Sydney Opera House, the National Gallery of Victoria at Melbourne, and the Whitney Museum, it can be seen, given Fontana's explanation, as a sound work whose origin and display is essentially sculptural, which begs the question as to whether the object is really necessary to sound sculpture—and whether sound art is truly just a form of installation art, even if it takes the form of a sound sculpture.

Finally, Paula Rabinowitz has written about Liz Phillips's installations as an extension of her work with sculpture:

> Trained originally as a sculptor, she found herself drawn as much to the emptiness surrounding the objects she made as to the objects themselves, interested as much in the complex dance of her audience as it attended each piece, as in the response

to the isolated object. Sculpture requires three-dimensional engagement; walking around the object to see its fullness, forces acknowledging, if only subliminally, the space beyond the object, encouraging an active looking, a physical dance as the spectator charts the gallery space, or studio space with new vectors in an effort to see the totality of the object. Inevitably, this process of drafting the architecture of emptiness became her primary focus; she defines space through an electronic call and response that encompasses echoes, resonance, and ambient sound measured by time and distance.[115]

Removing the sculpture from her work in order to concentrate on the space surrounding it and the viewer's movements in the space is a bit like Cage detaching the music from the concert stage in order to better hear the audience's rustlings and coughs, not to mention the extraneous sounds of the room. If we follow this logic then by working with the bodily relationship to observing sculpture, as the art is activated by movement rather than observed through it, Phillips has essentially collapsed sculpture and spectator into one. And even without tracking the visitors' movements with sound, sound installations that require movement throughout the room to be experienced will always share this exhibitive quality with sculpture.

Part Three

Sound and the Art World

Sound by visual artists

The relationship of sound and music to the art world cannot be disregarded in the rise of sound art. As we have already seen, the Futurist and Dada movements produced several theories about using noise in music, mechanized instrumentation, and spatialized sound; sound sculpture could be considered to a certain extent to be an offshoot of Kinetic art; and sound installation has an aesthetic kinship to Land art. In the twentieth century, there have been numerous examples of sound or music pieces made by visual artists. Following the departure from traditional painting and sculpture toward other forms of visual art and performance that began with Dadaism and Futurism, artists affiliated with Fluxus and early video and performance art in the 1960s also engaged with sound as another alternative medium. Most sound by visual artists is formulated and/or performed as music, although in Conceptual art sound becomes an element in installation works that seek to dismantle the accepted definitions of an art object. Nonetheless, it's an important facet of sound art's mise-en-scène inasmuch as it shows a lineage of artists looking to sound as a means of expression and continuation of their visual aesthetic and galleries' occasional role as a venue or as a label producing albums as a kind of artist's multiple edition. And most significantly, in the first three decades of sound exhibitions in galleries and museums, sound or music by visual artists was almost invariably included.

Music and painting have always existed side by side; composer Morton Feldman, himself profoundly influenced by modern art, summarized the history of their structural correlations:

> Music and painting, as far as construction is concerned, parallel each other until the early years of the twentieth century. Thus, Byzantine art, at least in its uncluttered flatness, was not unlike the Gregorian chant or plainsong. The

beginning of a more complex and rhythmic organization of material in the early fifteenth century with the music of [Guillaume de] Machaut was akin to Giotto. Music also introduced "illusionistic" elements during the early Renaissance by way of inaugurating passages of both loud and soft sounds. The miraculous blending or fusing of the registers into a homogeneous entity, as in the choral music of Josquin [des Pres], could also be said of the painting of that era. What characterized the Baroque was the interdependence of all the parts and its subsequent organization by means of a varied and subtle harmonic palette. With the nineteenth century, philosophy took over—or to be more precise, the spectre of Hegel's dialectic took over. The "unification of opposites" not only explains Karl Marx, but equally explains the long era that includes both Beethoven and Manet.

In the early years of the twentieth century we have (thank heaven!) the last significant organizational idea in both painting and music—Picasso's analytical cubism, and a decade later, Schoenberg's principle of composing with twelve tones. (Webern is even more related to Cubism in its formal fragmentation.)[1]

Wassily Kandinsky should also be noted as an artist affected by Schönberg's atonality, painting *Impression III (Concert)* (1911) in homage to a Schönberg concert he attended in Munich and even striking up a correspondence with the composer.[2] As it would in music, the influence of twelve-tone composition and serialism would be felt in painting well into the twentieth century; Karin v. Maur has likened the restricted palette of yellow, red, blue, black, white, and gray and limited directions (horizontal and vertical) of Piet Mondrian's "systematic compositions" to "such principles of Schoenberg's serial technique as symmetry, inversion, or retrogression" and observed that "the isolation of elements and their deployment in a systematic way" by Bauhaus artists such as Paul Klee and Joself Albers "corresponded to the field of music, to the isolation of sounds and their egalitarian treatment in serial composition."[3] Kandinsky was an authentic synaesthete, seeing colors upon hearing music, while Albers related color theory to tonality. However, in the Dada era, there is not just a concurrence of stylistic developments in music and art, or transliterations between sound and color, but visual artists make a direct application of their aesthetic to music, as both Marcel Duchamp and Kurt Schwitters turned to sound as an additional forum for their output. It would arguably not be until the advent of musiqe concrète that modern music would come up with a comparable genre. Beyond the readymades, Duchamp's advocacy of ideas over technical mastery of drawing or painting hovers over untrained musical forays by artists over the ensuing decades. Duchamp's famous dictum "No more masterpieces" reverberates in his three composed works, produced in 1913. *Erratum Musical* is scored for three voices. Each performer is given one of three sets of twenty-five cards and one

note is indicated per card. The cards were originally thrown in a hat by Duchamp, picked out one at a time at random and then written down (well ahead of the chance operations of Cage). *The Bride Stripped Bare by Her Bachelors, Even* is an unfinished work for "player piano, mechanical organs or other new instruments for which the virtuoso intermediary is suppressed." Numbered balls are dropped through a funnel into open-ended cars, again representing note values. Finally, *Sculpture Musicale* merely consists of a note on a small piece of paper.

Sound poetry, pioneered by F. T. Marinetti and Hugo Ball, took the Dada penchant for nonsense to a linguistic conclusion that was enacted with oral performativity. Upon hearing Raoul Hausmann's sound poem "fmsbw" in 1921, Schwitters, no doubt recognizing a counterpart to his collage technique, began including it in his lectures and eventually developed his own piece, *Sonate in Urlauten*, also known as *Ursonate* (1922–1932), which grew to four movements, including an introduction, cadenza, and a finale. He performed the piece himself ("Listening to the sonata is better than reading it. This is why I like to perform my sonata in public") and gave minimal instructions to other potential performers ("You yourself will certainly feel the rhythm, slack or strong, high or low, taut or loose. To explain in detail the variations and compositions of the themes would be tiresome in the end and detrimental to the pleasure of reading and listening, and after all I'm not a professor"). No pitches, tempi, or dynamics are indicated, just phrases like "Lanke trr gll." Sound poetry "made by and for the tape recorder," as Henri Chopin put it, comes of age in the late 1950s and early 1960s in the wake of both concrete poetry and musique concrète, and was documented extensively in Chopin's *Revue Ou* periodical, which included recordings by the form's major figures, such as Lettrists Francis Dufrene and Gil Wolman, Bernard Heidsieck, Åke Hodell, Sten Hanson, Mimmo Rotella, Bob Cobbing, Brion Gysin, Charles Amirkahanian, and Chopin himself. (Finding "sound art" on the cover of the book *Something Else Yearbook 1974*, an anthology of intermedia works published by Dick Higgins's Something Else Press, atop a somewhat tongue-in-cheek list of content subjects ("unspeakables" and "commerce" also appear), sound artist and researcher Bernhard Gal confirmed that the book's editor, Jan Herman, used "sound art" in reference to Heidsieck and Chopin's contributions. Gal further notes the term's "connection with 'text-sound-art,' better known as 'text-sound-composition,' synonymous terms describing the 'intermedium' of poetry and composition that emerged from the creative humus of the Stockholm-based art organization Fylkingen during the late 1960s."[4] The book also has entries from Alvin Lucier and composer Pauline Oliveros, which Herman may also have been mindful of as "sound art.")

Although Duchamp's music compositions coincided with the beginnings of his readymades, they have no equivalence to them. Thirty years later, Yves Klein's *Symphony of Monotone-Silence 1949–1961*, which sustains one chord and a silence for an equal length of time, was conceived at the same time as his monochrome paintings and evidence an aesthetic that could be interpreted through both music and visual art. Not finished until 1961, it was performed, in its final version, as nude models bathed in blue paint created body prints on the floor while a tuxedoed Klein conducted a twenty-two-piece ensemble with twenty singers. Jean Dubuffet also began carrying his Art Brut aesthetic of the 1950s into the aural realm in late 1960, initiating improvisations with Asger Jorn. Despite some previous musical experience, "we were intending to use instruments in such a way as to obtain new sounds from them. Besides a piano (not a very good one) our instruments were a violin, a cello, a trumpet, a recorder, a Saharan flute, a guitar and a tambourine," and the pair later added a hurdy gurdy, horns, xylophone, zither, cabrette (Auvergnat bagpipes), and bombarde (a kind of oboe)—"things we came upon by chance."[5] Dubuffet was not conversant with Cage or aleatory trends in modern classical composition, and he soon took to overdubbing all the instruments himself. The resulting recordings are a bracing early example of modulated cacophony.

Figure 3.1 Jean Dubuffet playing the Chinese trumpet, Paris 1961 © Archives Fondation Dubuffet, Paris/photo by Jean Weber.

Dubuffet's experiments proved to be an archetype for nonmusician visual artists playing "noise" music. Abstract Expressionist painter Karel Appel ventured into a recording studio in 1963 to create a soundtrack for a documentary about himself. Attacking a variety of instruments, including percussion, piano, and electric organ, he made several musique concrète pieces from the results, released on LP as *Musique Barbare*. The year before, the Artists Jazz Band started in Toronto. Comprised of painters Graham Coughtry, Harvey Cowan, Terry Forster, Jim Jones, Nobuo Kubota, Robert Markle, Gerald McAdam, Gordon Rayner, and later joined by Michael Snow, the group was inspired by free jazz and produced a social outlet for the artists as well. The Isaacs Gallery released a double album in 1973 that came with a limited-edition set of prints, one by each artist. A little south of Toronto in London, Ontario, artists Greg Curnoe, John Boyle, and Murray Favro formed the Nihilist Spasm Band in 1965, similarly in homage to free jazz improvisation, and psychedelic rock, although unlike the Artists Jazz Band they had no musical training ("Even if we wanted to play 'Melancholy Baby,' we couldn't," reads the liner note to their album *Vol. 2*). Armed with homemade electric kazoos, guitars (some made by Favro), drums, vocals, violin, and electronics, they've played every Monday night in London for the past fifty-plus years and despite the passing of Curnoe and long-time bassist Hugh McIntyre, they show no sign of stopping.

Nonmusicians making noise collectively has become integral to the performances of artist Herman Nitsch. Based in Austria, Nitsch is the originator of the Orgien Mysterien Theater. Since the 1960s he has staged *Aktionen* (German for "actions," used as a term for performance art activity) involving bloodletting, other bodily fluids, animal carcasses, crucifixions, etc., staging a ritualistic catharsis event that can last several days. Nitsch enlists horns, organ, percussion, choirs, and other noise-making devices that sustain tones in an enveloping semi-cacophony. He has also composed numerous droning organ and harmonium pieces, as well as several symphonies, which employ the "noise orchestras" of the *Aktionen* plus brass bands, folk bands, and choirs. Nitsch and fellow Vienna Actionist Günter Brus occasionally joined artist Dieter Roth, poet and playwright Gerhard Ruhm, and writer Oswald Wiener in playing music together under the name Selten Gehorte Musik, documented by Roth on a series of gallery edition LP box sets. Roth had been developing a sound alphabet since the 1960s and went on to give riotous solo concerts on multiple instruments. He also issued a twenty-four cassette collection of dogs barking and later made assemblages using keyboard instruments.

In 1978, while still a student at Cal Arts, artist Mike Kelley performed in a Nitsch Aktion noise orchestra. He had already been in the artists' noise band Destroy All Monsters with Jim Shaw, Cary Loren, and Niagra in Detroit from 1974 to 1976. Looking back on that period, he told an interviewer:

> My early interest was to try and make sculpture out of a rock band situation. I had discovered pictures of Joseph Beuys's more musical performance pieces and I was really interested in how all the equipment he used was sculpture. I was also intrigued by the pictures I'd seen of John Cage's performances, where his equipment with all of the wires was left lying around like post-Minimalist sculpture. I said, "Let's try and do something like that, but mix it with the ridiculousness of a theatrical rock band like Alice Cooper."[6]

At Cal Arts he teamed with video artist Tony Oursler for another band, The Poetics. Originally attempting songs, the two revised their thinking to create imaginary film soundtracks. Kelley took up percussion for the venture, and a variety of other members came and went. This too became the basis for a series of mixed-media presentations in the 1990s under the name The Poetics Project, some of which included video interviews with underground rock musicians. Kelley recruited the band Sonic Youth for a performance piece called *Plato's Cave, Rohtko's Chapel, Lincoln's Profile* in 1986; later, he collaborated with Scanner on an installation for the *Sonic Process* exhibition and formed a group called Gobbler with video artist Cameron Jamie and performance artist Paul McCarthy (there was also a trio with McCarthy and Japanese noise musician Violent Onsen Geisha). In one of Kelley's most sprawling mixed-media installations, *Day Is Done* (2005), music is heard everywhere (reviews consistently used the word "cacophony" in describing the exhibition).

Rauschenberg, Cage, and Fluxus

Embracing not only a range of visual media but also performance and dance, Robert Rauschenberg stood at the forefront of the dissolving of aesthetic boundaries between high and low culture and the arts themselves in the 1950s, and exerted a major influence on many in the musical avant-garde of the time. Rauschenberg's white paintings were particularly inspirational to Cage's 4'33": "When I saw those I said 'Oh yes, I must; otherwise I'm lagging, music is lagging.'" Douglas Kahn elaborates: "He [Cage], noticed how, on a canvas of nearly nothing, notably absent of the expressive outpourings characteristic of the time, another

plenitude replaced the effusiveness in the complex and changing play of light and shadow and the presence of dust. Correspondingly, environmental sounds rushed in to fill the absence of music sound in *4' 33.'*"[7] Karlheinz Stockhausen also cites the unifying found objects in Rauschenberg's Combines as an influence on his *Kontakte* and *Gesang der Jünglinge*, while Morton Feldman recalled that when composing his later piece *The Viola in My Life* "my intention was to think of melody and motivic fragments—somewhat the way Robert Rauschenberg uses photographs in his painting—and superimpose this on a static sound world more characteristic of my music."[8] Invited to provide music for a Rauschenberg dance performance in the 1964 series *Five New York Evenings* at the Moderna Museet in Stockholm, David Tudor attached contact mics to 200 fluorescent lights in the museum's space, calling the piece *Fluorescent Sound*. As part of Experiments in Arts & Technology (E.A.T.)'s *Nine Evenings* series two years later, Tudor staged *Bandoneon!* (*A Combine*), referencing Rauschenberg's Combines in the title. He played a bandoneon outfitted with contact mics, using the signals to trigger various lighting effects and video projections. He also put carts in motion via remote control–carrying special speakers that vibrated metal objects.

To a limited degree Rauschenberg also played a role in bringing sound further into the art world; he was a visiting student at Black Mountain College and participated in Cage's proto-Happening "Untitled Event" there in 1952, along with Tudor, choreographer Merce Cunningham, and poets Charles Olson and M. C. Richards. He put contact mics on his brushes while creating a painting titled *First Time Painting* during a 1961 event called *Homage to David Tudor* at Theatre de l'Ambassade des Etas Unis in Paris (Tudor performed Cage's *Variations II* simultaneously). His sculptural piece *Dry Cell* (1963) was included in *For Eyes and Ears*, a 1964 show at the Cordier and Ekstrom Gallery in New York. Visitors were asked to speak or make sounds into a microphone on the front of the work, which in turn was wired to a toy motor that activated a propeller-like piece of metal. This was made in collaboration with engineers Billy Klüver and Harold Hodges, who also worked on his assemblage *Oracle* (1965), where AM radios were placed in five different metal constructions, with visitors able to scan a radio dial randomly via remote control, á la Cage. Rauschenberg's 1968 piece *Soundings* had lights on a series of panels that could only be triggered by visitors making loud sounds, and in the slightly later *Mud Muse* (1968–1971) he made a kind of feedback loop in a vat of mud, using sound-activated pneumatic tubes responding to a recording of the mud burbling to push air that in turn creates the burbling.

Rauschenberg was thought to be an inheritor of Duchamp's, fusing the collage and readymade aesthetics in his Combines, and Cage, in his promotion of everyday sounds as potential compositional material, is often considered to be the music world's answer to Duchamp, a debt he acknowledges in 1947's *Music for Marcel Duchamp* (originally written for Duchamp's sequence in Hans Richter's film *Dreams That Money Can Buy*) and in a plexigram multiple with Calvin Sumsion, *Not Wanting to Say Anything about Marcel* (1969). Cage's *Living Room Music* (1940) shows the influence of the readymade—the instrumentation is "objects to be found in a living room." It can also be traced to his once-controversial championing of Erik Satie and his call for "a music which is like furniture ... which will be part of the noises of the environment, that will take them into consideration."[9] Cage was also doubtless aware of Satie's friendship with sculptor Constantin Brancusi and his collaboration with Pablo Picasso, Jean Cocteau, and Leonide Marsine on the ballet *Parade* in his own cultivation of acquaintances in the art world (including Duchamp, who he met in the 1940s).

Cage's engagement with the art world became even more pronounced with his teaching stint at the New School from 1956 to 1960. His course was in experimental music composition, but by welcoming those with no technical musical background or experience it attracted artists more than it did composers. Cage's gleanings from Duchamp and Rauschenberg and his understanding of art world currents were then reinjected back into the next generation of downtown New York artists. Allan Kaprow, one student in the class, had moved from action painting to environments, rooms filled with objects for an audience to interact with (in one instance including five tape recorders playing electronic sounds made by Kaprow[10]), an early post-Dada example of installation art. In Cage's course Kaprow developed the idea into the more theatrical Happenings, influenced by Cage's description of the multimedia Black Mountain College event.[11] Several of Cage's other students– George Brecht, Jackson MacLow, Al Hansen, Dick Higgins—became active in the Fluxus art movement in the early 1960s, introducing neo-Dada music/theater pieces that are likewise informed by action painting and the Black Mountain College event. Brecht was a painter who had already been using chance operations in his work before enrolling in Cage's course; he began composing music pieces that he called "events." His *Motor Vehicle Sundown (Event)* arranged for a number of cars to meet at dusk, with a set of instruction cards providing direction for a number of actions, aural or not, related to the functions of the car.[12] Brecht's *Solo for Violin* (in which the performer polishes the instrument) and *String Quartet* (in

which the performers simply shake hands) follow Cage in the upending of concert performance expectations and etiquette, while *Drip Music (Drip Event)* (in which water drips into an empty vessel) and *Comb Music (Comb Event)* (which directs a performer to move their finger along a comb and activate its prongs) are indebted to Cage's "all sounds are music" philosophy.

Composer La Monte Young had, independently, come up with a series of instruction pieces in 1960, including *Composition 1960 #2* ("build a fire in front of the audience"), *Composition 1960 #4* ("announce to the audience that the lights will be turned off for the duration of the composition (It may be any length))", and *Composition 1960 #5* ("Turn a butterfly (or any number of butterflies) loose in the performance area"). Young had sent the pieces to Brecht shortly after his move to New York the same year, and they caught on with what became the Fluxus crowd. Yoko Ono, who had audited Cage's class when her then husband, composer Toshi Ichiyanagi was a student, had been doing instruction pieces for both painting and music (paintings to be stepped on or slept on, tape pieces for "the sound of the stone aging," "the sound of the room breathing," or "the sound of the stars moving"). Dick Higgins's *Danger Music* series offered instructions with little or no aurality involved at all (number one read "Spontaneously catch hold of a hoist and be raised up at least three stories," number two "Hat. Rags. Paper. Heave. Shave," while number three dispensed incense among the participants and number eight advised to "Play it Safe"). Alison Knowles's event scores not only employ simple gestures (shuffling, applying hand lotion, making a soup or salad) but also can be more complex (*#17, Color Music No. 1 for Dick Higgins* asks the performer to list five problems and corresponding solutions and colors, and then to concentrate on the color if the solution cannot be immediately enacted).

These pieces in effect respond to the inaction of the concert performer of *4'33"*, suggesting a seemingly infinite number of activities whose performance could be construed as music, whether they made a sound or not and whether they took place in a concert hall or not. Cage's own "answer" to the event scores/instruction pieces of his students, and indeed dedicated to Ichiyanagi and Ono, was *0'00"* (1963), which called for the amplification of a "disciplined action" that could not be interrupted, repeated in a subsequent performance, or involve a music composition (it was even subtitled *4'33" No. 2*). Its titular lack of a specified time duration also edges toward the open-ended temporality of sound installation, even if it still prescribes a performative gesture. Cage, though, later stressed the quotidian nature of the piece rather than its theatricality, commenting that it

should be performed "without any notion of concert or theatre or the public, but simply continuing one's daily work."[13] Cage's *Variations III*, composed around the same time, reverts to his use of chance operations with circles on transparencies to be overlaid on a blank piece of paper but never mentions sound, as the score indicates that the piece is "for any one or any number of people performing any actions." In the late 1960s, Cage orchestrated more elaborate Happening-type multimedia events like *Musicircus* (1968) or *HPSCHD* (1967). As time went on, Cage became more politically engaged and began to see his ideas in terms of human nature and behavior. As Feldman wrote, "Cage's idea, summed up years later as 'Everything is music,' has led him more and more towards a social point of view, less and less towards an artistic one … Cage gave up art to bring it together with society."[14]

Fluxus's musical excursions, mostly "noise," were made by a mix of trained and untrained musicians, as befitted its roots in Cage's course. La Monte Young organized a proto-Fluxus concert series at Yoko Ono's loft starting in December 1960, once a month until June 1961, which included Terry Jennings, Toshi Ichiyanagi, Henry Flynt, Joseph Byrd, Jackson MacLow, Richard Maxfield (who took over Cage's course at the New School), Simone Forti, Robert Morris, and Dennis Lindberg. This was followed by another series at Fluxus CEO George Maciunas's A/G Gallery in spring of 1961 which gave nights to Maxfield, Cage, Storm de Hirsch, Ichiyanagi, MacLow, Byrd, Young, Flynt, Walter de Maria, and Ray Johnson, plus a painting show by Ono. There was also a similar lineup at Living Theatre concert in 1960 featuring pieces by Kaprow, Brecht, Johnson, Maxfield, Cage, Hansen, and Rauschenberg. Maciunas continued to do Fluxus concerts, including one at Carnegie Hall in 1965 by the Fluxus Symphony Orchestra, but as a self-described "combination of Spike Jones, vaudeville, gags, children's games, and Duchamp,"[15] Fluxus music is still in the tradition of Dada performance, strongly influenced by Cage's concert hall antics. As Fluxus created its own everyday objects (tickets, toys, furniture, etc.) as well as films, books, prints, poetry and paintings, it followed that music would be another one of its by-products.

Like the Cabaret Voltaire and other Dada-era performances, Fluxus pieces did not require musical training to perform, yet several Fluxus participants have musical backgrounds.

Nam June Paik studied music, wrote a thesis on Schönberg, and worked in the electronic music studio at WDR. He gave various Cage-inspired piano performances between 1959 and 1963, and his first major exhibition with the

TV sets he was to become known for was entitled *Exposition of Music-Electronic Television* (1963), which signaled his departure from music making as his primary activity. (The exhibition also included prepared piano, mechanical sound objects, *Schallplatten Schaschlik* (1963), a record-playing sculpture that suspended several records in air and was equipped with a free-floating tone arm that facilitated switching back and forth between records, and *Random Access Music* (1963) in which the viewer could run a detached tapehead across tape hung on the wall.) He had a long-standing collaboration with cellist Charlotte Moorman and gave occasional music performances, either solo or in collaborations with Joseph Beuys, Takis, and others.

Philip Corner studied music with composers Henry Cowell and Olivier Messiaen. While doing his share of graphic scores and text instruction pieces, Corner has also composed over four hundred works for gamelan and numerous piano pieces, as well as much poetry, calligraphy, and visual art. Jackson MacLow had studied composition and several instruments extensively by the time he arrived in Cage's class; although perhaps best known for his poetry (he served as Fluxus's literary director) he made numerous music compositions, both deterministic and aleatory, as well as text-sound pieces and sound poetry.

Joe Jones began as a jazz drummer and studied at the Hartnett School of Music. Finding little call for his skills in the jazz scene he investigated experimental music, studying with Cage at the New School and then Earle Brown (after Cage's class was canceled due to under-enrollment). They introduced him to Dick Higgins and Alison Knowles. Jones sublet their studio and began building his music machines out of broken toy instruments, and performed on them, at Knowles' suggestion, at the pre-Fluxus Yam Festival organized by George Brecht and Bob Watts, meeting Al Hansen and many of the other people later affiliated with Fluxus. Later using the brand name "Tone Deaf Music Co.," these toy-like contraptions would be performed by Jones en masse, resulting in crazy quilt soundscapes that were glittering and animated yet hardly seemed to go anywhere, a sonic stasis. They sound much like the sounds produced by Jean Tinguely's machines, only far less explosive.

Takehisa Kosugi studied musicology in college, although he had no formal training on the violin, his chosen instrument. Kosugi was interested in improvisation and chance methods in the very early 1960s, and unaware of Cage, formed a free improvisation group, Group Ongaku, with literature student Yasunao Tone in Tokyo in 1960 (which predates the Cage-influenced free improvisation scene in Europe by a half-dozen years). Tone notes, "We thought,

then, our improvisational performance could be a form of automatic writing, in a sense that the drip painting of Jackson Pollock was a form of automatic writing ... The question I posited then was, could Duchamp's *Paris Air* or urinal be translated into musical performance. That led us to use everyday objects as instruments."[16] Tone did pick up saxophone for the group, though he had no music training. Tone made his first sound installation in 1962 for an annual group art show, Yomiuri Independent Salon, a looping tape recorder covered in white cloth so as to appear invisible. Also participating in concerts by Yoko Ono and Toshi Ichiyanagi, Tone managed to get his score for *Anagram for Strings* (a graphic score composed of all glissandi) to George Maciunas, who published it, and Tone subsequently organized a Fluxus week in Tokyo in 1965. Kosugi also participated in Fluxus and made several instruction scores in the mid-1960s, including *Theatre Music* ("Keep walking intently") and *Micro 1* (in which a microphone is wrapped in paper and amplifies the sound of the wrapping unraveling). He also had an early sound installation, *Catch-Wave* (1967), in which he suspended transmitters and radios from the ceiling, with their waves interacting and causing interference, initially through people's movement in the space and later with aid of electric fans to make a continuous movement of air currents. Ultimately, he replaced Cage as the musical director of the Merce Cunningham Dance Company.

Joseph Beuys was a sometime Fluxus participant and had a background in violin and cello. His *Siberian Symphony* (1963) was his first Fluxus performance in Dusseldorf; there was a piano solo, then a Satie piece was played as Beuys hung a dead hare on a blackboard, stuffed the piano with clay and branches, and finally removed the hare's heart. He also collaborated extensively with composer Henning Christiansen, who was affiliated with Fluxus, and created a series of sound-oriented sculptures—*Bone Gramophone* (1958), *Homogeneous Infiltration for Piano* (1966), and *The Noiseless Blackboard Eraser* (1974).

Wolf Vostell defined his "de/collage music" as "all noises which are propagated when a form is destroyed."[17] Indeed, he did a version of Satie's *Furniture Music* in which he smashed the furniture, and in the piece *Kleenex* (1962) he smashed one hundred lightbulbs. "When the light bulb is smashed," he has said, "it no longer produces light, but sound."[18] Vostell's other hijinks included a piece involving opening and closing a car door 750 times and having instrumentalists play torn up scores of classical pieces or "play" silences for every written note in a score.

Italian composer Walter Marchetti cofounded the ZAJ group with Juan Hidalgo in Madrid, who followed in the footsteps of Fluxus and also took part in their European performances. Calling his work "visible music," in one of his *Chamber Music* pieces (which number nearly 300), he lies asleep on a gallery floor, in essence taking the performative passivity of Cage's *4' 33"* to a logical conclusion, turning it into a temporary installation rather than a five-minute performance and transposing it into an art world context rather than that of classical music. Marchetti's late 1990s compositions for eight orchestras or eight instrumental ensembles or eight organs are a surprisingly rare example of conceptual sound art, in that it's unlikely that the pieces can be realized due to technical limitations.

A lesser-known visual artist acquaintance of Cage's was William Anastasi, who had a show of his "sound objects" at the Virginia Dwan Gallery in 1966 (Dwan was also a key supporter of Land art, hosting the epochal *Earth Works* show, curated by Robert Smithson, in 1968 and funding several key works by Smithson, Michael Heizer, and Walter De Maria). These were everyday items displayed alongside recordings of the sounds they make while functioning. *Sound Object [Radiator]*, 1964, is a resituated radiator with a recording of its previous operation playing through two speakers affixed to it, while *Sound Object [Deflated Tire]*, 1964, reverses the idea of Robert Morris's *Box with the Sound of Its Own Making* by taping the process of disabling an entity—deflating a tire—rather than its construction. In *Microphone* (1963), a reel-to-reel tape recorder plays back a tape Anastasi made of the same machine running, thereby doubling the live sound with a recorded one, and 1977's *The World's Greatest Music* recalls Cage's use of variable speed turntables in *Imaginary Landscape No. 1* (1939). Here, Anastasi places three dusty 78 rpm albums of Mozart, Wagner, and Brahms on portable children's record players with the needle in the runoff groove, each spinning at a different rate of speed. The 1963 series "Constellation Drawings" was executed while Anastasi listened to a recording of Bach's *The Well-Tempered Clavier*, allowing the length of the music to determine the duration of the drawing process itself. His method, which consists of closing his eyes and deliberately marking a piece of paper without following the rhythm of the music, echoes Cage and Cunningham's asynchronous approach to music and dance. (Anastasi met Cage shortly before the Dwan show and became closer to the composer in 1977, after a collaborative performance at the Clocktower Gallery led to daily chess games that continued for a number of years.)

Conceptual art, performance art, and records

Anastasi is considered one of the original Conceptual artists, and sound was often used by other Conceptualists of the 1960s. Joseph Beuys made a conceptual audio piece, the hour-long 1968 recording *Ja Ja Ja Ne Ne Ne* of himself, Henning Christensen, and Johannes Sttütgen saying "yes, yes, yes, no, no, no" over and over. The 1969 album *Art by Telephone* was the catalogue for an exhibition at MoCA in Chicago that never happened. *Art by Telephone* focused on voice as a medium for relaying Conceptual art projects; the artists (including John Baldessari, James Lee Byars, Hans Haacke, Richard Hamilton, Ed Kienholz, Les Levine, Sol LeWitt, Robert Morris, Bruce Nauman, Claes Oldenburg, Dennis Oppenheim, Richard Serra, Robert Smithson, and William Wegman) were not permitted to make drawings or written instructions for the pieces. The museum apparently recorded the instructions as relayed to them over the phone by the artists themselves, then failed to ever execute any of them due to technical difficulties. A slightly later example of an LP released documenting a Conceptual art conceit involving the telephone is Keith Sonnier's *Air to Air* (1975), made from recordings of a double installation at Leo Castelli in New York and the Ace Gallery in Los Angeles of an "amplified space installation with transmission systems for communications by long distance audio connection" in which staff and visitors could talk on an open line to the other coast without using a telephone, just a microphone and speakers. Robert Barry made two conceptual spoken word recordings, of non-sequitur words sparsely distributed, that were released by art institutions: *Otherwise* (1981, Van Abbemuseum) and *Sky Land Sea* (1997, La Villa Arson).

Other conceptual pieces used sound to investigate existence. Christine Kozlov's instruction piece *Information: No Theory* (1969) proposed a continually self-erasing tape recorder:

1. THE RECORDER IS EQUIPPED WITH A CONTINUOUS LOOP TAPE.
2. FOR THE DURATION OF THE EXHIBITION (APRIL 9 TO AUGUST 23) THE TAPE RECORDER WILL BE SET AT "RECORD." ALL THE SOUNDS AUDIBLE IN THIS ROOM DURING THAT TIME WILL BE RECORDED.
3. THE NATURE OF THE LOOP TAPE NECESSITATES THAT NEW INFORMATION ERASES OLD INFORMATION. THE

"LIFE" OF THE INFORMATION, THAT IS, THE TIME IT TAKES
FOR THE INFORMATION TO GO FROM "NEW" TO "OLD" IS
APPROXIMATELY TWO (2) MINUTES.

4. PROOF OF THE EXISTENCE OF THE INFORMATION DOES
IN FACT NOT EXIST IN ACTUALITY, BUT IS BASED ON
PROBABILITY.[19]

Sound here is an instrument in making time vanish from a recording, which is designed to render moments in time permanently, almost as quickly as it can in unmediated reality. The constant self-erasure mechanizes sound's ephemerality. It also suggests that the ambient sounds of the room, as in Cage's *4'33"*, have a mortality to them; its nullification of the recording process recalls that piece's negation of music performance in a concert situation (in Kozlov's piece, two minutes of sound is recorded before being erased).

Robert Barry used sound as a sign of the presence of the invisible. In his series *Inert Gas* (1969) he released containers of gas into natural environments, commenting to an interviewer on one iteration of Xenon released into the desert that the sound of the gas escaping the canister "is all we know of it being there."[20] Yet he documented the piece with photographs—"to deny the existence of visual evidence," as Alexander Alberro wrote[21]—not an audio recording. That an "invisible" piece would still be recorded with visual means is a conundrum that is probably intended as a deconstruction of visual practice, with sound being another invisible element. Barry also used electromagnetic waves from a radio station and a citizen's band transmitter in a gallery setting, which would only be detectable with the use of a radio (not included in the exhibition),[22] and made *Ultrasonic Wave Piece* (1968), installed as part of the *Software* show at the Jewish Museum in 1970, in which ultrasonic sound waves were "reflected off interior surfaces, filling selected areas with invisible changing patterns and forms."[23] Barry said his work featured "various kinds of energy";[24] they are readymades that are immaterial. But here the goal is not sonic art but an escape from visual art that diverts the viewer's experience to their other senses.

Similarly, the California Light and Space artists of the late 1960s turned to anechoic chambers to toy with sensory experience. Doug Wheeler's *PSAD Synthetic Desert III*, which was conceptualized in 1968 but not realized until 2017, used a series of doors and passways to isolate the space from outside noise and anechoic padding inside the space to provide as much sound absorption as possible, as visitors gazed out into a seeming void where diffused white light also unsettled their sense of distance. (When I visited the installation at the

Guggenheim Museum in 2017, a guard mentioned to me in conversation that another visitor had said they'd been reminded of Maryanne Amacher's work by it—presumably in terms of intensity since Amacher's sound pieces tended to be earsplittingly loud, although Amacher did have one piece that utilized nearly sub-audio frequencies that could have been perceived to be nearly as silent as Wheeler's project.) James Turrell and Robert Irwin, both also known for their light environments, made a project of visiting anechoic tanks in the late 1960s as an experiment in sensory deprivation; neither one produced work as a direct result of the experience. Their use of light as way to alter the perception of an otherwise empty space, though, is reminiscent of Neuhaus and Leitner's implement of sound to articulate space.

Michael Asher, taking an even more severe approach to reimagining an emptied room, initially used sound to help shift perception when modifying a preexisting space. His practice of making "interventions" within a specific indoor environment, most notoriously by removing the front door of a gallery or the wall separating its office from the exhibition space, were seminal gestures in what later became known as institutional critique. In an 1969 exhibition at La Jolla Museum of Art, he adjusted the room acoustically by putting down carpet to dampen sound while at the same time having an audio oscillator vibrate the other surfaces, forming a dead spot in the center of the room as the frequencies cancelled each other out. The same year he did another installation as part of the *Spaces* group show at the Museum of Modern Art in which he eliminated acoustic reflection and reverberation completely, while going the opposite direction for a 1970 gallery show in Pomona, in which he removed the door, allowing sounds from the street to fill the space, accentuating it by the construction of a narrow passageway between a small and larger room that functioned as a funnel for the sounds.

Performance art emerged in the same era, with the same devaluation of the art object. Vito Acconci had straddled the art and poetry worlds as co-editor of the magazine *0 to 9*, whose contributors included Conceptualists (Robert Barry, Sol Lewitt), Land artists (Robert Smithson, Michael Heizer), Fluxus associates (Jackson MacLow, Emmett Williams), and New York School poets (Ted Berrigan, Kenneth Koch, Aram Saroyan). He made tape pieces in the late 1960s as he was leaving poetry and transitioning to performance and video. *Running Tape*, made in Central Park in 1969, is a sound document of a performance piece, termed a "tape situation" by Acconci, of himself running in the park, counting his steps aloud. Most of his audio work is dominated by spoken word—not surprising

as he was originally doing poetry readings. But Acconci felt that sound and performance led him off the page and away from the writer's desk—so in his case, sound can engender embodiment as well as disembodiment. Acconci made many installations that include audio, usually in the form of monologues addressed to the audience, such as *Air Time* (1973) (consisting of a series of wooden boxes containing tapes, each one a "radio station"—Acconci calls the tapes "radio programs" that relate stories to the installation viewers), *Other Voices for a Second Sight* (1974) (literally set as a radio studio, with Acconci portraying an all-night DJ, playing light jazz like Chick Corea as well as the Velvet Underground's "White Light White Heat" but mostly talking through a series of thirteen "programs," touching on autobiography, political history, and science fiction), and *The American Gift* (1976) (Acconci conducting language drills addressed to Europeans, on the occasion of America's bicentennial, with clips from the "Voice of America" radio program, Aaron Copland music and the sounds of gunshots, a woman's scream, and airplanes). Later installations have more extensive visual components, using swings (*Another Candy Bar from GI Joe* (1977), *The People Machine* (1979)), red, white, and blue temporary walls (*Gangster Sister from Chicago* (1977)), and a ladder in the Whitney Museum stairwell (*Tonight We Escape from New York* (1977)), with more spoken audio.

An artist of the time who moved into performance from Conceptual art (and Land art) was Dennis Oppenheim. Like Acconci, Oppenheim did a series of performance pieces centered around his own body, but quickly proceeded to performance works that would have a substitute for his own physical participation. Oppenheim did an untitled 1973 performance in which he placed a dead dog on top of an electric organ, which would theoretically produce sound by holding the keys down with its weight until its body deteriorated into nothing. Oppenheim's *Attempt to Raise Hell* (1974) has a marionette bang its metal head into a bell (drawn by magnets) over and over, creating a clanging sound, while *Theme for a Major Hit* (1974) has another puppet, also controlled by magnets, move to a pop song written and performed by Oppenheim.

Terry Fox was another body-oriented performance artist, doing pieces that tested his physical endurance (fasting, not sleeping, trying to levitate), whose work with sound proved to be longer-lived, extending well into the 1990s. After doing one performance in Dusseldorf with Joseph Beuys (*Isolation Unit*, 1970, also released as an album), where he used two iron pipes to produce sound waves that would affect both other elements of the space (the windows) and other objects in the performance (a candle's flame), he decided to increasingly

integrate sound into his performances and work, proclaiming that "sound is sculpture." During Documenta 5 in 1972, he performed *Action for a Tower Room*, playing a tamboura six hours a day for three days to fully test the room's acoustics. As part of his *Labyrinth* series of works modeled after the floor plan of a labyrinth at Chartres Cathedral (1971–1978), he made a recording that has been anthologized in several collections of artists' music in which he mixed the sounds of eleven cats purring according to a score assigning each cat to one concentric ring of the labyrinth. He also made a score from Berlin's map for piano wires, helicopters, and barking dogs, as well as *The Berlin Wall Scored for Sound* (1980–1982) in which six acoustic sounds go in an endless loop (like the Wall). In the 1987 installation *Instruments to be Played by the Movement of the Earth*, he fashioned structures that would be sensitive to seismic tremors or vibrations caused by passing trucks and make sounds as a result; one was a stack of glasses and glass plates, another a funnel filled with dried peas that would fall into a Chinese wok at the slightest vibration. In some of his 1990s pieces he created standing sound waves in a room utilizing only tubes and empty bottles.

Charlemagne Palestine, a composer-performer often associated with Minimal music, was also active in performance art, video, and drawing. Influenced by Rothko's color field paintings, in 1967 he began experimenting with oscillators to create electronic fields of sound, with minute changes in overtones apparent only through assiduous listening. In the early 1970s, he became known for the piano pieces he'd developed, particularly "Strumming Music," an additive-process piece in which he hammered out a vigorous tremolos, producing a cloud of overtones floating above the fray of his keyboard attack. He also entered the art world at this time, as Sonnabend Gallery released a double album, *Four Manifestations on Six Elements*, produced several videos, and exhibited drawings. Palestine did gallery performances, some documented in his videos, in which he ran around holding a single tone vocally as he barreled into walls; this fit in with the body art of the time (e.g., Acconci, Oppenheim, Fox, Chris Burden) but also was an experiment in acoustics and sound perception. Similarly, in the video *Island Song* (1976) he holds a single tone while riding a motorcycle; eventually he arrives at the other end of the island, his voice in sync with a foghorn emitting the same pitch. Burned out on performance and dispirited by the commercialization of Minimalism, Palestine's activities shifting to sculpture and mixed media in the early 1980s, retaining the stuffed animals he often surrounded himself with during his concerts. He returned to music-making in the 1990s while maintaining his art practice.

Performance artist Laurie Anderson trained as a classical violinist but received a degree in art history; later she completed an MFA in sculpture and wrote art criticism. Anderson was exhibiting "sound sculptures," little boxes containing tape loops placed on stilts, as early as 1970. Her 1975 performance piece *Duets on Ice* found her playing violin along to a prerecorded tape in the street, wearing ice skates with two blocks of ice fastened to them on a summer day; the performance ended when the ice had melted. The next year she also started performing on a self-invented instrument, the Viophonograph, that mounted a battery-powered record player where the bridge would be on a violin. Using a bow with a phonograph needle embedded in the middle, she would play 7" records of recordings of her own voice or of violin sounds. This was replaced by the Tape Violin Bow, another invention where she replaced a violin bow's horsehair with recording tape and installed a tape head in the violin, so by drawing the bow back and forth she could play an audio tape forwards and backwards.

Figure 3.2 Laurie Anderson, *For Instants* (1976). Courtesy Vito Schnabel Projects.

In early 1977, Tom Johnson reviewed a gallery show by Anderson in which she installed a jukebox with twenty-four singles of her music on it and pencil-written texts accompanied by single photos. Admitting he was slightly aware of her reputation as a performance artist but had never seen her perform, Johnson was coming to the show cold. He noted that most of the singles had vocals on them (hers) and were produced "quite professionally."[25] He concluded with "one basic question: Is the gallery situation necessary to the music?" and contends:

If it is necessary, then the music should only be discussed as an element in a multimedia exhibit, and it certainly should not be issued on an ordinary LP, as it apparently will before long. On the other hand, if the music has its own integrity, then why bother to put it in a gallery situation? Why not just present it as music?

One can't generalize about such things because so many works do function in more than one medium. Ballet scores become pure orchestral pieces, operas become record albums, books become movies, sculptures become theatre sets, and there is no reason why a gallery exhibit shouldn't occasionally become a recording. Usually, however, works have to undergo a great deal of translating, revising, and adapting before they really come alive in a second medium. In Anderson's case I sensed a bit of opportunism, an attempt to have it both ways, and I sense a bit of cynicism in my response. I just can't stop suspecting that maybe the exhibition was a covert publicity stunt, an attempt to con us into noticing some music that we probably wouldn't have paid much attention to in a more conventional presentation.[26]

While there may have been a self-promotional element to the show, as Johnson indicates, it did make a statement that the same music that worked in the Kitchen (New York's premiere "New Music" venue at the time) should work in an art gallery. This doesn't make it sound art, but it does support the idea of a gallery as a listening space. For what it's worth, artist Jack Goldstein had already made and exhibited his own 45s of sound effects the year before (not to mention Fluxus artist Ben Vautier's found 45s with his own labels, from the mid-1960s). Additionally, composer Philip Glass, who had already used work by Alan Saret and Sol LeWitt on his album covers in the early 1970s, ran a label, Chatham Square, with gallerist Klaus Kertess. (Glass had also worked as an assistant to Richard Serra in the late 1960s, and the two collaborated on a sound installation in 1969 called *Word Location Project*, which set up speakers spread out over a thirty-one-acre site in Long Beach Island, NJ, that played different words related to a current state of being (e.g., "is")). Composer Steve Reich had worked with John Gibson Multiples to produce an early double album edition of his piece *Drumming* in 1971. If galleries could release records, why not exhibit them? Indeed, the first exhibition of artists' records, *The Record as Artwork 1953–1973*, comprised of 100 records from curator Germano Celant's own collection, had opened at Royal College of Art, London, in 1973 and traveled in expanded form as *The Record as Artwork: From Futurism to Conceptual Art* in the United States several months after Anderson's Holly Solomon exhibit.

The double album *Airwaves*, featuring artists' recordings, was also released in 1977 and includes Anderson's calypso pop number "It's Not the Bullet That Kills

You, It's the Hole," inspired by Chris Burden's *Shoot Piece*, Vito Acconci crooning a tango, one of Meredith Monk's more plaintive vocal/piano songs, and Jim Burton's country-western instrumental "High Country Helium"—so Anderson clearly wasn't the only artist intrigued by pop songs. Acconci had earlier made a video called *Theme Song* (1973) in which he sang along with pop songs on a cassette player and addressed the viewer as if he was using the lyrics to woo them and had also selected Anderson for an exhibition at Artists Space in 1974. Anderson went on to land a recording contract with Warner Brothers, and while she has only scored one cult hit ("O Superman") she nevertheless remains a major label recording artist and crossover signifier. Since then, visual artists like Julian Schnabel, Albert Oehlen, Martin Kippenberger, Martin Creed, Stephen Prina, and Kai Althoff have released albums of their songs, or others, but Anderson's only successor as a European chart-maker was Fischerspooner. Originally a duo of Warren Fischer and Casey Spooner who met at the Art Institute of Chicago, their ranks soon ballooned up to twenty with dancers and guest vocalists. Their over-the-top electro-pop performances in galleries caused a sensation in the art world in the early 2000s. They had a hit in Europe with "Emerge" and signed to Capitol Records; subsequent albums charted high on *Billboard*'s electronic charts, but not in the top 200.

Lesser-known as a crossover artist, Alan Vega was famed as the vocalist in the scarifying proto-punk duo Suicide, but started as a painter and then a light sculptor, and continued his art practice over the band's four-decade lifespan. Suicide's third gig took place at OK Harris in 1971 during an exhibition of Vega's light sculptures there; he also showed at Barbara Gladstone in 1983 and Deitch Projects in 2002, but despite the interest from high-profile gallerists Vega's art career remained obscure in his lifetime while his music attained legendary cult status. A correspondence can be discerned between the structures of his sculpture (lights, electronics, and sundry debris attached to chewed-up two-plank crosses) and his songs (streetwise lyrics over a distorted two or three note repeated figure played on rickety electronics and an obsessive, hypnotic beat). Vega made the lines between his music and art fluid; Suicide songs "Ghost Rider" and "Rocket USA" are invoked by the Ghost Rider and rocket ship stickers on late assemblages *Holy Ghost* (2016) and *Magister Ludi* (2007), respectively; the flickering Christmas tree lights in *American Supreme* (2016; also the title of a 2002 Suicide album) have the same unrelenting pulsation as Suicide's rhythm box; and the chain attached to *Bill Dee* (2013) recalls the bike chains Vega wielded onstage in Suicide's confrontational early concerts.

Conceptual artist Hanne Darboven went further in establishing a dual visual and music aesthetic, if not career; taking structuralism to an interdisciplanary next level, she literally translated her drawings, which consisted of reams of odd mathematical calculations based on the calendar, into music by converting numbers into note values and harmonies. Her drawing practice began in the late 1960s and it was not until the 1980s that she made her "mathematical music" adaptations. The music recalled the Minimalist music of Reich or Glass, with highly repetitive motifs and variations, and of course had the advantage that much music has a numerical basis to begin with not only in rhythm but in scales; standard music notation operates on a mathematical system. Even more than Klein or Dubuffet, Darboven melded sound and visual into one, with only sound sculpture being a more seamless fusion.

Early video art

Artists were attracted to the newly available Sony Porta-pak video recorder in the late 1960s/early 1970s, leading to the advent of single-channel video installations. This brought the moving image away from cinemas or television into the art world, but like Earthworks (and sound art), video art had difficulty attracting collectors. Also, as some sound artists do not come from a background in music, many video artists do not have a background in film. In fact Nam June Paik, Bill Viola, Bruce Nauman, Charlemagne Palestine, Tony Conrad, Tony Oursler, Gary Hill, Steina Vasulka, Paul McCarthy, and Mike Kelley all worked in sound and/or visual arts before (and sometimes after) turning to video; Arnold Dreyblatt started in video and then worked with sound and then, intermedia.

This is not surprising, given Bill Viola's analysis of video and electronic sound that lays out their structural affinities:

> The video image is a standing wave pattern of electrical energy, a vibrating system composed of specific frequencies as one would expect to find in any resonating object. ... Technologically, video has evolved out of sound (the electromagnetic), and its close association with cinema is misleading since film and its grandparent, the photographic process, are members of a completely different branch of the genealogical tree (the mechanical/chemical). The video camera, as an electronic transducer of physical energy into electrical impulses, bears a closer original relation to the microphone than to the film camera.[27]

Viola also notes that "musically speaking, the physics of a broadcast is a type of drone. The video image perpetually repeats itself without rest at the same set of

frequencies."[28] Viola relates it to the increased familiarity of drone-based Indian music in the West—which also surfaced in the use of drones and/or repetitions in sound works and installations from the same era as video art (La Monte Young in particular being heavily influenced by Indian music).

Figure 3.3 Bill Viola setting up David Tudor's *Rainforest IV*, Chocorua, NH 1973. Photo by John Driscoll. Courtesy John Driscoll.

Viola was involved in electronic music, with the Moog synthesizer, and his own self-built sound-producing electronic circuits, while also studying video and experimenting with techniques like feedback and using oscillators to create video interference. He worked extensively with David Tudor on a production of *Rainforest IV*, making field recordings and assisting in the setup. Viola did sound installations like *Hallway Nodes* (1972) that used sound waves to create a physical sensation—in this case having two loudspeakers at opposite ends of a corridor producing sine tones that intersect at distinct points (nodes), which can be felt more than heard. (Bruce Nauman also made several corridor pieces, not always involving sound, but *Diagonal Sound Wall (Acoustic Wall)* (1970), which does not produce any external sound, is designed to make the visitor feel changes in air pressure as they walk past an erected diagonal wall that becomes closer and closer to the gallery wall.) Viola views the ability to project an image as a factor in his shift to video from music in that it "freed the image

from the monitor box and expanded it to the architectural scale of both the room, and more importantly, of the human body."[29] Nevertheless, sound plays an important role in many of his early video works, such as *A Non Dairy Cremer* (1975), in which the soundtrack emphasizes "every minute noise connected to human presence and activity"; *A Million Other Things* (1975), once described as "the direct recording of different sounds and situations of light articulates the otherwise fixed framing of a man near a warehouse overlooking a lake"; and in *The Space between the Teeth* (1976) "the movement of the camera describes the close physical relationship between architectural space and the sound that periodically invades it" as a man shouts at the end of a corridor.[30] Viola also embarked on a project to record ambient sounds of various Florence cathedrals in 1981, and he was still performing sound pieces like *The Talking Drum* and *Hornpipes* which made extensive use of the echoes found in a given reverberant space, as late as 1982.

Sound in Joan Jonas's early films and videos was especially indicative of their outdoor settings' spatiality and perspective. In *Songdelay* (1973) performers standing in an outdoor lot on New York's west side by the Hudson River click wooden sticks over their heads, an echo doubling the sound; this conveys a much larger space than is evident onscreen (and was based on an earlier performance piece, *Delay Delay* (1972), in which the audience observed the performers clicking sticks from a rooftop viewpoint, where the echo underlined the distance between the audience and the performance). In another outdoor scene, two men have a conversation in the foreground, in a normal-volume speaking voice; behind them, two women also have a conversation, but one is in the middle distance, the other much further away. They have to shout in order to be heard. Here sound illustrates depth of field just as much as the picture does. In *Three Returns* (1973), a boy playing bagpipes makes a circular journey from the camera across a field three times; again the changes in sound depending on his distance from the recorder are given equal weight to his distance from the camera.

Gary Hill worked with sonic properties of steel welding rods when he was still a sculptor and experimented with feedback and tape loops (perhaps a structural influence on his performative video installation *Hole in the Wall* (1974), which shows the cutting of a wall to make room for the very monitor the video is displayed on). In *Sums and Differences* (1978) Hill switches around the sounds and images of different musical instruments; in *Soundings* (1979) loudspeakers are subjected to different materials being placed on the speaker cone as a voice on the soundtrack is modified in kind. In *Meditations* (1979–1986) sand falls on

a loudspeaker that begins to muffle the spoken sounds it's emitting, then piles up and the vibrations begin to create patterns in the sand, much like Alvin Lucier's *Queen of the South* or Takehisa Kosugi's 1980 installation *Interspersions,* and in *Full Circle* (1978) a circular image is created by Hill's voice. This sort of interplay goes back to the basic relationship between sound and video described by Viola (and is found much earlier in Nam June Paik's *Kuba TV* (1963) and *Participation TV* (1969), which connected a TV to a tape recorder and a microphone, respectively, and converted the sounds into visuals).

Bruce Nauman often used sound for a disjunctive effect in his films and videos; in *Playing a Note on the Violin While I Walk around the Studio* (1967–1968) the image of himself playing violin is out of sync with his playing on the soundtrack, and in *Lip Sync* (1969) the soundtrack of Nauman saying the words "lip sync" goes in and out of sync with the image of his lips pronouncing them. Nauman was originally a jazz bass player and a classical guitarist before setting music aside because it required too much practice.[31] He has worked extensively with sound but always with the intention of an art context; his only significant appearance in the music world was a performance of Steve Reich's *Pendulum Music* (1968, a piece whose inception was witnessed and perhaps partially instigated by Nauman and painter William Wiley), and even that was part of the 1969 *Anti-Illusion* show at the Whitney Museum, which Nauman was also included in.[32] One of his earliest exhibitions, at Galerie Konrad Fischer, was entirely given over to sound; titled *Six Sound Problems for Konrad Fischer* (1968) it featured six separate tape loops that were played back on a tape machine in the gallery, each containing sounds that had been recorded on site of Nauman walking, playing the violin, bouncing two balls in different combinations. All of the sounds were previously heard in Nauman films and videos that documented himself performing each respective activity. The tapes were each assigned to the six days of the week the gallery was open and rotated daily, and even the position of the tape machine in the gallery was varied. The same year he made the album *Record* (1969) of himself sawing away on the violin (an instrument he was untrained in) on one side and stomping in different rhythms on the other; both the installation and the record show the sounds of the actions he undertakes in his videos as having a stand-alone value once divorced from both image and performance.

Like many late 1960s Conceptual artists, much of Nauman's work dealt with language, in his neon signs and text works on paper and other materials; 1968's sound installation *Get Out of My Mind, Get Out of This Room* confronted the visitor with Nauman's voice speaking the title in a strained whisper from hidden

loudspeakers in an empty room illuminated by a bare lightbulb. He repeats it over and over, varying the cadence (the basic rhythm is an even tick-tock pulse identical to the one set by the metronome in *Dance or Exercise on the Perimeter of a Square (Square Dance)* (1968)—see Part Two); his videos show him performing repetitive activities in his studio without speaking, while here his disembodied voice deploys the work's tautology. Nauman's voice is menacing but not necessarily directed at the audience; he has recalled that the piece stemmed from the demands and pressure he felt from his initial success in the art world at the time.[33] "This room" could very well be the artist's own studio rather than the space the work is installed in. In 2004 he had a sound installation at Turbine Hall in the Tate Modern, *Raw Materials*, consisting of twenty-two spoken texts culled from his work of the last four decades as well as soundtrack material from his videos. Walking through the long hallway, the visitor would encounter each text, which would fall out of earshot and be replaced by another (some were very short loops, others longer). He made another sound installation in 2009, *Days*, in which the days of the week were recited and then played back in random order through fourteen speakers that formed a corridor, seven speakers on each side.

Nauman also did installations that could be categorized as sound sculpture. In 1969's *Separate Touch and Sound* (also known as *Touch and Sound Walls*) he created two false walls, one with mics that would pick up the sounds of the viewer touching it, the other located forty feet away with speakers that transmit the sound, creating a delay in hearing the amplified touching sounds. For *Diamond Africa with Chair Tuned D.E.A.D* (1981), he "tuned" the chair by throwing a dime at it and listening to the ring ("the whole chair has a really good ring … I worked for two weeks with a tuning fork trying to find out what all the different notes were"[34]). This piece was silent, but another one, *Musical Chairs* (1983), had a hanging chair and two suspended steel bars in an X position that swing and bang into each other to "actually make noise—make music."[35]

Early audio exhibitions

The first sound exhibitions of the 1960s and 1970s took into account these various trends in the art world, but were surveys of sound *in* art, and/or sound *and* art, rather than sound art. 1964's *For Eyes and Ears*, curated by surrealist poet and art historian Nicolas Calas at the Cordier and Ekstrom Gallery in

New York, presented a wide variety of sound-making visual works, ranging from Man Ray and Duchamp to Tinguely and Takis to Brecht and Joe Jones to Morris and DeMaria to Jim Dine, Rauschenberg, and Larry Rivers. *Sound, Light, Silence: Art That Performs* (1966) curated by Ralph T. Coe at the Nelson Gallery of Art (now the Nelson Gallery—Atkins Museum of Art) in Kansas City, Missouri, connected Pop, Op, Kinetic, Minimal, Primary Structures, Process Art, and E.A.T. as art forms that stimulated the senses beyond vision and included Rauschenberg, Frank Stella, Donald Judd, Andy Warhol, Len Lye, and Howard Jones. *SOUND* (1969), curated by Ray Pierotti at Museum of Contemporary Crafts of the American Crafts Council NYC (now Museum of Art & Design) had more of an emphasis on sound. It included a survey of "sounding sculpture," a "walk-through" of a composition by Bülent Arel that laid out four sound sources that were then electronically processed, demonstrations of a Moog synthesizer, two instruments designed to be played by visitors by a composer named Aeon (Terry Fugate-Wilcox), a specially constructed anechoic chamber, and a selection of graphic scores. The catalogue was a reel-to-reel tape including sounds from the exhibition, a foreword by consultant Ann McMillen, and interviews by the curator with Edgar Varése, Alcides Lanza, Jon Hassell, Fugate-Wilcox, and William Sloan.

Two early 1970s exhibitions were more Fluxus related: 1973's *Sound as Visual/Visual as Sound* (Montreal, Vehicle Art curated by Suzy Lake and Allan Bealy) featured a number of Canadian artists as well as Fluxus stalwarts Dick Higgins, Alison Knowles, Ben Vautier, and Takehisa Kosugi, while *See In Order to Hear: Objects and Concerts of Visual Music in the 60s* at Stadtlichte Kunsthalle, Dusseldorf, 1975, was curated by Inge Baecker, who favored Fluxus artists—her gallery's inaugural show was of drawings by Wolf Vostell. The artists were John Cage, Mauricio Kagel, Charlotte Moorman, Nam June Paik, Giuseppe Chiari, Joe Jones, Dieter Schnebel, and Stephan von Huene, with an accompanying concert series.

The Berlin gallerist Renè Block also showed and arranged concerts by Fluxus artists, and promoted New Music concerts as well, including a rare performance of Satie's *Vexations*. He organized a landmark show titled *Für Augen und Ohren (For Eyes and Ears) From the Music Box to the Acoustic Environment: Objects, Installations, Performances*, which opened in January 1980 at Berlin's Akademie der Kunst after four years of preparation. "Besides working with artists of the Fluxus movement, I had strong connections to other 'outsiders,' especially to a new generation of artists and composers, such as Terry Fox, Sarkis, Bernhard

Leitner, Christina Kubisch, Bill Fontana, Laurie Anderson, Conny [*sic*] Beckley, or Rolf Julius," Block later told an interviewer.[36] He also saw modern classical music as belonging—"I wanted to include the 'fathers'—I would name Cage, David Tudor, and Earle Brown as such—and the grandfathers Marcel Duchamp, Luigi Russolo, Erik Satie, Charles Ives, Harry Partch, Percy Grainger, or Ivan Wyschnegradsky in the project—that is, the exhibition as well as the program of concerts, which were very important to me."[37] The exhibition occupied twelve rooms and had a 300-page catalogue; at the time, it was a definitive survey. In an inspired move, Block made an installation out of Satie's *Furniture Music*, certifying it as a proto-sound art work:

> When it premiered in 1917, three groups of eight musicians each had to play the three pieces of music (that were written especially by Satie) for as long as possible—that is, for several hours. In 1980, however, modern technology allowed for a brilliant yet poetic solution. We had prerecorded the three compositions, which were played in infinite loops. The room was furnished like a salon, with tapestry, armchairs, and a palm tree. Speakers were placed in different positions in the room, hidden under the tapestry, und thus the music became a permanent part of the environment—just like furniture.[38]

Figure 3.4 Catalogue for *Für Augen und Ohren* (*For Eyes and Ears*), 1980. Courtesy Seth Cluett, Sound Practice Archive.

Für Augen und Ohren actually capped a couple of years of mounting activity in exhibitions of audio art (as it was often termed then). An extensive survey of artists' recordings was mounted at New York's Artists Space in early 1978, *Audio Works*, which incorporated artists' tapes from a show at LA Institute of Contemporary Art (LAICA) called *Narrative Themes*—over seventy-five artists were shown, including Vito Acconci, Carl Andre, John Baldessari, Chris Burden, Terry Fox, Allan Kaprow, Julia Heyward, William Wegman, Michael Smith, Les Levine, Stuart Sherman, and Keith Sonnier plus installations by musician/ composers Rhys Chatham and Scott Johnson, and performances by Chatham, Johnson, and fellow musician/composer John Zorn. Artists Space had previously given exhibitions to Laurie Anderson and Michael Brewster, as well as showing a sound installation by Liz Phillips in 1974.[39] 1979 brought *Sound: An Exhibition of Sound Sculpture, Instrument Building, and Acoustically Tuned Spaces* at the Los Angeles Institute of Contemporary Art, which traveled to New York's PS1, curated by Robert Smith and Robert Wilhite, a large-scale show that still leaned heavily on Fluxus and contemporary avant-garde composers/musicians. Vienna's Modern Art Galerie hosted the summer-long *Audio Scene '79*, which began with a symposium, then an exhibition, and finally a series of concerts.

The momentum is still evident in the 1981 show *Soundings*, curated by Suzanne Delehanty at the Neuberger Museum at SUNY Purchase. Gathering paintings depicting musical instruments by Georges Braque, Pablo Picasso, Joan Miró, Arthur Dove, and Paul Klee, sound sculptures by the Baschets, Bertoia, Paik, Howard Jones, and von Huene, installations by Liz Phillips, Bernhard Leitner, Doug Hollis, and Bruce Nauman's *Acoustic Wall* plus a concert program including Earle Brown's *Calder Piece* (in which an actual Alexander Calder mobile is placed in the center of the performance space as a kind of "conductor" with four percussionists situated in each corner of the room reacting to its movements and even using it as another percussion instrument) and a performance by the Glass Orchestra on instruments made of glass, *Soundings* typified early sound exhibitions' attempts to make a case for music's place in a museum context and for sound's role in twentieth-century art, although the inclusions of sound installations and sound sculpture begin to identify work that may stand apart from music.

Avant-garde composer and sculptor William Hellermann's 1984 *Sound/ Art* exhibition at Sculpture Center in New York centered on mixed-media works by Vito Acconci (*Three Columns for America*, a wooden table with stools, a blackboard, and headphones), Les Levine (*Take 2*, audiotape and a mirror), Carolee Schneemann (*War Mop*, a sculpture/video installation with

a soundtrack of sirens and soprano voice), Keith Sonnier (*Tri-ped*, a sculpture with radio transmission), and Hannah Wilke (a photo loop with built-in audio "song-picture"), as well sonic sculpture by Bill and Mary Buchen (*Sonic Maze*, a pinball style game—a small ball activates idiophones), Nic Collins (*Under the Sun*, his first installation dating from 1976—a long wire with loop meant to articulate the harmonic series over an extended duration), Richard Dunlap (an arrangement of chimes), Hellermann (*Music Sculpture*, comprised of a tape recorder playing back a music piece and "motors that animate parts of the sculpture"), Jim Hobart ("hubcap harp"), and Richard Lerman (*Amplified Money*, piezo mics attached to currency). The pieces are as much visual as aural, dependent on both to be effective (and the show's documentation is in photography, not audio recording). Catalogue essayist Don Goddard argues:

> It may be that sound art adheres to curator Hellermann's perception that "hearing is felt as another form of seeing," that sound has meaning only when its connection with an image is understood. Hearing a recording of any of these works could produce meaning, through imagination, but it is the actuality, the action of the work that has ultimate, useful meaning. [40]

This asserts sound art's resistance to audio recording, but sound here is a common denominator between visual artists and composers making objects; Hellermann's selections articulate an aesthetic of creating for the eye and ear, but it is still not a grouping of artists working with sound as a dedicated practice.

Sound art recognizes itself

While exhibitions in the 1960s and 1970s were still tied to visual art in trying to make a case for a tentative audio art, there was also some activity indicating the existence of an autonomous genre. In Vancouver, John Grayson, an instrument builder and sound sculptor himself, produced a book (*Sound Sculpture*) and a record (*The Sounds of Sound Sculpture*) on his own A.R.C. imprint in 1975. Both are significant for collecting recordings of and essays by/about Harry Bertoia, Stephan von Huene, the Baschet Brothers, and others and dubbing them sound sculptors. The album limits itself to recordings of sound sculptures themselves and in that respect is groundbreaking; the book provides some context via essays by composer Harry Partch, who built his own instruments, and later on gets into examples of experimental music whose connection to sound sculpture is

tenuous, but notably does not try to link sound sculpture to Kinetic art, save for Charles Mattox labeling his own work as "audio-kinetic sculpture." Allan Kaprow contributes an essay on von Huene but assesses his work on its own terms.

Meanwhile, Galerie Giannozzo, the first gallery to be dedicated to showing sound installations with some regularity, had opened in Berlin in 1978, founded by Rolf Langebartels, a sculptor, musician, organizer, and sound art practitioner. He mostly showed photography until 1980, when, perhaps energized by *Für Augen und Ohren*, he mounted a show of photos accompanied by sound by Rolf Julius, titled *Body Horizon (Portrait of N)*; Julius's *The Dike Line*, his first piece to incorporate both photography and sound, was shown in *Für Augen und Ohren*. After that, sound shows at Giannozzo were still sporadic until 1982, at which point nearly every month there was either an installation or concert, many by German artists such as Ulrich Eller, Felix Hess, and Martin Riches, but also Fluxus veterans like Takehisa Kosugi and Philip Corner and experimental composers Alvin Curran and Phill Niblock.

Galerie Giannozzo closed in 1986, and its successor in Germany was not in Berlin; this was Stadtgalerie Saarbrücken, a gallery founded in 1985 by Bernard Schulz, a man with an unusually mixed professional life that spanned forest science, journalism, and theater. Langebartels had never done a group show, but in 1988 Schulz organized *Klangräume*, which included the Baschet Brothers, Gunter Demnig, Eller, von Huene, Julius, and Christina Kubisch. This was perhaps the first ever gallery show dedicated to artists working in sound installation and sound sculpture only, without the addition of visual artists or composers/musicians. Schulz went on to do solo shows with Eller, Julius, and Kubisch as well as Akio Suzuki, Qin Yufen, Terry Fox, Robin Minard, Hans Peter Kuhn, Felix Hess, and Alexander R. Titz, and continued to direct the gallery until its closing in 2002.[41]

Yet another important gallery for sound art in Germany appeared in Berlin in the mid-1990s. Singuhr Hoergalerie was founded by Carsten Seiffarth and Susanne Binas (with Markus Steffens joining Seiffarth after Binas departed in 2002) and lasted from 1996 to 2014. Originally located in a disused church (Parochialkirche) in East Berlin's Mitte district, which had been used as a furniture storage facility before the fall of the Berlin Wall, the gallery was open from May through October because there was no heating for the rooms in the winter months. Helga de la Motte-Haber describes the exhibition space in the church's belfry: "a spiral staircase, a small room in the middle, a niche

somewhere and a further small room, a vault under the roof that once housed the glockenspiel—called the 'singuhr' (singing clock) in common parlance—which chimed throughout Berlin."[42] She goes on to note that "works presented there had to be space oriented" and "made use of the prevailing acoustic characteristics"[43] and that "dedicating a particular space for sound art will give fresh impulse in its development."[44] Seiffarth has said that unlike a typical visual art gallery the venue "was not clean, not neutral,"[45] in terms of both its physical characteristics and identification with its former function.

Indeed most of the work hosted by Singuhr was made specifically for the space itself and in many cases was inspired by its history: Dirk Schwibbart's *12 Glasses* (1997) used recordings of bell chimes lasting 7.5 minutes, the same interval that the glockenspiel's chimes would sound. Alvin Lucier created *Twins* (1999), a "double version" of his long thin wire piece in order to take advantage of the two windows in the space that each wire could be attached to. Ed Osborn recorded his own footsteps in the space for *Measure for Measure* (2001). Christina Kubisch made a four-channel installation using the texts of the four epitaphs found in the church's entrance hall, and installing twenty-six loudspeakers in the same positions in a room where portraits of the church's former pastors once hung, with voices intoning the life stories of the church ministers. When the gallery moved to two reservoirs in Berlin's Prenzlauer Berg district in fall of 2006, the pieces remained very specific to the site. Pierre Berthet's *Extended Drops* (2010) made use of water droplet sounds, self-built loudspeakers and tin cans made into resonators as "an homage to the former function of the space as a water reservoir;"[46] Robert Henike's *Eternal Darkness* (2012) turned the large reservoir into a kind of giant pipe organ.

Singuhr's beyond-the-white-cube locales expressed Seiffarth's own ethos of how sound art should be presented. "Sound art has so far proven to be more of an ideal medium for charging the atmosphere of places which, thanks to their architecture or because of their historical and social context, already have a certain aura, and for turning them into a special venue for experiencing new things,"[47] he wrote in 2009, while declaring elsewhere that "eight-channel installation computer music you can do everywhere … for my interest it was this site specificity, the relationship to space."[48] Jørgen Larsson has observed that *Klangkunst*, and by extension the German sound art scene, "tends to exclude forms of sound art that lack a spatial or location-specific dimension,"[49] and Seiffarth has written "in my understanding, the term sound art primarily covers sound installations and sound sculptures that can be experienced in a unique

physical space that cannot simply be replaced,"[50] although he does go on to quote Helga de la Motte-Haber that sound sculptures "can be hung in different rooms, meaning they are not necessarily dependent on site."[51] Seiffarth's idea that a gallery for sound should be more than a display room respects the site-specific nature of sound installations to begin with and makes the venue a factor in the conceiving of new work, not just a destination.

Still, Singuhr's second location had its limitations. Visual art gallery spaces tend to be flexible to accommodate works of varying dimensions. Kersten Glandien observed that the reservoir

> presented a considerable challenge for the curators' aesthetic concept, both because of the highly reverberant nature of the two reservoir spaces and because of the limitations of its purpose-built architectural form. This inevitably constrained not only the kinds of sound works that could be presented, but also the artists who could be invited. The wide variety of Sound Art featured in the Parochial church gave way to a rather minimalist sound conception, which the gallery pursued until its final closure in May [2014].[52]

Seiffarth has said that the large reservoir had an eighteen-second delay, and the smaller one a six-second delay, and as a result "you can imagine it's really difficult for an artist to work there."[53] It became Singuhr Projects in 2014, an organization dedicated to aiding in the production of new sound art work, and a logical move inasmuch as the gallery was, in Seiffarth's view, a project space that wasn't trying to sell work.[54]

Beyond the art institution: Citywide festivals and Australia

If a gallery that narrowed its scope to sound works exclusively was one sign of sound art's coming of age as a distinct practice, an expanded conception of the kind of space needed for a large-scale survey with multiple works was another—specifically, the idea of the citywide festival, which would not only have installations at museums and galleries but in various locations across a city, in addition to concerts, radio events, film screenings, and symposia. Inevitably, these would include much work that would be more recognizable as music, but in each case the purpose was to at least advance a vision of sound works finding a home not only in an art context but within an assortment of public settings.

Such festivals also required organization between a several different institutions, somehow befitting a genre whose practitioners often come from, and occupy, a number of disciplinary areas. This was pioneered by the SoundCulture festival, which was first mounted in Sydney in 1991, then Tokyo in 1993, San Francisco in 1996, and New Zealand in 1999. Each concentrated on artists from the Pacific region—Australia, Japan, and the U.S. west coast. The first was a collaborative venture between "The Listening Room" program on Australian national radio, Performance Space in Sydney, and the Sound Studies department at the University of Technology, Sydney. SoundCulture 96, directed by sound artist Ed Osborn, comprised over 200 artists, seventeen separate exhibitions, and fifty-five events, taking place everywhere from warehouses to a shopping mall, the beach, clubs, and public transit. Packed into ten days in April, this required the participation of two dozen institutions, including arts centers, museums, galleries, radio, colleges, cinemas, concert venues, and record labels.

Back in Germany, Sound Art 95 took place over a month in Hanover, with installations at the Eisfabrik as well as disused buildings and a brewery; there was even a "noise hunt" devised by R. Murray Schafer in the town square. Organized by Hans Gierschik, Robert Jacobsen, and Georg Weckwerth, and again in cooperation with a wide array of institutions, it leaned toward German artists but it was dubbed an "internationale" and included Americans, Europeans, and Australians. More high-profile was the first Sonambiente festival, curated by Christian Kneisel, Matthias Osterwold, and Georg Weckwerth and staged in Berlin from August 8 to September 9, 1996. Held in celebration of the Akademie der Kunst's 300th anniversary, this was the true heir to *Für Augen und Ohren* (indeed, its subtitle was "Festival für augen und ohren"). As Berlin was still a city in transition from the reunification only a few years previous, the festival's locations included not only the Akademie but construction sites, the former GDR government headquarters, a nineteenth-century post office, and the ruins of a Franciscan church (whose unusual acoustics were prominent in a sound installation of chanting monks by Hans Gierschik). While SoundCulture 96 had made some disruptive public performances (one outdoor performance by Kazue Mishuzima slowed nearby traffic, a group of performers playing tapes of bird calls invaded a city bus), Sonambiente made a point of integrating sound art into the given locations and thinking about the city itself as a sound art space. At the Winehaus, situated on a construction site, Christina Kubisch made a work with transmission of the noise from the construction (leaving pauses where the actual sounds from outside would be audible through the walls), and roof

access was granted for listening to the work being done. In front of the state council building, Beate Lotz and Dirk Schwibbert mixed prerecorded electronic sounds with live transmission of passing traffic. Christian Marclay posted blank sheets of music paper all over the city, for passersby to mark and thereby create a cumulative score. Ron Kuivila made use of the glass roof truss in the atrium of the Akademie, which heats up to 50 degree celsius in the summer months to make an installation of spinning rotors and special microphones to make the sound audible. The concerts were mainly presentations by sound artists; only Mauricio Kagel and Henning Christiansen represented the twentieth-century classical avant-garde and Fluxus music, and Laurie Anderson, Charlemagne Palestine, David Moss, and Jon Rose were among the few participants who were better known as performers. The festival also published a 300-page catalogue titled *Klangkunst*, which in addition to documenting the artists and works featured twenty essays, a timeline of sound art by Helga de la Motte-Haber from 1900 on, and a full bibliography (three years later, de la Motte-Haber would edit another exhaustive volume of some 140 artists, *Klangkunst-Tonende Objekte, Klingende Raume*, part of a series on twentieth-century music). A second Sonambiente festival was held in Berlin in 2006, coordinated with the World Cup and not as commingled with the architectural landscape of the city, although it had very little overlap with the first festival as far as invited artists—a testament to how wide the field had become.

Another turning point came with the *Earmarks* exhibition at MassMOCA in 1998, housed in a former factory in North Adams, Massachusetts. An unofficial inaugural show for the museum planned in the spirit of its intention as a community center, eight site-specific sound installations (half of which, incidentally, were created by German sound artists) were made at the museum and in the town (with one at the Clark Art Institute in neighboring Williamstown), and two of them became permanent installations: Bruce Odland and Sam Auinger's *Harmonic Bridge* (placed in the museum's parking lot under an overpass, a C drone tone is played through two speakers, generated by funneling the sound of overhead traffic through a sixteen-foot tube with microphones set up at particular harmonic intervals) and Christina Kubisch's *Clocktower Project* (which recorded the bells in a disused clocktower for a database of sounds that are activated via solar sensors placed on the tower to correspond with the changing light). The museum would go on to commission other permanent site-specific sound works by Walter Fähndrich, Stephen Vitiello, and Julianne Swartz for their collection, showing an unusual art institutional commitment to sound art.

By the turn of the millennium, there had been annual sound art festivals in Krakow (Audio Art Festival, 1993–present), Barcelona (Zeppelin Sound Art Festival, 1997–present), Mexico City (Festival de Arte Sonoro, 1999–2001), Vienna (Shut Up and Listen! Festival, 2006–present), Canada (Sound Travels, 1998–present, SOUNDplay, 2001–present), Roskilde (Soundscape Bienniel, 1991–present), Belgium (City Sonic Festival, 2003–present), and Australia (Liquid Architecture, 2000–present), and exhibitions in Tokyo (the annual Sound Garden series 1987–1994 at the Striped House Museum of Art, *Sound Art—Sound As Media*, 2000, at the ICC), and Beijing (*Sound*, 2000, China Contemporary Art Gallery). A few galleries were founded outside of Germany (Studio Five Beekman/Diapason in New York, 1991–2013, e/Static in Torino, Italy, 1999–present, Lydgalleriet in Bergen, Norway, 2005–present). At this point sound art was a truly international phenomenon. The citywide festival, however, did not become the norm; a sporadic festival called Tuned City, held in Berlin in 2008, Tallinn in 2010, Nuremberg in 2011, Brussels in 2013, and Messene in 2018, that organized performances, installations, symposia, and workshops around the theme of sound's interaction with architecture and the urban environment was an anomaly. By and large, sound art festivals were mainly a combination of concerts and installations, patterned after music festivals. Already in the first two decades of the twenty-first century, sound art's standing as a no man's land persists, as its presentation is still torn between music, art, and academia, with less and less collaboration between the different factions.

The exception to this may be Australia, where the relationship between sound art and music has always been close-knit, and the abundance of activity rivals that of Germany. Sound art developed there parallel to its germination in Europe and North America from the 1970s onwards. With the exception of a few sculptors who worked with sound, by and large Australian sound art was a domain populated by composers, with little contact with the art world. Rather, it was nurtured and circulated by the experimental music scene, national radio, and academia. As a result, for Australians "sound art" was frequently synonymous with experimental music; two important essays, "A Brief Topology of Australian Sound Art and Experimental Broadcasting" by ABC producer Andrew McLennan and "Some Social and Musicological Aspects of Australian Experimental Music" by composer Warren Burt, cite many of the same events and figures in their respective histories.[55] The terminology there has perhaps been less problematic, and the boundaries of sound art have generally been more inclusive, while still contested to some degree. In her curatorial essay for

the 1995 survey *Sound in Space: Adventures in Australian Sound Art*, Rebecca Coyle described the parameters of the genre there (which recall McLennan's delineation of the ground covered in "The Listening Room" radio program quoted in Part One):

> In Australia, sound art practice reaches into fields of multi-media and sculpture, experimental and new music, performance, sound poetry, radiophony, and sound design. But sound art offers a dimension of experience inadequately described by these labels. The primary conceptual motivation in any sound artwork is the sound. Neither visual nor tactile, allusive rather than expository or descriptive, sound art requires the visitor to listen rather than merely hear, and to "read" allusions from a series of sonic signifiers and sensations.[56]

Australia also had its own forebear to sound art in the composer Percy Grainger (1882–1961). As a child Grainger had been fascinated by the wind in the hills of Adelaide, the lapping of water in a lake and beach in Melbourne, and the humming of telegraph wires activated by the wind in the outback. In his "Free Music" statement of 1938, Grainger called for a music inspired by these environmental sounds that would consist of continuous glissandi and irregular rhythms, attainable through sound-producing machines programmed by the composer, bypassing the need for a performer. By taking natural sounds as a source and envisioning an automated playback, Grainger's philosophy augurs sound art even more directly than Cage's did—and unlike Cage, he did not align his ideas with those of modern art.

Grainger managed to construct three machines in the 1950s, by which time he was living in America. The Kangaroo Pouch Free Music Machine had eight oscillators that were controlled by a moving paper scroll (similar to a player piano); the Reed Box Tone Tool was an air-powered reed box capable of microtonal intervals and sliding tones; and the third, the unfinished Electric Eye Tone Tool, also used oscillators and a clear plastic scroll that could be drawn on instead of punched out and read with photocells.[57]

Warren Burt has pointed out that Grainger's work was not well known in Australia and that "composers who have been clearly extending some of the principles of Grainger's work have, until recently, been largely unaware of his activities."[58] This applies to both Ernie Althoff, who began making his own music machines in the early 1980s, and Alan Lamb, who arrived at using telegraph wires activated by the wind to make sound by experiencing them himself.[59] Grainger's legacy is in finding Australia's own geographic makeup

conducive to what would become hallmarks of a sound art sensibility, as Ros Bandt has also suggested in discussing Aeolian harps. Burt also notes the arrival of Bill Fontana, who moved to Sydney in 1976, as a "turning point," with Fontana initiating a performing series but more importantly responsible for "a number of sound sculpture installations in most of the Australian State Galleries, and a number of live and taped radio events," including *Kiribilli Wharf.*[60]

One venue in which Althoff and other artists developed their work was Melbourne's Clifton Hill Community Music Center (CHCMC), a performance space of the late 1970s that also hosted an early sound installation by Ros Bandt, a highly active and influential figure during sound art's emergence in Australia, both as a practitioner and a chronicler through books and essays. Linda Ioanna Kouvaras, in her study of Australian sound art, *Loading the Silence: Australian Sound Art in the Post-Digital Age*, submits late 1970s/early 1980s performances by others associated with the CHCMC (Philip Brophy, David Chesworth, and Rik Rue) that referenced glam rock, muzak, and primitive sampling (respectively) as evidence of a proto-postmodern line of thought, as far as putting pop media in an experimental music context.[61] Proposing sound art in Australia as a decidedly postmodern enterprise, she goes on to discuss sound art there with pieces illustrating postmodernist concerns with gender, ecological politics, and the quotidian. There is an undeniable chronological intersection between sound art and postmodernism, and Douglas Kahn also remembers the attraction to using "art" in terming sound practices during the 1980s ("audio art," "sound art") because "art" had become less referential solely to the plastic arts and

> a postmodern mobility could be found heroically riding roughshod over categorical imperialisms while hand-delivering promise of greater artistic possibility. Those working in sound at that time were (as they are now) from many different backgrounds—music, theatre, "visual art," literature, cinema, media arts, media activism, sciences, engineering, etc.—and working among equally diverse forms and venues. The generalized notion of "art" seemed to be the most innocuous way to talk about this activity, since it provided plenty rhetorical room to move. Some artists made sound their sustained focus; others used it temporarily and then got back to what they were doing previously or moved on; others were somewhere between. The accommodative character of art was the most salient feature, whereas sound, audio, or radio were necessary but secondary and, at times, interchangeable terms.[62]

Many of the works Kouvaras discusses in her survey were made not in the 1980s but in the last twenty years, and indeed, outside of Australia sociological

issues have gained greater currency within sound art production in this period. Building on a previous aesthetic of *sound qua sound* to include cultural as well as perceptual objectives, perhaps sound art by and large has entered a postmodern period within itself. While there are many Australian sound artists working with installations that have little or nothing to do with these issues or postmodern theory, such as Les Gilbert and Nigel Heyler, the broadness of sound art in Australia now appears to reverberate in the twenty-first century across the globe.

Part Four

Recent Sound Art

Blurring the lines

In surveying the landscape of sound art of the last two decades, there is a sense that only some new works appear to be a cognizant advancement of "traditional" sound art, which is still little known. Others merely reuse many of the same ideas, although it's not always clear how versed in sound art's history younger artists are. There are bids to foster more dialogue between sound art, musical forms, records, and visual art, whether it is visual artists trying to make work about their own interest in music, or DJs trying to interface with the art world. Many works that might be considered examples of current sound art are in essence hybrids, art installations that have some engagement with music making or musical instruments. Both in the works themselves and the critical reception of the genre, the trend is toward pluralism. Since there has never been an agreed upon formal aesthetic for sound art, there are no "rules" to be broken. But a "classical" form of sound art—a sonic environment disposed toward stimulating a keen awareness of both listening and the site itself—no longer as predominates as it did during its origins alongside Conceptual art, Kinetic art, Land art, and video art. In fact, much current sound art—or art with sound—could even be viewed as being "post-sound art" (or "postmodernist sound art," as was suggested in the previous chapter).

Compare, for instance, Bruce Nauman's piece for a series of acoustic panels in the Conceptual era, first conceived in a 1969 drawing called *Acoustic Panels* and later realized as an 1971 exhibition, *Acoustic Pressure Piece*, with Jennie C. Jones's series of *Acoustic Paintings* (2011–). In Nauman's work, the blank panels were purely functional, intended to dampen the sound in the room as would be more or less noticeable depending on the viewer's proximity to each panel; Jones combines monochrome canvas paintings with sound absorbing panels, which

fulfill a dual purpose as art and soundproofing while nodding to art history (i.e., the Minimalism of Barnett Newman, Clyfford Still, or Agnes Martin). In some exhibitions these paintings have been exhibited alongside audio works by Jones, which would discernibly shift acoustically the closer one moved to the paintings. The audio works are made from samples from jazz albums, often slowed down or otherwise processed. Jones's earlier work included paintings based on Blue Note album cover design and drawings and sculpture from blank CD jewel boxes; in the acoustic paintings, to some extent the monochromes could be seen as a "package" for the acoustic panels in the same way that album covers serve as an attractive container for vinyl LPs. Jones is translating the experience of consuming music into visual art objects—she summarizes her aesthetic as "listening as a conceptual practice." In Nauman's piece there was "nothing" to look at, or to a certain extent, to hear, whereas Jones has both visual and, in some cases, aural reference points in exhibiting her panels.

Stan Douglas's six-hour video *Luanda-Kinshasha* (2013) is another contemporary example of visual art inspired by listening to music on records. It depicts a fictional recording session modeled after Miles Davis's vanguard early 1970s jazz-rock sessions with multiple pan-cultural musicians jamming together on acoustic and electric instruments in the studio. No footage of Davis's recording sessions exists; the records and perhaps some photos are the only documentation that remains. That Douglas wanted to show the process of the music being made perhaps implies that even studio performances should be seen and not just heard, a testament to the passion that music can inspire but also symptomatic of sound's secondary stature in the ocular world (nevertheless, a double album soundtrack from the film was released in 2016). Ragnar Kjartansson's video *The Visitors* (2012) shows the artist himself playing and singing an hour-long song, accompanied by several other musicians dispersed throughout a house in upstate New York. As a nine-channel installation, each musician was shown alone on one screen, letting the viewer to create their own mix as they walked around the screens. In some ways the song was just as repetitive as Nauman's violin playing, but here the material is popular music, and not sound or performance for its own sake.[1] Video artist Rodney Graham, who was once in a Vancouver New Wave band with photographer Jeff Wall called UJ3RK5 and has released several solo albums of songs, made *How I Became A Ramblin' Man* (1999), a video that has Graham himself playing and singing a cowboy song. His video installation *The Phonokinetoscope* (2001) showed him riding a bicycle through Berlin's Tiergarten under the influence of LSD while a

soundtrack of his band playing a fourteen-minute psychedelic jam was confined to a separate record, which had to be played by the viewer on a turntable as part of the installation, inherently varying its coordination with the visuals.

Also consider Hildegard Westerkamp's Vancouver soundwalks in contrast to artist Janet Cardiff's audio walks, begun in 1999. Westerkamp recorded her own ecologically minded thoughts and observations from visiting a location's sounds, a project that was concerned with both community and sonic experience, while in Cardiff's audio walks the listener/walker actually re-traces the artist's steps. The participant uses a portable audio device—initially a cassette Walkman, later a CD player or iPod, to hear Cardiff's narration as an invisible companion/guide, giving instructions for viewing and directions for the route, as well as asking questions. Cardiff also concocts events in the narration to blur the line between fact and fiction, some of which do serendipitously occur in the course of a walk, and introduces multiple storylines, generally along the lines of sci-fi or film noir, often using herself as a character. Movie-like sound effects and other extraneous sounds (conversations, sometimes documentary or historical sounds) are inserted into the aural landscape as well, superimposed on the ambient soundscape (which of course is ever-changing to begin with). Audio walks have taken place in art institutions and in cities: the Hirshhorn Museum, the Carnegie Mellon Library, the Whitechapel Gallery through the streets of London, Central Park, Münster, Sao Paolo, and San Francisco Museum of Modern Art. Cardiff has increasingly used film, sculpture, and video in the walks, which further jockeys with sound for the walker's attention. The walks are about the nature of reality, and Cardiff's own imagination; the sonic properties of the walks' sites are an ingredient in the work but not the main focus.

Another Cardiff installation, *40-Part Motet* (2001), is devoted to classical music, namely Thomas Tallis's 1575 composition *Spem in Alium nunquam habui*, written for eight choirs of five voices. A recording of the piece was made in which each voice was assigned to a separate speaker, set up in a ring, encouraging the listener to make their own mix as they walked through the space and to hear each voice individually in a way that would never be possible in a concert situation (for audient and vocalist alike). Whereas many sound artists have used such a spatialized setup to bring attention to the acoustics of the space itself, *40-Part Motet* is designed to give a new perspective on the performance and structure of the music. While technically an audio installation, it could also be described as an installation with a classical music piece as its subject. In a later piece, *Experiment in F# Minor* (2013), made in collaboration with George Bures

Miller, a visitor's movements around a table trigger a series of loudspeakers to go on and off, emitting a rock song that follows the visitor as they walk. A more pointed use of song is Camille Norment's *Swing Low* (2009), where the first two notes of the spiritual "Swing Low, Sweet Chariot" are whistled by several voices and the tones extended, then played back through a moving sound-focusing speaker to effect a swinging motion meant to evoke not only the lyric but also lynchings of African Americans.

The most renowned recent sound work to use a song is Susan Philipsz's *Lowlands* (2008/10), which became the first sound piece to win Britain's Turner Prize. *Lowlands* was originally mounted as a smaller work for a Berlin gallery which overlooked the canal that Rosa Luxemburg was thrown into after being shot in the head in 1919. The story of Luxemburg's demise had reminded Philipsz of the river spirit Anna Livia Plurabelle of James Joyce's *Finnegan's Wake*, and she then found a musical counterpart in the Scottish lament "Lowlands Away" in which a drowned man haunts his lover.[2] The bigger, better-known version of *Lowlands* was the response to an invitation from the Glasgow International art festival. Three versions of the song, sung acapella by Philipsz, were installed under three bridges in the Glasgow city center, which was perhaps an ideal context as opposed to a gallery; as Philipsz put it, "the trains overhead and the sound of the water was all part of the experience ... when it's presented in the gallery it's a much more intimate experience of the sound, you can spend a lot longer with it, and people were lying down on the benches, it's more contemplative."[3] In this regard, *Lowlands'* in situ iteration was perhaps comparable to one of Cardiff's audio walks as far as putting a recorded audio element on top of an existing soundscape, albeit using a song instead of a spoken narrative and speakers rather than headphones, and its gallery incarnation more like *40-Part Motet*, where the white cube permits more concentration on the music itself.

Long-standing sound art ideas of sonic relocation and historical resonance are brought to bear in Philipsz's *Surround Me: A Song Cycle for the City of London* (2010), where she transplanted various sixteenth- and seventeenth-century British madrigals, rounds, and songs, again sung by herself, into different areas of London's Square Mile. "I draw on existing music that had a life somewhere," Philipsz has said. "It's like working with a found object that has a history and then taking it and putting it in a particular context. It can change the meaning."[4] Philipsz's work is somewhere between sound art and installation art whose subject is music. Philipsz, though, was puzzled by being labeled a sound artist post-Turner Prize:

One of the stranger things that has happened to me since winning the Turner Prize is that people now refer to me as a sound artist. Before that I was an artist, like any other artist and I would participate in group shows and biennials with other artists where there is no discrimination between an artist who works with film or photography or paint or any other medium. However recently I have been asked more and more to be in sound art exhibitions, where the only common element between the artists is that they work with sound. These are very limiting criteria and you usually get a very mixed bag of artists. In time I think people will stop using the term sound art and I can go back to being a normal artist again.[5]

Philipsz's practice of using solo singing also introduces an emotional element often lacking in traditional sound art. While much sound art involves triggers of some kind—usually movement or electronics triggering a sound—with the use of familiar music and especially singing it has moved into the territory of emotional triggers, and a new kind of accessibility. Philipsz notes that "everyone can identify with the human voice … The way I sing is also quite natural and untrained so there is the sense it could be anybody's voice."[6] She has also claimed that she sings "not as a performance, but as if I am singing to myself,"[7] and that "it's important that you don't see me perform,"[8] which extends a sense of intimacy that does perhaps differ from concert music (and even could be seen as a kind of "activation" of a song in the way that Harry Bertoia, for one, activated his sound sculptures). It also distances her from being a "musician," and shares sound art's de-emphasis on performance. Furthermore, Philipsz maintains:

> When you listen to music at home or at a concert, you can be transported by the music, it can take you away. When you listen to my installations, you become very much aware of the space you're in and yourself in that space. It's a simultaneous experience of being with the sound but also grounded in the present. Especially when the work is placed in a gritty urban setting, you're prevented from fully entering into a state of reverie. You can become aware of how the sound defines the architecture and draws attention to it in a new way. [9]

The cognition of space is, of course, a key tenet of sound art; unlike much sound art though, Philipsz's work is not exclusively about outlining a space *through* sound, or translocating ambient sound from one space to another, although she has stated that she's "interested in how sound can define space ….even in a gallery context you become more aware of the space that you're in, and it heightens your sense of yourself. I'm interested in how it works spatially, architecturally."[10]

The placing of a work at an historic outdoor site versus a gallery space was a more complicated issue for another Philipsz work, *Study for Strings* (2012). Made for Documenta 13, held in Kassel, the work consisted of twenty-four speakers carrying the cello and viola parts of *Study for String Orchestra*, (1943) written by composer Pavel Haas while he was interred at the Terezin concentration camp (he perished at Auschwitz a year later) and was installed in the town's former train station, which had been a departure point for the camps during the Second World War. The installation took place at the far end of the platform, away from the ambient sounds of the station itself. By removing all but two instrumental parts from the score, Philipsz underscores the feeling of eradication and loss prompted by the music's origins in the Holocaust. Subsequent installations in galleries and museums must rely upon a wall text, photo, or video documentation to relay the significance of the work's initial siting. Consequently, part of the effect is lost, and the work's basis in a music composition, which is meant to be adaptable to different stagings, contributes to the undermining of its impact as it's exhibited elsewhere. Changes in speaker placement also affect the work; the intermedia artist and critic Jessica Feldman noted of its installation as part of the group show *Soundings* at MoMA in 2013:

> The clever move in the Kassel installation was to splay out the instrumental voices across the tracks, forcing listeners to engage with the site and to grapple with the fleeting nature of sound (and human life) as their listening through the space attempted (and failed) to bring together these recorded pitches in the same time and place. The MoMA installation negates this move: the speakers are brought close together and the sound starts to congeal. In this case, we literally can observe the ways in which the move into a gallery space can cause a piece to begin to glob into an object. The power of this work was in its *dispersion*, and the imagination that dispersion required of the listeners because of the empty holes it articulated: in time, space, ensembles, and communities.[11]

Philipsz has said that "a sound installation is no different from any other installation,"[12] yet Anri Sala's video installations *The Present Moment (in D)* and *The Present Moment (in Bb)* (both 2014), avoided a similar problem. Like Philipsz, Sala made a reduction of a classical music score, isolating two notes from Arnold Schönberg's *Verklärte Nacht (Transfigured Night)* (1899) that are reshuffled according to Schönberg's twelve-tone system (which this late-Romantic-era piece predates). These are spatialized and passed through a series of speakers, so that it sounds as if each tone is darting laterally across the room. The videos show a string sextet doggedly bowing only the D and Bb notes, respectively, in

the score. They are stationed in an airy building, which turns out to be the Haus der Kunst museum, a relic from Nazi Germany that would have been off-limits to Schönberg (whom the Nazis ranked among "degenerate artists"). The deconstruction of the music and the connotative choice of arena are suggestive of potential impermanence in both musical structure and institutionality, whether due to artistic intervention or societal change. But by recording the sound and image of a performance *at* the site, rather than temporarily installing the music there, he has embedded the setting as an intrinsic part of the work itself, and as a result made something much more conducive to traveling exhibition.

Sala's video *Tlatetlolco Clash* (2011) puts the 1982 Clash song "Should I Stay or Should I Go" in a site that has a long history, but with no relation to the song—the Plaza de la Tres Culturas in Mexico City, where students and demonstrators were massacred in 1968 and the Aztecs battled Cortez in 1521. The song is played by organ grinders by using a card with the melody punched out, like a player piano roll; the players may not even be familiar with the song, although they play it at different tempos given their own predilections for hand cranking, which may have nothing to do with the feel of the original version. The video has an interplay of associations and histories; while the emptiness of the site is underlined by the sound echoing on the soundtrack, the Clash song itself is clearly meant as a cultural signifier. Rather than translocating environmental sound, here Sala directs a transcultural migration, using popular music as a tool to spark identification in the viewer.

Not just music, but musical instruments are now a part of installations, further calling into question the boundaries between music and sound art. Sala's *Moth* drum series (2015) fastened snare drums to the ceiling with sticks attached, that would play a drum roll when activated by sub-audio sounds coming from a loudspeaker set inside the drum, a musical instrument operated like a sound sculpture; Ulrich Eller had done earlier pieces with snare drums and speakers that would make them resonate—*In the Circle of Drums* (1996), *Drum Orchestra + score* (2008), and *Talking Drums* (2008). David Byrne's *Playing the Building* (2008), an installation in disused waiting room of a ferry terminal in lower Manhattan, invited visitors to play a small, weathered organ, which was connected to pipes, plumbing, beams, and other built-in metalworks via long cables. When keys were pressed, the surfaces would be struck to produce clanking sounds, whistling flute sounds, and low rumbles from motors pressed against girders. The room became a giant sound sculpture, with the organ acting as a kind of sampling keyboard. While the sounds were spatialized, it

was more for effect than to delineate the acoustic space per se. And because the onus was on the visitor to activate the sounds, in a way the piece was more about non-musicians making music than it was about the sounds themselves. That the piece was titled *Playing the Building* and not *Listening to the Building* is telling; the relationship of Byrne to the installation's visitors is that of player-to-player, not listener-to-listener. The use of the organ, both as a controller and as a signifier, made the installation part sound sculpture, part impromptu music concert. (Nam June Paik had also made a piece in which a piano keyboard was hooked up to activate other parts of the room, *Piano for All Senses*, in 1963.)

Céleste Boursier Mougenot has several installations involving musical instruments with non-human players, again applying some of the procedure of sound sculpture to familiar musical instruments: *from here to ear* (1999–) has seventy birds (zebra finches) perching on and inadvertently plucking the strings of electric guitars and basses, *harmonichaos 2*.1 (2006) fitted harmonicas to vacuum cleaners, and in *Indexes* (2012) a piano was triggered by a live internet feed of stock market data (an earlier version, *Index*, triggered the piano with the keyboard typing of gallery staff). John Wynne's *Installation for 300 speakers, Pianola, and Vaccum Cleaner* (2009) stacks 300 speakers mostly in one corner of a gallery; there is computer-controlled spatialization but the speaker placement is not organized in a way to reflect it. A player piano controlled by the vacuum cleaner plays a roll from the 1909 operetta *Gypsy Love* by Franz Lehar, although modified to turn slowly and to accentuate the notes that are most sympathetic to the installation room's resonant frequencies. There are also electronic sounds, parallel but not synchronized to the pianola. A towering assemblage but sonically sparse and lyrical a la Satie or ambient Eno, it notably was the first sound piece acquired by famed collector Charles Saatchi and later installed in his gallery in 2010.

Haroon Mirza's *Taka Tak* (2008) was another assemblage tagged as sound art, combining a video on a monitor of street chef in Pakistan making a rhythm with knives in the preparation of a dish (which is called Taka Tak, named for the sound the knives make in its creation), a revolving turntable with a sculpture of a Sufi musician and a transistor radio, and a Qu'ran box with LED lights that are synchronized to the rhythm. It created a stir when it was purchased by the British Council and won the Northern Art Prize. Mirza came from a DJ background and makes literal and metaphorical connections between beat-mixing and assemblage; there are often turntables present in his works. *Paradise Loft* (2009), whose title refers to two long-gone New York discos, the Paradise Garage and

the Loft, also has a radio set on a spinning turntable; the radio's antenna knocks a hanging light bulb, which causes static interference with the radio, and comes into contact with a piezo transducer connected to a speaker. With or without the signifier of the turntable, Mirza's assemblages always produce pulsed beats; *Tescotrain (Homage to Guy Sherwin)* (2012) stacks three video monitors, with footage of a flashing Tesco sign and flickering strip lighting converted to a sonic pulse via a copper strip, with an LED light also locked in to the beat. Even the drone in *The National Apavilion of Then and Now* (2011), an anechoic chamber in which a LED halo grows brighter as the drone builds in volume, ends with a pop, as the light cuts out and the process starts over again. These works are about chain reactions as much as they are about disruption, and rhythm. Sound provides a connective tissue between objects and supports the visual repeated movements. There is more to look at than to hear in Mirza's works, but there is also a co-dependence between the sound and the objects, as neither would function as completely as an artwork on their own. He resists being identified as a sound artist, preferring "composer": "I'm not trying to transform space with sound. I'm composing acoustic space and also visual objects in that space, the way a painter would compose a painting. I think a composer is very different from a sound artist."[13] Sound art is certainly a reductive term in Mirza's case, as his work is uniformly mixed media. Yet he's informed on sound art, claiming Max Neuhaus as an inspiration, doing an installation called *Sitting in a Chamber* (2013) that used Alvin Lucier's *I Am Sitting in a Room* in conjunction with a skipping record and a foghorn sound, and working with Tinguely sculptures.

Kevin Beasley also comes from DJ culture and attracted notice with a sensational performance at MoMA in 2012, *I Want My Spot Back*, in which he live DJ'd samples from deceased rappers Biggie Smalls and Tupac Shakur as a kind of resurrection. He made an installation of 5,000 cassette tapes spliced together at the Casey Kaplan Gallery, titled *… for this moment, this moment is yours …* (2013). Each of the fifty reels he assembled contains forty hours of sound and music, enough for the installation to theoretically run for a full year (it was installed at the gallery for two months). Beasley noted that the piece "focused on time,"[14] which is at odds with sound art's primary reconsideration of sound in relation to time and space (as per Max Neuhaus's dictum, "I've taken sound out of time and made it into an entity"[15]). Nor is it in line with La Monte Young's belief in potentially unlimited time, both to achieve perfect tuning, and, within a sound environment, to not only let the ears comprehend the sounds but the body physically calibrate to being enveloped by a set of high-volume frequencies.

Beasley's tape assembly is more a comment on the overflow of recorded music extant, and maybe a reckoning of how much time is spent listening to music, if stacked up end to end. Another Beasley installation, *As I rest under many skies, I hear my body escape me* (2014), at the Studio Museum of Harlem, uses the more traditional sound art trope of translocation, installing interior and exterior field recordings from his family's home in Virginia as well as ambient recordings of the museum itself made previously by Beasley during a residency. The museum recordings were only audible on noise-canceling headphones, separating them from the Virginia sounds. But again, the temporal displacement becomes just as important as the spatial one, as all the sounds are from the past.

Figure 4.1 Ryoji Ikeda, *test pattern [nº5]*, audiovisual installation at Carriageworks, Sydney, Australia, 2013 © Ryoji Ikeda photo by Zan Wimberley.

Ryoji Ikeda started off as a DJ in the early 1990s, but he was simultaneously working with the performance art collective Dumb Type. While he has released many CDs of electronic music, and his first installations tailored sine tones and white noise to a specific space, he is mostly known for his video installations that integrate electronic sound with visualizations of data—source code translated into both sound and image. These sizable works utilize a flood of visual and sonic information—in the series *test pattern* (2008–) enormous projections of what appear to be pure black and white geometric patterns or pointillistic abstractions

are, on closer inspection, composed of streams of binary numerals—to create a high-velocity synaesthetic experience that is also resolutely digital, unlike the low-tech, often analog concatenations of Mirza, where the sound and image are also rigidly synced but far less complex. Ikeda's sounds are taggable as polyphonic electronic music, and both *test pattern* and *datamatics* (2006–) have been realized not only as installations but also as concerts and CDs. As with Mirza, Ikeda also describes himself as a composer: "I compose visual elements, sounds, colours, intensities, and data … I love to orchestrate all these things into one single art form—sometimes as a concert, sometimes as an installation, sometimes as public art, sometimes as film."[16] Ikeda also equates the scale of his installations to what he experienced in techno clubs. Speaking to an interviewer while installing a new work, Ikeda observed:

> Twenty years ago the club scene was completely different from now. It was all like this scale … really extreme. I don't see me as having really progressed from clubs to here … I do installations but it feels the same as when I was a 25-year-old D.J. Technically, my artistic method has become really sophisticated, but I think at the core, it's the same as it always was.[17]

Although the visceral experience of Ikeda's fast-changing visuals and electronic sounds can rival that of a club, the body feels dwarfed by the onslaught in his installations, rather than an impulse to react to a beat by dancing. For all their spectacle, his work is fundamentally about the overwhelming ubiquity of information and its centralization in computer technology. Ikeda's dual entreaty to "the eye and ear" would meet the criteria of *Klangkunst*, but his work must be accommodated by a room, rather than the other way around.

Ikeda, along with Carsten Nicolai, DJ Spooky and Scanner, went back and forth between the art and electronic music worlds in the late 1990s, as a curatorial and critical alignment between sound art and electronica began to develop. This was an outgrowth of the commercial ascent of ambient music in the early 1990s—a genre pioneered in the 1970s by the rock producer Brian Eno. Well acquainted with the avant-garde (while still an art student in the late 1960s he performed La Monte Young's *X for Henry Flynt,* a *Vexations*-like instruction piece for playing the exact same cluster or sound hundreds of times in a row), Eno created mostly electronic instrumental pieces with an eye toward "building up a small but versatile catalogue of environmental music suited to a wide variety of moods and atmospheres." Answering Erik Satie's call for music that would mix with the dinner table sounds of knives and forks, he felt ambient

music "must be as ignorable as it is interesting,"[18] This was realized on a series of albums in the late 1970s and early 1980s, including *Discreet Music, Music for Airports* (initially an installation at New York's LaGuardia airport) and *On Land*; these were met with limited acceptance by critics and Eno's progressive rock fan base at the time, but by the early 1990s Aphex Twin and other electronic artists had developed Eno's ideas into a niche market, with dance clubs offering "ambient chill out rooms" in which club goers could just sit and listen to drifting electronic soundscapes.

Eno was included the 1996 Sonambiente festival, which may have led other curators or critics to think of ambient as sound art. By the same token, the low-volume installations of Rolf Julius in large rooms, composed of chirps, whirs, and drones which he dubbed "small music," would be received in some circles as ambient music, or related to it; Julius's early outdoor concerts, though quite obscure, bolster the association. Steve Roden's "lowercase" music, often presented as installations, also coincided with ambient in the early 1990s and shared some of the same audience. It would be admittedly easy, on first glance, to draw parallels between the ambient chill out room and the sound installation in a gallery, and environmental sound as a source and model for both ambient and sound art. Both the ambient chill out room and a sound art installation can be a respite from an urban environment, as an atrium would—the sounds are often meant to approximate natural settings. But ambient was meant to decorate a room, not to map it; it was perhaps a commercialization of some of sound art's qualities, rather than an extension or a mirror of them.

A moving party like New York's late 1990s Soundlab attracted a mix of the art crowd and club kids, downtown experimental music vets and laptop electronic newcomers. Locations like the Brooklyn Anchorage, a huge space located at the base of the Brooklyn Bridge, made for a sound-installation-like experience where attendees could sense the difference in acoustics as they moved around—a kind of spatialization, even if the room's acoustic properties were not accounted for ahead of time. "People start using spaces differently and that means listening to them in a different way," Soundlab co-founder Beth Coleman told Philadelphia's *City Paper* in 1997.[19] "Since I've been DJing, I don't hear the city the way I used to. I have a friend who lives on the East Side near a big power plant. One morning she was walking home from one of our shows, and she heard the hum of that plant and it sounded like music to her."[20] This fulfills John Cage's desire that all sounds be listened to as music, as well as specifically recalling Neuhaus's *Listen* field trips. The crossover continued to be felt even ten years later, in Christina

Kubisch's *Five Electrical Walks* CD (2007), in which she used recordings of her "electrical walks," to create studio compositions around the rhythms created by urban electric circuitry that could easily be mistaken for electronic instruments, and Stephen Vitiello's *Listening to Donald Judd* CD (also 2007), in which Vitiello made field recordings of himself "playing" Donald Judd sculptures at Marfa Texas (i.e., treating them as if they were sound sculptures, extracting sound from them by physically hitting them or otherwise interacting with them) and then dropped beats into the mix later in the studio.

An improvising turntablist and visual artist, Christian Marclay is another figure whose coexistent activity in the experimental music and visual art worlds has strengthened the links between the two for critics and curators. Occasionally included in sound art exhibitions, Marclay is certainly not a sound artist in the classic sense, but nor is he just a visual artist who makes music. All of his work, whether it is aural or visual, is preoccupied with sound, yet "the overwhelming majority of Marclay's works make no sound," as curator Russell Ferguson has commented.[21] This is a striking observation to be made of a visual artist, but demonstrates the degree to which music and sound form the nucleus of Marclay's oeuvre. His early 1980s performances with turntables precede the DJ pedigrees of artists like Mirza, Beasley, and Ikeda, but Marclay was never involved in dance clubs; he played the small venues that catered to free improvised music (although he later worked with DJ Olive and other DJs from the 1990s "illbient" scene in New York) and was influenced by performance art and punk (he has likened the scratching and other misuse of his records to the Vito Acconci's taboo-shattering body art performances). Beats were usually not involved, and the music was fast-changing collisions of sound rather than ambient drone. He expanded on his recycled records, made of shards of various albums glued together, with his *Body Mix* (1991–1992) series of collages made from different album covers, piecing together intersexual full-length portraits from individual body parts featured on album front or back covers—several had a conductor's torso and female legs from a disco record. Marclay felt that records are an incomplete reproduction of music since the visual component of the music's performance is taken away—he began using skipping records when performing, instead of tape loops, to show an audience how he was creating the sounds—and *Body Mix* implies an analogy in album packaging that only depicts part of a person's body rather than the whole.

Marclay's video scores, such as *Screen Play* (2005) and *The Bell and the Glass* (2003) are intended to be interpreted by musicians, even though they also stand

on their own as a visual work. *Screen Play* is a succession of clips from old black-and-white stock footage and feature films overlaid with colorful dots and lines meant to resemble musical notation. It presents a complex chain of events and information; the players must respond to numerous kinds of movement and shapes, taking into consideration relationships onscreen between the lines and dots and the film clips, the tempos of film montage, and all manner of activity—things or people spinning, falling, breaking apart, swaying, or traveling (via cars, boats, horses), not to mention actors' physiognomy and the elements (water and fire particularly figure prominently in the clips). Watching three consecutive performances of *Screenplay* by three different groups at Eyebeam in the first Performa Biennial in 2005, I was struck by how each film clip would seem to take on a different identity as a new set of instrumentalists interpreted it. For example, the accompaniment to one sequence of a woman doing a series of back flips in a country setting ranged from frantic cello screeches by the TOT Trio to old-school electronic music bleeps and blurps by Elliott Sharp to a deconstructed shuffle beat overlaid with accordion clusters by the Zeena Parkins Ensemble.

The four turntables Marclay used in performance were somewhat regenerated as four video screens in *Video Quartet* (2002), which shows people playing musical instruments in clips from Hollywood movies or concert documentaries. Many of the players in *Video Quartet* are recognizable movie stars; in a turntable piece you might hear a toy xylophone juxtaposed with a piano, but in *Video Quartet* you see and hear Dustin Hoffman playing a toy xylophone in *Midnight Cowboy* and Jack Nicholson playing a piano in *Five Easy Pieces*. The viewer must keep up with the synergetic associations between the sounds, the people making the sounds, and the film sources. Unlike Marclay's improvised musical montages, the clips are carefully arranged and bounce from screen to screen or alternate with each other at a speed that would be nearly impossible to achieve with turntables. This was the first of Marclay's works to be strictly composed, but there's still an improvisational feel to *Video Quartet*, as if each clip is reacting to another spontaneously. With his later magnum opus, *The Clock* (2010), a twenty-four-hour video compilation of film clips that included a clock showing every minute of the day synchronized with the actual time of day, Marclay took the culling of fragments that began in his work with turntables to a monumental apex, while leaving the framework of music behind.

Awarded the Golden Lion at the Venice Biennale and setting new records in acquisition fees paid by museums for a video piece, the attention attracted by

The Clock was perhaps a factor in yet another perceived sound art "moment," along with the awarding of the 2010 Turner Prize to Susan Philipsz for *Lowlands*. This culminated in the media activity around MoMA's first sound art survey, *Soundings* (2013), and the installation of *40 Part Motet* at the Cloisters, the first contemporary work to be installed there, including a cover story in *Art News* and extensive coverage in the *New York Times*. *Soundings* gave a good sampling of the recent hybridized trends in sound art—the crossover with electronica (Carsten Nicolai, Florian Hecker), field recording and multimedia (Jana Winderen, Jacob Kirkegaard) works on paper (Marco Fusinato, Christine Sun Kim), intermedia assemblage (Richard Garet, Camille Norment, Haroon Mirza, Luke Fowler & Toshiya Tsunoda), and works more in line with traditional sound sculpture and sound installation (Sergei Tcherepnin's subway station bench equipped with transducers that send electronic sound vibrations through the body when sitting on it, Stephen Vitiello's outdoor installation of bells recorded around the city). Most of the pieces were made within the previous two years; the oldest work dated from 2007. However, there were sound art exhibitions in the same period that garnered less publicity but were much larger and more comprehensive than *Soundings*—2009's *See This Sound* at Lentos Kunstmuseum, a massive historical survey, and 2012's *Sound Art: Sound as a Medium of Art* at ZKM, Karlsruhe, Germany, a big show of contemporary works from the 1990s onwards (though somewhat controversially placed in close proximity to each other). More sound galleries and organizations had appeared in this period as well, including Sound Fjord, an itinerant organization in London founded in 2009, the Overtoon residency/production platform in Brussels (founded 2005), Le Bon Accueil in Rennes, France (founded 2007), the Errant Bodies project space and Galerie Mario Mazzoli in Berlin (founded 2010 and 2009, respectively), Akusmata in Helsinki (founded 2012), Auricle Gallery in New Zealand (founded 2013) and Audio Visual Arts in New York (founded 2008). Sound began to appear more often in art fairs; while it had always been found at Documenta, Frieze undertook a program of commissioned sound works cosponsored by BMW, accessible at listening stations as well as in onsite BMW vehicles, from 2012 to 2016, Context Art Miami likewise had listening stations for its curated Sound Positions series (2014–present), while Miami Art Basel initiated its Artist's Surround Sound Project in 2015, facilitated by a 160-speaker setup in local SoundScape Park, although the selections were not installed but played through the system in several programs; curator David Grynn also maintains an online platform for video and sound works called Daata Editions.

Sound studies and sociopolitical sound art

Not only has sound found increasing prevalence in the art world, but also in academia, where sound studies has become a burgeoning field. Jim Drobnick, in the introduction to his 2004 anthology *Aural Cultures*, identified a "sonic turn" in scholarship, "referring to the increasing significance of the acoustic as simultaneously a site for analysis, a medium for aesthetic engagement, and a model for theorization."[22] Just as sound artists came from a variety of backgrounds, sound studies scholarship can be found in a range of academic disciplines, and is seemingly applicable to any field of study: Marcel Cobussen has listed "history, philosophy, sociology and anthropology; the history and sociology of music and art; musicology, ethnomusicology, organology, and sound art; urban, media, cultural, performance, science, and technology studies; acoustics and psychoacoustics; medical history and architecture" as all potentially falling under the sound studies umbrella.[23] This all-embracing stance has likely influenced the willingness to widen the definition of "sound art" as much as possible. In some academic situations, sound art practice and sound studies are conjoined; at the London College of Communication, the Creative Research into Sound Arts Practice (CriSAP) is a research arm affiliated with their sound arts programs. Their researchers are also practicing sound artists; on its website, research areas like Sound & Environment, Sound, Gender & Feminism, and Sound & Anthropology come with links to specific artistic projects undertaken by its members, including John Wynne. His *second installation for high and low frequencies* (2012), which explored standing waves and beat frequencies in a site-specific architectural space in the mode of "classic" sound art, was curated by the Fieldgate Gallery and held at the Angus-Hughes Gallery in London but is, within the context of CriSAP, considered research; and an academic seminar on "Sound and Space" took place at the gallery during its exhibition.

Perhaps this could be viewed as descending from sound ecology, where theory and artistic production went hand in hand. In 1977 R. Murray Schafer was already anticipating sound studies in defining a soundscape as "any acoustic field of study" and stating that soundscape studies

> will be the middle ground between science, society, and the arts. From acoustics and psycho-acoustics we will learn about the physical properties of sound and the way sound is interpreted by the human brain. From society we will learn how humanity behaves with sounds and how sounds affect and change behavior.

From the arts, particularly music, we will learn how humanity creates ideal soundscapes for that other life, the life of imagination and psychic reflection.[24]

Sound studies has notably yielded a wealth of new soundscape scholarship, in a niche devoted to historical soundscapes, which researches the relationship between the developments in societies and the sounds they produce, rather than analyzing present-day environmental sounds. Alain Corbin's book *Village Bells* (1998) detailed how town bells were both a timekeeper and a central tool of communication in nineteenth-century rural France, while Emily Thompson's *The Soundscape of Modernity* (2002) traced how architectural acoustic design and new electronic technologies converged in urban America in the early twentieth century. For Thompson "a soundscape, like a landscape, ultimately has more to do with civilization than with nature," a position which she feels demarcates her interests from Schafer's, for whom a soundscape was, as she describes it, "a sonic environment, a definition that reflected his engagement with the environmental movements of the 1970s and emphasized his ecologically based concern about the 'polluted' nature of the soundscape of that era."[25]

One recent example of a sociologically, rather than environmentally, motivated soundscape is Andrea Fraser's *Down the River* (2016), an audio recording made at Sing Sing Prison that was installed in the Whitney Museum's otherwise-empty 18,200-foot fifth floor. The sounds were mostly metal doors clanging and crowd murmur, with occasional shouting and PA announcements. It was a fifty-five-minute loop, but it would have been difficult to determine the beginning or the end. It seemed meant to be heard and not listened to—visitors made no effort to be quiet in order to listen (although the banging is loud)— and the sound was somewhat spatialized to accommodate the dimensions of the room, but not in order to spotlight them. The intent is to establish correspondences between a prison cellblock and a museum floor. The large, reverberant empty space would already amplify footsteps and conversations, making the birdsong and metal door sounds the main clues to an exterior sound source on a crowded day at the museum (in fact, some visitors apparently thought it was sounds from elsewhere in the building piped in[26]). In her wall text Fraser addressed the increase of both museums and prisons, in number as well as attendance and prison population over the last several decades, and while the differences far outweigh the similarities, when one considers the pacing back and forth in the space in order to hear the piece, and the presence of security guards, the institutional critique can be felt. How conscious most of the visitors were of the sounds' origins is hard to say, of course, and many flocked to the

windows at either end of the hall in order to appreciate the views of the Hudson River and the High Line. The installation was site-specific in that Sing Sing is also located on the Hudson; in this sense Fraser's piece has some commonality with the translocation sound art tradition and the German aesthetic of making a piece for a specific location.

Just as some sound studies academics use sound as another means to chart history, certain artists expressly work with sound as way to deal with politics within an art context. Lawrence Abu Hamdan, who calls his practice "forensic listening," exemplifies this. Several of his installed audio documentaries are based on voice analysis: in lie detector tests (*The Whole Truth*, 2012) and in immigration for asylum seekers in the UK (*The Freedom of Speech Itself*, 2012). He also makes paintings or sculptures (using acoustically absorbent material) based on voiceprints or other sonifications of voice analysis. One installation also used audio ballistic studies he made in determining whether rubber bullets or live ammunition had been used by Israeli soldiers in the shooting of two teenagers in the West Bank in 2014 (*Earshot*, 2015). A long-standing group dedicated to relating sound to political activism is Ultra-red, founded in 1994 by two AIDS activists. They engage in what they call "militant sound research," documenting what could be called "political soundscapes" as opposed to the historical soundscapes of academics Corbin and Thompson or Schafer's environmental ones. Ultra-red records collective political actions, and listen back as a way to improve their own tactics; they often hold listening sessions in museums. *What Are the Sounds of Anti-Racism?* asked anti-racist activists to name a site that was historically significant to their work; Ultra-red made field recordings at the sites, and then had a collective listening session where all group members listen to recordings and compare notes. Ultra-red also references Pierre Schaeffer and his four modes of listening, explicitly interpreting the fourth mode, which finds a meaning to an identified sound, as a *social* meaning.

Their motto is "what did you hear" as opposed to "what did you see"; since you can only see what's in front of you but you can hear from all directions, hearing gives a better sense of everything that was happening at a given time and place. As the opening to their *SILENT/LISTEN* series of events (2005–2008) they performed Cage's *4'33"* and asked the crowd, which was a mix of invited members of community and AIDS organizations and the public, "What did you hear?" In the past, sound artists have looked at *4'33"* as a starting point to explore the sonic activity of a given environment, but for Ultra-red listening as a collective experience is the significance of the piece, as well as the responses it generates in

discussion.[27] Since there is no pretext of a concert, there is no dialectic between the sounds in the room and the absence of music; the heightened sense of perception in listening to "silence" is framed as political consciousness as opposed to a new appreciation of sound beyond musical construction. Audience members were then asked to read statements, which were simultaneously recorded and layered as they went along; these were released as an audio file online and also took the form of an installation. They've also used *4'33"* as the beginning of soundwalks, which again ended with the question "what did you hear," and a discussion and analysis of the responses.

The sounds of interest to Hamdan and Ultra-red all originate with the presence or interaction of human beings, and there is perhaps more of an expectation now for sound art to acknowledge the social via the human voice. In her review of the MoMA *Soundings* show, Jessica Feldman expressed concern that "in an allegedly definitive, comprehensive, international survey of contemporary sound art, *not a single voice was heard*," further quoting Rousseau that "speech is the first social institution."[28] It might also be worth noting that Thomas Edison placed music fourth on a list of potential uses for the phonograph, behind three spoken word undertakings: dictation, reading to the blind, and language instruction, prompting Michael Glasmeier to comment, "it becomes clear that its recreational aspect … was considered to be a far second behind its social benefit."[29] In other words, from the beginning, the playback of sound has had a sense of social obligation made through the human voice.

Voice is an obvious tool in grounding a sound piece in the sociopolitical. It acts as an intermediary to cultural heritage via language in pieces like Andy Graydon's *Fig 1 these things we know* (2015) a sound installation in which two voices read descriptions of paintings from the Honolulu Museum's collection, one in English, one in ʔielo HawaiʻI (Hawaiian), or *The Song of the Germans (Deutschland)* (2015) by Emeka Ogboh. Ogboh, himself an African living in Germany, enlisted a choir of African immigrants to sing the German national anthem in ten separate native African languages. Each voice is positioned in a separate speaker in the manner of Cardiff's *40 Part Motet*, but the piece is sung in unison, having the effect of separating out the differing languages instead of parsing the harmonic structure of a contrapuntal piece of classical music. Ros Bandt's *Speak Before It's Too Late* (2000–2001) focused on disappearing languages in her native Australia, including ancient Greek and Latin, placing a six-channel installation inside of a set of urns. John Wynne examined vanishing cultures in the installation *Hearing Voices* (2005), which used the endangered

"click languages" of the Khoi and San people of the Kalahari Desert as source material, alongside photos of the people speaking on the original recordings.

The idea of community, diversity, and universality come together in James Webb's *Prayer* (2000–present), a multiple-channel sound installation made up of recordings of chanting at various religious services that Webb himself records in the communities that will ultimately host the installation itself. The web of prayers conveys the simultaneity of ways of life through different belief systems within a society, much like Amacher brought together the sounds of numerous city environments in *City-Links*. Community is addressed in a different way by a large-scale sound installation in the Oslo Central Railway station *Norge— et lydrike [Norway, country of sound], Norway Remixed* (2002). Organized by the Norwegian Broadcasting Corporation and the Norwegian Network for Technology, Acoustics and Music, it was conceived to "bring the country together in sound," according to scholar Jøran Rudi, who also reported:

> many notes in the visitors' journal state that some of the sounding material triggers memories—memories of childhood, identity, special events and history. Every recollection is unique, but builds on much of the same sonic material. A reference is here made to radio memories, which are often common property in Norway, due to the late arrival of television (1961), and certain well-known radio personalities and programme series. The installation framework with the explicit nationwide perspective was intended to stimulate population self-awareness, and suggest something about the common experiences and background that binds it together—building blocks of culture.[30]

Here sound is used to promote collective experience and as an emotional trigger, this time using archived mass media transmissions instead of composed music. The train station is symbolic of a crossroads used by thousands of people, and perhaps the analogy is extended to radio as well. Radio was not only a sonic component but lent an aleatoric, real-time dimension to assemblages by Rauschenberg and Tinguely, not to mention Cage's 1950s compositions *Imaginary Landscape No. 4, Radio Music,* and *Speech*; here it is deployed as an archival device to stimulate nostalgia. Rather than listener-to-listener, this is programmer-to-listeners, an offshoot of mass communication.

However, both Brenda Hutchinson and Viv Corringham have made sound works that are based on memories accessed in one-to-one verbal encounters with people. While she was still a student, Hutchinson created a sound piece from recordings she made of her grandmother telling stories. For 1996's *How Do You Get to Carnegie Hall?* She went on a cross-country trip, asking people if they

wanted to play her piano and getting them to talk about their relationship to piano. *What Can You Do?* (2012) also made a request of people to show her some kind of sound-making skill they had. Hutchinson has done sound installations, although she is not a sound artist in the usual sense. But while her work is about communication, the material she extracts from people is somewhat latent in the way a sound of an object is—not that a person would otherwise be silent, but since they're strangers they might not otherwise talk to her, or ordinarily talk about what she is querying. Her work takes a different approach to listening-oriented composition, concentrating on what someone is saying, rather than an omnifarous listening philosophy. Much as Neuhaus used sound to conjure a sense of place, rather than an end in itself, Hutchinson feels her exchanges are meant to establish a feeling of personal connection: "The goal of the act is to develop intimacy and openness among people. Working with strangers in public space … through sound is a means to experience these relational possibilities."[31] Hutchinson's conversations are, in their own way, a kind of public artwork.

Corringham's *Shadow-Walks* (2003–) involve Corringham herself traveling to a new place, asking a person to talk her on a walk that they have made numerous times and is meaningful to them, and recording their conversations as they make the walk. She then retraces the walk alone and records her own improvised singing as she responds to her own memories of her companion's experiences with the walk and the actual environment. The recordings are then made into a piece, which have taken the form of audio-walk, radio piece, or gallery installation. The installations sometimes include objects, or photos of objects, that Corringham may pick up on the walk (inspired by the practice of British artist Richard Long, known for his walks). Corringham notes that her subjects "generally select routes that reinforce a connection with their own locality, however mundane the walk may be. Few choose walks where natural beauty is the main feature; mostly the walk is embedded in their daily lives and, even with young people, often it relates to their own history."[32] This is much different than either Hildegard Westerkamp's soundwalks' subjective take on ambient sound, or Janet Cardiff's audio walks, which made the walker a participant in a constructed narrative. In this case the ambient sound is overlaid with both the conversation and Corringham's vocals; all three are intended to be listened to, but the walk is meant to trigger stories and emotions from the walker, and that in turn inspires Corringham's vocal improvisations.

In many of her sound installations, Julianne Swartz recruits dozens of people to have their voices recorded, in the interest of inducing emotional memory.

In *Affirmation* (2006) she asked participants to say something that would be a positive reinforcement, responding to her query of "What could someone say to you that would make you feel completely loved (acknowledged, understood, respected, cared for, attractive, embraced, supported, safe, cherished ...)?" letting the messages play in various parts of a museum. *Terrain* (2007–2008) carried whispered messages of love in multiple languages, as well as humming that could lead into a remembered song, played through 100 speakers hanging overhead. The effect was largely textural, sounding like the breeze in a natural setting, with occasional detection of the lingual. For the 2004 Whitney Biennial, she had sixty-four people sing or speak the song "Somewhere Over the Rainbow," the recording carried through tubes in the museum's stairwell over four flights. Although this stresses the individuality of how each participant works with the song, it also assumes the commonality of their and the visitors' familiarity with it. *Harmonicity, The Tonal Walkway* (2016), a long-term exhibition installed in a passageway at MASS MoCA, is more of an accommodation between classic modes of sound installation—spatialized sustained tones with harmonic relationships that shift depending on whether the visitor is standing still or moving—and the relationship between music with emotion, as the material derives from a nineteenth-century theory about specific emotive qualities associated with each note of a diatonic scale (again, the pitches were vocalized by a series of people ranging in age and musical experience who were instructed by Swartz to reflect on the emotional component before singing). Swartz actually came to work with sound by virtue of its temporal quality, as a means of extending both the work itself and the amount of time the visitor spends with it: "Sound draws attention, and listening can both focus and stretch out an experience. Prolonging the duration of a piece is really important. That is something I am going for in every work—not an instant read, but an understanding deepened through time."[33] Listening, for Swartz, is about ensuring a length of time for a piece to unfold and an inducement for the visitor to stay as long as possible.

Swartz's recent works of sound sculpture, though, are more in keeping with older properties of sound art. *Sine Body* (2017) produces a sine tone from glass and ceramic sculptures through a feedback process, while the series *Bone Scores* (2016) used audio files of breathing, a heartbeat, machines, animals, and many other sounds, all distorted as to be unrecognizable, to cause movement in sculptures made from wire, paper, ceramics, and magnets. In her installations a person had to move through a room or an entire museum in order to fully experience the work; here it is the sculpture itself that is in motion. In a

way the progression evidenced in Swartz's newer sound sculptures is a reverse of sound art's own turn toward emotional content: "More recently, I've been interested in sound as a physical entity. I've shifted (for now) from mining sound for its emotion and affect to exploring the energy it carries."[34]

Jacob Kirkegaard's work strikes a balance, being attuned to the expanding social themes of sound art while remaining true to its essential attributes of environmental sound and installation. He has picked some fraught locations in which to find sounds, namely, four disused locations in the nuclear-contaminated city of Chernobyl (*Four Rooms*, 2005) and a fully functional nuclear power plant in Estonia (*Koirohi*, 2012). In the Chernobyl piece, he captured the room tone of each space—a swimming pool, a concert hall, a gymnasium, and a church—and replayed/rerecorded it in the space multiple times, in the manner of *I Am Sitting in a Room*. The ensuing rich drone is also the sound of abandonment or uninhabitability (at least if you know the backstory). *Koirohi*, a sixteen-channel installation, likewise has a pleasing drone sound brimming with overtones created by the various motors and pipes at work at the power plant, though the source is forbidding—potentially toxic. An Israel West Bank Barrier wall was the subject of another installation, *Through the Wall* (2013). The wall itself was made of concrete and not especially resonant, so Kirkegaard close-mic'd the wall and made recordings of the vibrations, as well as extraneous sounds like the Palestinian call to prayer, which was audible on both sides of the wall. He notes:

> While it is difficult to clearly differentiate between the sounds from the two sides of the wall, there is a world of a difference between the physical environment and the realities of life on the two sides. On one side the wall sometimes surrounds a tiny house, or creates dead-end corridors where the shops have lost most of their customers, while on the other side a large new recreation area with park and playground is being constructed. [35]

The wall has a political association, but in this case, its sound, while normally inaudible, does not tell you as much about it as a visual would.

Kirkegaard has also made use of geyser volcanic activity in Iceland, ice melting in Greenland, and the singing sands of the desert in Oman—natural phenomena in remote locations. These typify sound art's predilection for the unheard, and for natural sonic environments. Another field recordist/sound artist, Jana Winderen, has made a practice of recording sounds found in the hidden recesses of the world's oceans using hydrophones. Both Winderen and Kirkegaard

use their recordings not just for sound installations but also for CDs and live performances. Older sound artists have worked with infrasound to document otherwise inaudible sounds in nature: David Dunn recorded the sounds of bark beetles inside a tree in New Mexico, while Annea Lockwood and Bob Bielecki collaborated on *Wild Energy* (2014), a fifty-minute loop installed at the Caramoor Center for Music and Arts that compiled a wide array of infrasound recordings made by various scientific organizations: solar oscillations (pressure waves on the sun), volcanic tremors, electromagnetic waves, earthquakes, oceanic vents, and ultrasonic tree emissions. The installation was situated outdoors on Caramoor's grounds, with the speakers hidden amid trees and bushes; breaks were scheduled between the sounds to permit interludes of listening to the site's own ambience.

Figure 4.2 Christina Kubisch, *Electrical Walk*, Darmstadt, 2018. Photo by Christina Kubisch. Courtesy Christina Kubisch.

Then there are the concealed sounds of an urban environment. In 2003, Christina Kubisch introduced *Electrical Walks*, in which specially designed headphones amplify different aboveground and underground electric currents that would otherwise be undetected and unheard in outdoor city environments— much like the ultraviolet light in some of her other work brings out visual elements of the space that would not otherwise be perceived. Taking ambient sound to a

microscopic level, the headphones reveal the inner sonic life of neon signs, bank machines, and all kinds of electronic circuitry a city dweller normally sees rather than hears. When asked how the walks differed from city to city, Kubisch replied:

> Madrid: very nervous. Mobile phone signals all over. New York: chaotic frequencies, which change every second. Bavaria: I recorded a thunderstorm, the electric fences for cows, the high density electrical wires in the air—very distinctive sounds. Tokyo: I do not understand where these sounds come from, just mysterious density. Berlin: some embassies have interesting hidden sounds, like the American one; some do not sound at all … London: the tower of Heathrow Airport sounds like a science fiction film.[36]

Experiencing the work in fall 2006 when it was exhibited at the Kitchen in New York, I found only scant buzzing in my wanderings around the nearby streets in Chelsea, but a full-bore drone filled the headphones as I stood outside the Hard Rock Café in Times Square. In a 2018 email exchange, Kubisch commented to me that the electromagnetic soundscape had changed considerably since 2005. "Some sounds have disappeared, mostly those of analog origin. The number of mobile phone signals has increased in a really unforeseen way." She also mentioned that she has to record sounds like "big routers in public places, light advertisements, and communications systems" early or late in the day to avoid interference from cell phone signals—"there is not only acoustic noise pollution but as well electromagnetic noise pollution."[37]

Buildings' structures themselves have a sound: as part of an artist's residency at the World Trade Center in 1999, Stephen Vitiello rigged the windows of his 91st floor studio with contact microphones and recorded and amplified the sounds of the building's movements along with the wind, planes, helicopters, traffic, and people below. The results are a compelling soundscape reminiscent of a ship's creaky hull, and naturally have gained considerable resonance after 9/11. Mark Bain's *Bug* (2009) embedded a sensor during the construction of an office building in Berlin, picking up vibrations which a listener could hear through headphones. These are the interior sounds of construction, masked by the exterior noises of demolition and building.

Related to the ideas of both teasing unseen sound or acoustic phenomena out of a space and importing or exporting sounds from elsewhere is that of surveillance. Sound art's beginnings in the late 1960s and early 1970s coincide with Earthworks/Land art, light art, video art, and performance art,

but the Watergate tapes as well. Andy Warhol remembered that in the late 1960s "everyone, absolutely everyone [he knew], was tape recording everyone else" and he would tape all of his phone calls, as would his friends (though he notes that other people would be paranoid if they knew they were being taped).[38] At the end of the film *The Conversation* (1974), the protagonist, a sound recordist, ends up receiving a phone call letting him know that he's being sonically watched as the person on the other end plays back the sound of him playing his saxophone just before the phone rang. He then rips his apartment apart trying to find the bug his surveillant is using (the last shot uses oscillating camerawork to mimic a surveillance camera). Wiring a room for sound not only reflects Watergate but also translocational sound installations that do not seek to spy on other people, necessarily, but on other areas or situations.

In works by Stuart Marshall around this same time, the sounds of a corridor are picked up by microphones and fed into an adjacent room. Two decades later, in a piece titled *Recorded Delivery*, Janek Schaefer recorded the first seventy-two minutes of a package's journey through the postal system—the package was a sound-activated Dictaphone machine. In a sense he was spying on the package. Bernhard Gal did a similar experiment with a piece of luggage checked at an airport in *Soundbagism* (2004). In *Mapping the Studio (Fat Chance John Cage)* (2002) Bruce Nauman videotaped his studio in his absence at night to record the comings and goings of his cat and several mice, which had infested the studio. Lasting nearly five hours as an installation, the bare, dim setting makes both the outside sounds and the limited indoor sounds (heating fans) more noticeable. The Cage reference owes to the chance operations of the cat and mice's movements, but as the video reveals that Nauman's studio is never silent even when it's supposedly dormant overnight, it also infers a Cagean position on sound and silence.

Scanner (Robin Rimbaud) created controversy by scanning cell phone conversations and using them, unbeknownst to the callers, in his early electronic music concerts of the mid-1990s. In Achim Wollscheid's *Intersite* and *Redlighthaze* (both 2004) LED lights affixed to the outside of a building change patterns based on quotidian sound input (traffic, noises by passersby), while some of his other works use motion detectors to affect other lighting setups in buildings. In a project with architects Gabi Seifert and Goetz Stoeckmann, he installed microphones and loudspeakers inside and outside a private home, piping the interior sounds to the outside world and vice versa after turning each

into tones via computer. In this case, sound is used as conduit to raise the issue of privacy.

Less ominously, Céleste Boursier Mougenot installed video cameras outside the Paula Cooper Gallery and projected the images of passersby inside the gallery, converting the hum from amplifying the video signal into a harmonized drone (*Videodrones*, 2001). Rather than trying to monitor the pedestrians' activities, this was more about transmuting image into sound via electronics, with the flow of street life supplying a visual counterpart to the continuity of the drone. Brandon LaBelle has stated that "sound is never a private affair,"[39] and his *Learning from Seedbed* (2003) revisits Vito Acconci's infamous performance piece *Seedbed* (1972) where he masturbated hidden from view under a ramp in a gallery space, and spoke his fantasies into a microphone connected to an amplifier in the gallery as he heard the gallery visitors' footsteps above him. Acconci's piece touched on taboos that are eliminated in LaBelle's sanitized version, where the ramp itself is open to gallery goers. Contact mics are placed on the ramp set to the point of a feedback tone, which is modulated by visitors' movements on the ramp, but LaBelle's piece is not so much about sound as about revisiting Acconci's original setup as a social space without the discomfort of the enforced eavesdropping on Acconci's sexually deviant running commentary (and, intentionally or not, connotes Acconci's own abandonment of performance in favor of architectural projects).

Appropriate to the expansion of sound art's boundaries and scholarship, and perhaps inevitable given the mixed reception of the term "sound art" to begin with, there have been several additions to the nomenclature. "Sonic art" or "the sonic arts" is the most commonly found, sometimes as a synonym for sound art but more often, as scholar Leigh Landy details, "allowing for sound art, soundscape composition, noise music and acousmatic electroacoustic music … to fall under a single umbrella."[40] (Interestingly, the first use of "sonic arts" may have been a 1966 concert at the Lincoln Center Performing Arts Library by the collective of composers/performers Alvin Lucier, David Behrman, Gordon Mumma and Robert Ashley billed as "Sonic Arts Group" which included works by Lucier and Max Neuhaus as well as Fluxus associates Takehisa Kosugi and Ben Patterson; the collective changed the name to "Sonic Arts Union" for their subsequent group activity.[41]) In the UK, the Sonic Arts Network promoted both experimental music and sound art events since the late 1970s (it is now known as Sound and Music after a

merger with other British contemporary music organizations). "Sonic Arts"
has become widely adapted as a name for academic departments that exist
as a subset of a college music department, offering curriculums that cover
music composition and audio technology/sound design, often with electronic
music and sometimes improvisation and even visual art thrown in as well.
"Sounding art," as defined in 2017's *The Routledge Companion to Sounding
Art* by editor Vincent Meelberg, is "human-made artistic and/or aesthetic
applications of sound, be it in music, muzak, sound art, games, jingles and
commercials, multi-media events, and sound design."[42] This is the most
inclusive definition yet; Meelberg's is based in sound studies (which, he
maintains, "includes, potentially, the investigation of all sounds,"[43] rather than
sounding art's categorization of sound in the service of artistic expression),
whereas Landy's springs from musicology. Sound art was largely a product of
both visual art and music of the twentieth century; the debate over whether
to see it as a subgenre of art or music (or neither) is wholly indicative of its
paradoxical nature. The term "sound art" itself would seem to descend from
the visual art world's habitual use of "art" in denoting new styles, i.e., Pop art,
Op art, Kinetic art, video art, performance art, etc. "Sounding art" seems to
discount the fine art association in favor of media and communications, but
to classify muzak (which Neuhaus, for one, abhorred) and jingles with Harry
Bertoia's sound sculptures or an installation like Jan-Peter E. R. Sonntag's
GAMMAvert/a x-sea-scape (2006), where low-frequency standing waves
pushed through subwoofer speakers are intended to make the visitor feel like
they are wading through knee-high water, while a sensor transforms gamma
rays emitted from a photograph developed using uranium nitrate into
electronic beeps on the basis of sound as a common factor, makes "sounding
art" even more susceptible than "sound art" to the criticism that the term
merely describes the medium used.

Seth Kim-Cohen's 2009 book *In the Blink of an Ear: Towards a Non-Cochlear
Sonic Art* introduced the phrase "non-cochlear sonic art" in trying to theorize
an art practice that involved sound but was completely divorced not only from
music but also from music appreciation. "Non-cochlear" is an application
of Duchamp's aesthetic of "non-retinal" art, which proposes objects as art
not due to any inherent or constructed quality of beauty but rather from a
conceptual premise.[44] (Gerald Hartnett preceded Kim-Cohen over a decade
earlier in an editorial for *Leonardo Music Journal,* written in reaction to the
plethora of radiophony, phonography, and telephony he encountered during

SoundCulture '96, that named Duchamp's "non-retinal" concept as potentially "instructive for audio artists" and concluded: "Please consider this entreaty a provocation to develop non-cochleal—make that extra-cochleal—audio art that not only admits any and all sound into compositional practice, but expands upon the readymade, applies grammatical and textual theory and takes as its subject(s) the manufacture of smart bombs, access to abortion clinics, and even (or especially) banal talk-show programs."[45]) Borrowing Rosalind Krauss's description of postmodernist sculpture "in the expanded field," Kim-Cohen notes that non-cochlear sonic art can "present itself in any medium: photography, books, lines on walls, mirrors, sculpture, as well as performance, speech, choreography, social practice, and so on."[46] In short, it is a form of Conceptual art concerned with sound or the implications of sound, but not always requiring audio.

This is in step with the cross-disciplinary and inclusionary tendencies of recent sound art considerations but also narrows the field to exclude anything that takes or solicits a music-like pleasure in sound. Kim-Cohen dispenses with the idea of sound art's basis in listening, or in sound for its own sake ("sound-in-itself"); non-cochlear sonic art is aware of and grounded in its overall context, predominantly. He offers Luc Ferrari's *Presque Rien No. 1* (1968), a twenty-minute tape piece made from a composite of real-time field recordings of a fishing village's activities at dawn, as an example, as the sounds' "connection to social reality is left intact. More than that, the social meanings of the sounds play a part in determining their placement and treatment in the composition."[47] This is the result, he argues, of Ferrari reading the sounds, not just listening to them. Kim-Cohen quotes Ferrari that he "recorded those sounds which repeated every day: the first fisherman passing by same time every day, with his bicycle ... and then the lorry which left at 6am to the port to pick up people arriving on the boat. Events determined by society."[48] Contrast this with Fontana's recording of Kirribilli Wharf, which also drew from a daily repeating aurality, but of a natural rather than a societal cycle, one that implied a kind of timelessness, not a narrative arc that unfolds like clockwork day in and day out. The soundscape of civilization, rather than nature, is what Kim-Cohen is speaking up for here. Kim-Cohen favors displacing "cochlear" sound art with the non-cochlear variety, which seems unnecessary, but his theory goes a long way toward distinguishing between the older aesthetics of the form and its newer social-oriented leanings.

Conclusion

An advertisement for the 2018 Tuned City festival in Messene, Greece read, in part:

> Listening to the voice.
> Listening to the stones and the city.
> Listening to the history and mythology.
> Listening to the environment.
> Listening to each other.

This succinctly states the condition of sound art in the twenty-first century, a practice of not only listening to sounds or summoning sound from the inanimate but regarding sound as a tool for understanding human cultures of the past and present. In the first edition of this book I had written that sound art "speaks to the listener as living denizen of the planet, reacting to sound and environment as any animal would" with sound being "a primal common denominator."[49] Sound art once stemmed from an underlying idea of sound being omnipresent, that the sounds generated by societies are just a subset of the sounds of the universe, larger than the individual listener, be it the artist or the one encountering the piece. In Liz Phillips's interactive electromagnetic pieces or Bernhard Leitner's sound chair there was also a one-to-one relationship between the sound itself and the audient. But it is clear that increasingly sound art's listener-to-listener principle has come to mean *person-to-person*: that sound is framed within society rather than the planet as a whole. Listener-to-listener suggests a relationship between the artists and their audience, but listener-to-listener can also be the relationship between a recordist and the microphone blindly recording the sounds. The mechanical proxy of the microphone, and the disconnect between the intentionality of the artist and the neutrality of the recording device—a neutrality which mirrors nature's seeming indifference to humankind—is perhaps part of what recent sound art is rebelling against. "Sound occurs among bodies; that is, clapping my hands occurs in the presence of others, either as actual people in the room, directly in front of me, or in the other room and beyond, as eavesdroppers, intentional or not," Brandon LaBelle wrote in 2007. "Sound is produced and inflected not only by the materiality of space but also by the presence of others ... Thus, the acoustical event is also a social one."[50] This doesn't take into account how much sound art drew on sounds that occur in nature within earshot or not, or whether or not a human is there to record it.

It speaks to sound art's increased sourcing of human interactions, rather than its consideration of sound as an elemental force. Even when birds are perched on electric guitars in Bourgier-Mountenot's piece, the guitars intimate a human presence, an extension of the body, and a mass-manufactured consumer product.

Kevin Beasley's installation *A view of a landscape: a cotton gin motor* (2012–2018), displayed at the Whitney Museum in late 2018, epitomizes sound art loaded with the weight of cultural history and curiously both indebted to and detached from its own sound art precursors. Centered around a one-ton motorized cotton gin that Beasley purchased off eBay from its owner in Alabama, the gin is enclosed in a soundproof glass case in one room. Surrounded by seven different microphones picking up various sonic aspects of its motor running, the sound is fed into a neighboring, larger room and put through a synthesizer, metamorphosing as a fifteen-channel continual sound piece. There is a high-pitched drone and low churning sound, a persistent knocking that may be an untreated part of the machine's sound, additional white noise that is mainly audible when standing in front of the speaker it's directed to, and the occasional electronic squiggle suggesting a glitch or slight irregularity in the motor spinning. Benches in the room have also been wired to transmit a bass rumble from the subwoofers, which is felt when seated but not heard. There are also sound absorbing panels to further contain the sound. It was not a high-volume, dense, rainforest-like piece but more an ambient soundscape.

In some ways Beasley's installation is quintessential sound art: separating the sound entirely from its source and relaying it to a different space, utilizing sound as additional material from what is essentially a readymade, setting an enveloping, droning sound field in continual motion, putting sound not only in air but through physical objects. Visually, it resembles Paul Kos's *Sound of the Ice Melting*, where microphones also encircled the block of ice, and Beasley invited musicians to come in and perform with the piece, as La Monte Young was known to do with his own group during *Dream House* realizations. But the motor's sound is heavily processed by electronics, not used for its own character; and unlike Schaeffer's acousmatic approach, the sound source is not only visible but also part of the piece's title. The work is not about transmitting the sound as much as re-purposing the cotton gin, harnessing the sound of its operation rather than the machine's intended function. The gin's own history is double-edged: while cotton gins originally increased cotton production in the slavery-era US south, the motorized version in the installation, which had been in use from 1940 to 1973, had actually eliminated some of the need for workers

and played a part in breaking the cycle of sharecropping, which led to migrations north for different opportunities.[51] Much is made of the gin's sourcing near the civil rights crucible of Selma, Alabama and of cotton's role in Beasley's family's property in Virginia, and there were accompanying mixed-media sculptures by Beasley that go into cotton's role in African American history even more directly; however, there was no mention of sound art in either the curators' writing about the piece or its critical reception. The *New York Times* referred to it as an "electronic symphony"[52] and Beasley was described as playing the motor like a musical instrument in other instances. This is an example of a missed opportunity, where a sound piece, despite drawing on a half-century of sound art aesthetics (knowingly or not), is still chiefly received as music due to a lack of familiarity with the genre's history and hallmarks.

Where can sound art go next? Two emerging artists, Samson Young and Christine Sun Kim, may provide a clue. Both are exemplars of non-cochlear sonic art, but also represent a kind of sound art that transcends sound art, rather than replaces it, by transcending sound itself. Samson Young has a dual practice in music composition and visual art; his art, which encompasses performance, drawing, and video, is engaged with sound or music in one form or another yet seems quite distinct from his music. Young himself performs in many of his artworks: in *Canon* (2016), where an LRAD (long range acoustical device, a "sound cannon" mostly used to disperse crowds or scare away birds) shot birdcall recordings over a 150-foot space, he dressed in a 1979 colonial Hong Kong policeman's uniform and sang birdcalls in response; in *Pastoral Music* (2014–) he sings Cantonese nursery rhymes along the Gin Drinkers Line (the old Second World War-era British military defense buildings in Hong Kong); in *Nocturne* (2015), he took away the soundtrack from war zone footage he found on the internet and performed Foley effects to recreate the sounds of explosions and gunfire; and at the end of the multimedia walk *So You Are Old by the Time You Reach the Island* (2016), a blend of fictional narrative about Cold War-era spies and the sites of the more recent umbrella movement protests in Hong Kong, he sang love songs to each of the walkers over their cell phones. *Pastoral Music* is in line with other works discussed which use singing to signify cultural heritage, while *Canon* & *Nocturne* are politically minded—*Canon* de-weaponizing the LRAD while also referencing the 1979 Vietnamese refugee crisis in Hong Kong (a bench in the installation is marked "Skyluck," the name of the ship carrying the refugees, who were denied entry, and other ephemera related to the time is displayed).

Ultimately perhaps more of a performance artist than a sound artist, Young wants to show things to his audience rather than ask them to listen. The Foley effects in *Nocture* are only audible if you don headphones in gallery—one could easily visit the installation and hear nothing. The *Landschaft (Landscape)* (2015–) series are visual transcriptions of environmental recordings he's made (the recordings have not been made public) using watercolor, drawing, music staff notation, and onomatopoeia. The soundscape, then, is transformed into a visual representation. Young also has a series titled *Muted Situations* (2014), videos of concert performances of Western classical music without sound, so you only see the vocalists and/or instrumentalists playing but don't hear the music. This centralizes the social construct of a group of concert musicians in action; if *4'33"* asked the performer to abstain from playing the piano and the audience to forget the performance in favor of listening to sounds that are usually masked by the music, in blocking the audio a *Muted Situation* asks the audience to watch the performers' physiognomy and movement—and whatever emotion or psychology may lie behind it—instead of paying attention to sound. As a composer who writes for classical ensembles, Young is in essence deconstructing part of his own practice—he has another series where he decorates his own music scores with his drawings.

Christine Sun Kim's *Face Opera* (2013), in which a choir, including Kim herself, does not sing but uses only body movement and facial expressions, is a performance piece that also subtracts music from a concert situation. The difference is that Kim is deaf from birth, as are the other performers. *Face Opera* is not, for her, an alternate to an ordinary concert, but derives from a life experience that does not include hearing music—in fact, her entire conception of sound, she has said, is from watching other people respond to different sounds. Her own behavior has been shaped by what she terms "sound etiquette," i.e., not slamming a door or eating too loudly based on how people have reacted when she did such things.[53] Kim's life experience seems to echo the person-to-person ethos of recent sound art (and unlike other sound artists, most of the people who come upon Kim's work are able to hear; the typical listener-to-listener situation of sound art is not possible in her case). Like Young, Kim is translating sound into visual terms, but for Kim, that is also part of her daily communication, rather than being an aesthetic decision by a multidisciplinary artist.

Kim was originally a painter, but during a residency in Berlin in 2008 she noticed that the art galleries she frequented were only showing sound works, not visual art. Interested by what she perceived to be a trend, she began investigating

how to work with sound herself. She tried working with vibrations but this proved unsatisfactory; a crucial breakthrough came when she discovered the similarities between ASL (American Sign Language) and musical notation. ASL is a substitute for the voice, a method of translation into visual movement; notes are likewise a visual translation of pitches into symbols. Her drawings *All Day* and *All Night* (both 2012) are based on the arm movements that represent those phrases in ASL; other drawings use multiple *p*'s, the musical notation for *piano* meaning to be played softly, as a way of articulating an accumulated quiet that is almost incomprehensible (in music notation, a rest indicates silence, so the *p*'s also imply an impossibility of silence in music).

In late 2016, Kim did a series of soundwalks titled *(LISTEN)*, invoking Neuhaus's *Listen* walks in the same East Village neighborhood some fifty years before. The parentheses reference close-captioning on movies or television, where a sound effect is often bracketed, e.g., "(loud noise)." While Neuhaus said nothing during the walks while pointing out sound locations to his fellow walkers, Kim's walks consisted entirely of her commentary, expressed by a series of textual descriptions of sounds (some fairly abstract, like "the sound of uncertainty" or "the sound of not trying to smell") on an iPad, and of her memories or associations with the locations, spoken by an interpreter. The walkers could then compare those with their own, or with whatever sounds happened to be present during the walk. Sound is the theme of the walk, but not the objective; as with Corringham's walks, listening to someone's memories of the area is the purpose, although Corringham is gathering material from others' stories rather than sharing her own.

4x4 (2015) is indebted to another seminal sound artwork, Lucier's *I Am Sitting in a Room*. Kim wrote four songs and recorded them sung by four different voices. They were played back below audible range through four subwoofers arranged throughout a gallery space; the frequencies could only be felt, and rattled the gallery windows in some instances. Like Lucier, Kim used sound to activate a room's acoustics, but she did so in a non-auditory way. That she used songs rather than speech is another way of indicating music's absence from her primary experience to the visitor. Lucier used speech to be changed into tones by the room's acoustic; Kim used music to set off pure vibration. In Kim's work sound's presence doesn't need to be heard, and listening has to do with paying attention rather than hearing. In its own way, it raises consciousness about sound as much as any sound art of previous eras that relied on hearing.

There is a hint of relational aesthetics, an art trend identified in the mid-1990s that set up social situations in a gallery context (Rikrit Tiravanija's famous installation where he cooked and served Thai food, or Tino Sehgal's performances where he selected individuals to be in a gallery for conversations among themselves and with visitors being two examples) in some of Young and Kim's work and other recent socially oriented sound art. Their prioritization of visuals in dealing with sound, rather than the "eye and ear" equanimity of some sound art of the past, has made their work easier for the art world to digest, yet sound art risks losing some of its identity if too much weight is given to seeing rather than listening, and social consciousness over cosmic consciousness. If sound art was found to be lacking, in some way, a recognition of the social, that lack has been addressed. What remains now is to find a way reconcile the human and the universal within the scope of sound, and create new sound art works that possess a balanced sense of the genre's past, present, and future.

Notes

Preface

1 I only discovered it after finishing *Sound Art: Beyond Music, Between Categories*, but David Toop's *Haunted Weather* (2004), a meditation on sound and silence and a running account of Toop's own travels in the experimental music world of the late 1990s, is one of the most approachable books on the subject. While never described or marketed as a book about sound art, Toop's encounters with artists like Felix Hess, Ryoji Ikeda, Rolf Julius, Yasunao Tone, Stephen Vitiello, Christina Kubisch, Akio Suzuki, and Toshiya Tsunoda make for a congenial and informative guide to some of the genre's significant players.

2 Email to the author, December 7, 2007.

Part One

1 Bernd Schulz, *Resonances: Aspects of Sound Art* (Heidelberg: Kehrer Verlag, 2002), 14.

2 David Toop, "Sonic Boom," in *Sonic Boom* exhibition catalogue (London: Hawyard Gallery Publishing, 2000), 107.

3 "Glossary," Christoph Cox and David Warner, ed. *Audio Culture: Readings in Modern Music*, ed. (New York: Continuum Publishing, 2004), 415.

4 Caleb Kelly, ed. *Sound* (London/Cambridge: Whitechapel Gallery/MIT Press, 2011), 14.

5 Max Neuhaus, "Sound Art?" in *Volume: Bed of Sound* liner notes to exhibition CD catalogue (New York: PS1, 2000), accessed at www.max-neuhaus.info/soundworks/soundart/SoundArt.html.

6 Annea Lockwood, "What Is Sound Art?," accessed at http://emfinstitute.emf.org/articles/aldrich03/lockwood.html (no longer available online).

7 Neuhaus, "Sound Art?"

8 Quoted in Philip Sherburne, "This Artist Makes Music You've Never Seen Before and Art Like You've Never Heard Before," *Interview* (March 2005): 162.

9 Barbara London, "Soundings: From the 1960s to the Present," in *Soundings: A Contemporary Score* (New York: Museum of Modern Art, 2013), 10. An earlier usage of "sound art," on the cover of *The Something Else Yearbook 1974*, is discussed in Part Three.

10 Press release for "Sound Art" exhibition, Museum of Modern Art, NY, 1979, accessed at https://www.moma.org/documents/moma_press-release_327230.pdf.

11 Peter Frank, "Soundings at SUNY," *Art Journal* 42, no. 1 (Spring, 1982): 58.

12 Don Goddard, "Sound/Art: Living Presences," in *Sound/Art* exhibition catalogue (New York: The SoundArt Foundation, 1983), unpaginated.

13 Kevin Concannon, "Sound Sculpture," *Media Arts*, Fall 1985, 9.

14 Ibid.

15 Kevin Concannon, "Notes on Sound Art," *Art New England*, March 1986, 5.

16 Dan Lander and Micah Lexier, ed., *Sound by Artists* (Toronto/Banff: Art Metropole/Walter Phillips Gallery, 1990), 375.

17 Kate Lacey, "Auditory Capital, Media Publics and the Sounding Arts," in *The Routledge Companion to Sounding Art*, ed. Marcel Cobusser, Vincent Meelberg, and Barry Truax (New York: Routledge, 2017), 216.

18 Douglas Kahn, "The Arts of Sound and Music," accessed at http://www.douglaskahn.com/writings/douglas_kahn-sound_art.pdf.

19 Nic Collins, *At the Tone the Time Will Be…*, June 2000, accessed at https://www.nicolascollins.com/texts/atthetone.pdf.

20 Alvin Lucier, "Thoughts on Installations," Zeitgleich symposium text, 1995, accessed at http://kunstradio.at/ZEITGLEICH/CATALOG/ENGLISH/lucier-e.html.

21 Cathy Lane, "Why Am I a Sound Artist? Am I a Sound Artist? Some Thoughts on the Relationship between Music and Sound Art," in *Colloquium: Sound Art and Music*, ed. Thomas Gardner and Salomé Voegelin (Winchester: Zero Books, 2016), 79.

22 Conversation with the author, May 27, 2006, and in an email, June 24, 2006.

23 Bernard Baschet, "Structures Sonores," in *Sound Sculpture*, ed. John Grayson (Vancouver: ARC, 1975), 4.

24 Bill Fontana quoted in Julian Crowley, "Cross-Platform: Bill Fontana," *The WIRE*, April 2004, 82.

25 Ros Bandt, "Sound Installation: Blurring the Boundaries of the Eye, the Ear, Space and Time," *Contemporary Music Review* 25, no. 4 (August 2006): 358.

26 Ibid.

27 Max Neuhaus, "Lecture at Seibu Museum Tokyo, 1982," in *Max Neuhaus Sound Works Vol. 1*, ed. Neuhaus & Gregory des Jardins (Ostfildern: Cantz Verlag, 1994), 58.

28 Max Neuhaus, "Conversation with Ulrich Loock," in *Max Neuhaus Sound Works Vol. 1*, ed. Neuhaus & Gregory des Jardins (Ostfildern: Cantz Verlag, 1994), 124.

29 Conversation with the author, May 27, 2006.

30 Quoted in Donald F. Richards, "The Creative Ear: The ABC's The Listening Room and the Nurturing of Sound Art in Australia" (Doctorate diss., School of Contemporary Arts, College of Arts Education and Social Sciences, University of Western Sydney, 2003), 155.

31 Ros Bandt, "Taming the Wind: Aeolian Sound Practices in Australasia," *Organised Sound* 8, no. 2 (2003): 200.

32 R. Murray Schafer, *The Soundscape: Our Sonic Environment and the Tuning of the World* (1977: repr. Rochester, VT: Destiny Books, 1994), 11.

33 Jonathan Cott, *Stockhausen: Conversations with the Composer* (New York: Simon & Schuster, 1973), 212.

34 Carsten Seiffarth, "About Sound Installation Art," *Kunstjournalen B-post* No. 1_12, accessed at https://b-post.no/en/12/seiffarth.html.

35 Quoted in Heidi Grundmann, *Re-Play* exhibition catalogue text, 2000, accessed at http://www.kunstradio.at/REPLAY/cat-text-eng.html.

36 Jørgen Larsson, "Sound Art in 2012," *Kunstjournalen B-post* No. 1_12, accessed at https://b-post.no/en/12/larsson.html.

37 Laura Maes and Marc Leman, "Defining Sound Art," in *The Routledge Companion to Sounding Art*, 30.

38 Quoted in Seiffarth, "About Sound Installation Art."

39 Interview with Sabine Breitsameter, *Audiohyperspace* (September 2002), accessed at https://www.swr.de/swr2/audiohyperspace/ (no longer available online).

40 Frances Dyson, "Art: Sound: Matter," lecture at Sound Art Matters conference, Aarhus University, June 2016. Video accessed at https://www.youtube.com/watch?v=Iq7cfwqp-wE.

41 Quoted in Alicia Zuckerman, "Max Neuhaus' Times Square," *Arts Electric*, 2002, accessed at http://www.arts-electric.org/articles0203/020530.neuhaus.html (no longer available online).

42 Bill Fontana, "Resoundings," accessed at http://resoundings.org/Pages/Resoundings.html.

43 Interview in *Ask the Artists: Janet Cardiff*, Carnegie International 1999/2000, accessed at www.cmoga.com (no longer available online).

44 Brandon LaBelle, "Speaking Volumes," accessed at http://soundartarchive.net/articles/Labelle-xxxx-Speaking%20Volumes.pdf.

45 Ibid.

46 Tom Johnson, "The Max Neuhaus Beep: But What's It For?" in *The Voice of New Music: New York City 1972–1982* (Eindhoven: Het Apollohuis, 1989), 84.

Part Two

1 Donald Goddard, "Sound/Art: Living Presences," in *Sound/Art* exhibition catalogue (New York: The SoundArt Foundation, 1983), unpaginated.

2 Alberto Cavalcanti, "Sound in Films," in *Film Sound: Theory and Practice*, ed. Elisabeth Weis and John Belton (New York: Columbia University Press, 1985), 98.

3 Michael Ondaatje, *The Conversations: Walter Murch and the Art of Editing Film* (New York: Alfred A. Knopf, 2002), 112.

4 Walter Ruttmann, "Neue Gestaltung von Tonfilm und Funk. Programm einer photographischen Hörkunst," in *Film-Kurier*, October 26, 1929, no. 255, p. 1.

5 Christoph Cox and Daniel Warner, introduction to "II. Modes of Listening," in *Audio Culture: Readings in Modern Music*, ed. Cox and Warner (New York: Continuum, 2004), 65.

6 Quoted in Gavin Bryars, "Vexations and Its Performers" (1983) *JEMS: An Online Journal of Experimental Music Studies,* accessed at http://www.gavinbryars.com/work/writing/occasional-writings/vexations-and-its-performers http://www.users.waitrose.com/~chubbs/Bryars.html.

7 Stephen Whittington, "Serious Immobiles: On the Centenary of Erik Satie's Vexations," The University of Adelaide, Australia, 1999, accessed at http://hymns.reactor-core.org/secular/Vexations.html.

8 Quoted in Arnold Aronson, *American Avant-Garde Theatre: A History* (London: Routledge, 2000), 115.

9 Ibid.

10 Bill Fontana, "Resoundings," accessed at http://resoundings.org/Pages/Resoundings.html.

11 Bernhard Leitner and Ulrich Conrads, "Acoustic Space: A Conversation between Bernhard Leitner and Ulrich Conrads," in *DAIDALOS*, no. 17 (September 1985), accessed at http://www.bernhardleitner.at/texts.

12 Bela Belazs, "Theory of Film: Sound," in *Film Sound: Theory and Practice*, 124.

13 Brian Eno, "The Studio as Compositional Tool," in *Audio Culture*, 128.

14 Glenn Gould, "The Prospects of Recording," in *The Glenn Gould Reader*, ed. Tim Page (New York: Vintage Books, 1990), 347.

15 Bill Viola, "The Sound of One Line Scanning," in *Sound by Artists*, ed. Dan Lander and Micah Lexier (Toronto/Banff: Art Metropole/Walter Phillips Gallery, 1990), 41.

16 Quoted in Julian Crowley, "Cross-Platform: Bill Fontana," *The WIRE*, April 2004, 82.

17 Viola, "The Sound of One Line Scanning," 41.

18 Leitner and Conrads, "Acoustic Space."

19 Ibid.

20 Edgard Varèse, "The Liberation of Sound," *Audio Culture*, 19.

21 Jonathan Cott, *Stockhausen: Conversations with the Composer* (New York: Simon & Schuster, 1973), 204.

22 Ibid., 200–201.

23 Ibid., 212.

24 Marcel Duchamp, "Musical Sculpture c. 1912–21," in *Sound*, ed. Caleb Kelly (London/Cambridge MA: Whitechapel Gallery/MIT Press, 2011), 168.

25 Laszlo Moholy-Nagy, "Theater, Circus, Variety," in *The Theater of the Bauhaus*,
 ed. Walter Gropius and trans. Arthur S. Wensinger (Middletown, CT: Wesleyan
 University Press, 1961), 94; cited in Dore Ashton, "Sensoria," in *Soundings*
 exhibition catalogue (Purchase, NY: The Neuberger Museum, 1981), 19.

26 Douglas Kahn, *Noise Water Meat: A History of Sound in the Arts* (Cambridge, MA:
 MIT Press, 1999), 108.

27 Carsten Seiffarth, "About Sound Installation Art," *Kunstjournalen B-post*, no. 1_12,
 accessed at https://b-post.no/en/12/seiffarth.html.

28 "Pierre Henry 'Spatiodynamisme' 7" single (with Nicolas Schöffer book)"
 Continuo weblog entry, February 22, 2010, accessed at https://continuo.wordpress.
 com/2010/02/22/pierre-henry-spatiodynamisme-7-single-with-nicolas-schoffer-
 book/.

29 "Eliane Radigue Interview," in *Prism Escape Journal*, no. 4 (2004), accessed at http://
 www.ideologic.org/news/view/eliane_radigue_interview.

30 La Monte Young, "Lecture 1960," in *La Monte Young Marian Zazeela Selected
 Writings*, ed. Young and Zazeela (Munich: Heiner Friedrich, 1969), unpaginated.

31 La Monte Young, "The Romantic Symmetry (over a 60 cycle base) from The
 Symmetries in Prime Time from 144 to 112 with 119 (89 I 30 NYC)," in *Sound and
 Light: La Monte Young and Marian Zazeela*, ed. William Duckworth and Richard
 Fleming (Lewisburg: Bucknell University Press, 1996), 215.

32 Quoted in Liz Kotz, "Max Neuhaus: Sound into Space," in *Max Neuhaus: Times
 Square, Time Piece Beacon*, ed. Lynne Cooke, Karen Kelly, and Barbara Schröder
 (New York: Dia Art Foundation, 2009), 103.

33 Bernhard Leitner, "Sound Space Manifesto," (1977), accessed at https://www.
 bernhardleitner.at/texts.

34 Max Neuhaus, "Conversation with Ulrich Loock," in *Max Neuhaus Sound Works
 Volume 1*, ed. Neuhaus and Gregory des Jardins (Ostfildern: Cantz Verlag,
 1994), 123.

35 Max Neuhaus, "Three Similar Rooms," 1990, accessed at http://www.exibart.com/
 profilo/eventiV2.asp?idelemento=72468.

36 Neuhaus, "Conversation with Ulrich Loock," 123.

37 Doris von Drathen, "Max Neuhaus: Invisible Sculpture, Molded Sound," in *Max
 Neuhaus Sound Works Vol. 1*, 111.

38 Neuhaus, "Untitled," drawing from 1992, in *Max Neuhaus: Evocare l'udible/ Evoquer
 l'auditif exhibition catalogue* (Milan: Charta, 1995), 51.

39 Carter Ratcliff, "Space, Time and Silence: Max Neuhaus' Sound Installations," in
 Max Neuhaus Sound Works Vol. 1, 26.

40 Tom Johnson, "Creating the Context: Max Neuhaus," in *The Voice of New Music:
 New York City 1972–1982*, ed. Tom Johnson (Eindhoven: Het Apollohuis,
 1989), 255.

41 Charles Eppley, "Circuit Scores: An Interview with Liz Phillips," *Avant.org*, April 8, 2016, accessed at http://avant.org/artifact/liz-phillips/.

42 Liz Phillips, "Sound Structures," *Radical Software* 1, no. 3 (Spring 1971): 8.

43 Tony Reveaux, "The Responsive Rocks," in *Artweek*, December 26, 1987, 5.

44 Joyce Hinterding, "Sensitive Systems and Abstract Machines, The Experience of," in "CD Companion Contributors Notes," *Leonardo Music Journal* 6 (1996): 114.

45 "Alvin Lucier in Conversation with Douglas Simon," in *Sound by Artists*, 196.

46 Caleb Kelly, *Gallery Sound* (New York: Bloomsbury, 2017), 70.

47 R. Murray Schafer, "The Music of the Environment," in *Audio Culture*, 32.

48 Ibid.

49 R. Murray Schafer, *The Soundscape: Our Sonic Environment and the Tuning of the World* (1977: repr. Rochester, VT: Destiny Books, 1994), 104.

50 Ibid.

51 Ibid.

52 Michael Nyman, *Experimental Music: Cage and Beyond*, 2nd edition (1974: repr. Cambridge, England: Cambridge University Press, 1999), 59.

53 Cott, *Stockhausen*, 210–211.

54 Hildegard Westerkamp, "Soundwalking," *Sound Heritage*, no. 3/4 (1974): 25; cited in Andra McCartney, "Soundscape Works, Listening, and the Touch of Sound," in *Aural Cultures*, ed. Jim Drobnick (Toronto/Banff: YYZ Books/Walter Phillips Gallery, 2004), 181.

55 Luigi Russolo, "The Art of Noises: Futurist Manifesto," in *Audio Culture*, 11.

56 Ibid., 11–12.

57 Ibid., 12.

58 Karin v. Maur, *The Sound of Painting: Music in Modern Art* (Munich: Prestel Verlag, 1999), 121.

59 Kahn, *Noise Water Meat*, 130; Caroline Potter, *Erik Satie: A Parisian Composer and His World* (Woodbridge, UK: Boydell & Brewer, 2016), 61.

60 La Monte Young, liner notes to *The Second Dream of the High-Tension Line Stepdown Transformer from the Four Dreams of China* CD, Gramavision, 1991.

61 Ibid.

62 Tony Conrad, "Inside the Dream Syndicate," *Film Culture*, no. 41 (Summer 1966): 5.

63 Ibid., 6.

64 Quoted in Victor Bockris and Gerard Malanga, *Up-Tight: The Velvet Underground Story* (New York: Quill, 1983), 13.

65 La Monte Young, "Dream House," in *Selected Writings*, ed. La Monte Young and Marian Zazeela (Munich: Heiner Friedrich, 1969), unpaginated. Note that 50 Hz is the European standard and the essay was written for the opening of a Dream House at Galerie Heiner Friedrich in Munich, Germany.

66 Varèse, "The Liberation of Sound," 20.

67 Michael Zwerin, "A Lethal Measurement," in *John Cage*, ed. Richard Kostelanetz (New York: Praeger, 1970), 166. Quoted in Kahn, *Noise Water Meat*, 163.

68 Ibid., 188.

69 Edward Strickland, "The Well-Tuned Piano: An Interview with La Monte Young," *Fanfare* 11, no. 1 (September/October 1987): 85.

70 Ugochukwu-Smooth Nzewi, "Lagos Soundscape: An Interview with Sound Artist Emeka Ogboh," *theculturetrip.com* (2013), accessed at https://theculturetrip.com/africa/nigeria/articles/lagos-soundscapes-an-interview-with-sound-artist-emeka-ogboh/.

71 Ibid.

72 Suzaan Boettger, *Earthworks: Art and the Landscape of the Sixties* (Berkeley: University of California Press, 2002), 24–25.

73 Ibid., 25.

74 Ibid., 116.

75 Linda Yablonsky, "Sound Garden," *New York Times Style Magazine*, March 30, 2012, accessed at https://www.nytimes.com/2012/04/01/t-magazine/doug-aitkens-sound-garden.html.

76 Frank Oteri, "Annea Lockwood beside the Hudson River," *New Music Box*, January 1, 2004, accessed at https://nmbx.newmusicusa.org/annea-lockwood-beside-the-hudson-river/.

77 "Biographical Details" at hildegardwesterkamp.ca, accessed at http://www.sfu.ca/~westerka/bio.html.

78 Michael Parsons, "The Scratch Orchestra and the Visual Arts," *Leonardo Music Journal* 11 (2001): 7.

79 Ibid.

80 Tom Johnson, "Jon Hassell: Solid State," in Johnson, *The Voice of New Music*, 119.

81 Bill Fontana, "The Environment as a Musical Resource" (2000), accessed at http://resoundings.org/Pages/musical%20resource.html.

82 "Maryanne Amacher: City Links," exhibition booklet, Ludlow 38, 2010, accessed at http://www.ludlow38.org/files/mabooklet.pdf.

83 Quoted in Leah Durner, "Maryanne Amacher: Architect of Aural Design," *EAR* (February 1990): 29.

84 Liza Béar and Willoughby Sharp, "Discussion with Heizer, Oppenheim, Smithson," in *Robert Smithson: The Collected Writings*, ed. Jack Flam (Berkeley: University of California Press, 1996), 246.

85 Francisco Lopez, "Profound Listening and Environmental Sound Matter," in *Audio Culture*, 86.

86 Quoted in Boettger, *Earthworks*, 57.

87 Conversation with the author, May 26, 2006.

88 Boettger, *Earthworks*, 211.

89 Seiffarth, "About Sound Installation Art."

90 Les Levine, "The Disposable Transient Environment," *0 to 9*, no. 5 (1969): 41.

91 Gwen Lee and Doris Elaine Sauter, eds., *What If Our World Is Their Heaven? The Final Conversations of Philip K. Dick* (New York: Overlook Press, 2003), 69.

92 Kahn, *Noise Water Meat*, 196–197.

93 The premiere of *Rainforest V* was at the Inside Out exhibition at Laborotorio Arte Alameda in Mexico City, curated by the author.

94 Liner notes to *The Sounds of Sound Sculpture* LP, ARC Recordings, 1975.

95 Ralph T. Coe, "Breaking the Sound Barrier," in *Sound*, ed. Caleb Kelly (London/ Cambridge MA: Whitechapel Gallery/MIT Press, 2011), 57–59.

96 Marita Sturken, "TV as a Creative Medium: Howard Wise and Video Art," in *Afterimage*, May 1984, 8.

97 Renny Pritikin, "Interview with Paul DeMarinis," *www.artpractical.com* 3.13/The Sound Issue (April 19, 2012), accessed at https://www.artpractical.com/feature/ interview_with_paul_demarinis/%20%20depends%20on%20radio/.

98 Maryanne Amacher notes on structure-borne sound *c.* 1988, accessed at http:// www.ludlow38.org/files/oei54-542011p845-865.pdf.

99 Quoted in an interview with Wolfgang Pehnt, *Künstler im Gespräch, Documenta- Documente* (Cologne: Artemedia, 1984), accessed at http://www.bernhardleitner. at/texts (no longer available online).

100 Ibid.

101 Tom Johnson, "The Evolution of Jim Burton," in Johnson, *The Voice of New Music*, 155–156.

102 Quoted in Rene van Peer, *Interviews with Sound Artists Taking Part in the Festival ECHO* (Eindhoven: Het Apollohuis, 1987), 86.

103 Christoph Cox, "Positive Feedback: Alvin Lucier," in *The WIRE*, July 2004, 46.

104 Ellen Fullman interview by Xavier Hug, April 2, 2016, accessed at https://static1. squarespace.com/static/57a56154ebbd1acee615687c/t/5845f017e6f2e12d64ca6c 1c/1480978456580/Xavier+Hug+Interview%2C+April+2%2C+2016.pdf.

105 Ros Bandt, "Taming the Wind: Aeolian Sound Practices in Australasia," *Organised Sound* 8, no. 2 (2003): 196.

106 Ibid., 195.

107 Ibid., 197.

108 Max Eastley, "Aeolian Instruments," *Musics*, no. 5 (December 1975/January 1976): 22.

109 "radiOM: MOCA-FM: Sound Sculpture As," accessed at http://radiom.org/detail. php?omid=MFM.1970.04.30.c3.

110 Quoted in Heidi Grundmann, *Re-Play* exhibition catalogue text, 2000, accessed at http://www.kunstradio.at/REPLAY/cat-text-eng.html.

111 Eno, "The Studio as a Compositional Tool," in *Audio Culture*, 128.

112 Robin Minard, "Musique Concrète and Its Importance to the Visual Arts," in *Resonances: Aspects of Sound*, ed. Bernd Schulz (Heidelberg: Kehrer Verlag, 2002), 46.

113 Fontana, "Resoundings."

114 Ibid.

115 Paula Rabinowitz, "The Sound of Reformed Space: Liz Phillips' Responsive Installations," in *PAJ: A Journal of Performance and Art* 24, no. 3 (September 2002): 36.

Part Three

1 Morton Feldman, "Between Categories," in *Give My Regards to Eighth Street: Collected Writings of Morton Feldman* (Cambridge MA: Exact Change, 2000), 86.

2 Karin v. Maur, *The Sound of Painting: Music in Modern Art* (Munich: Prestel Verlag, 1999), 33–35.

3 Ibid., 102–103.

4 Bernhard Gal, "Updating the History of Sound Art: Additions, Clarifications, More Questions," in *Leonardo Music Journal* 27, 1 (December 2017), 79.

5 Jean Dubuffet, "Musical Experiences," in *Broken Music: Artists' Recordworks*, ed. Ursula Block and Michael Glasmeier (Berlin: DAAD/Gelbe Musik, 1989), 69.

6 Quoted in Edwin Pouncey, "Anti-Rock Consortium: Mike Kelley," *The WIRE*, September 2003, 36.

7 Douglas Kahn, *Noise Water Meat: A History of Sound in the Arts* (Cambridge MA: MIT Press, 1999), 168.

8 Feldman, "The Viola in My Life," in *Give My Regards to Eighth Street*, 90.

9 Matthew Shlomowitz, "Cage's Place in the Reception of Satie," DR diss., University of California, San Diego, 1999, accessed at http://www.shlom.com/?p=cagesatie.

10 Allan Kaprow, "A Statement," in *Happenings*, ed. Michael Kirby (New York: Dutton, 1965), 46.

11 Kahn, *Noise Water Meat*, 275.

12 Michael Nyman, *Experimental Music: Cage and Beyond*, 2nd edition (1974: repr. Cambridge, England: Cambridge University Press, 1999), 75.

13 Quoted in Douglas Kahn, "The Latest: Fluxus and Music," in *Sound*, ed. Caleb Kelly (London/Cambridge MA: Whitechapel Gallery/MIT Press, 2011), 36.

14 Feldman, "The Anxiety of Art," in *Give My Regards to Eighth Street*, 30.

15 Quoted in Jean Yves Bosseur, *Sound and the Visual Arts: Intersections between Music and the Plastic Arts Today* (Paris: Dis Voir, 1997), 90.

16 Quoted in Alan Licht, "Random Tone Bursts: Yasunao Tone," *The WIRE*, September 2002, 32.

17 Quoted in Bosseur, *Sound and the Visual Arts*, 105.

18 Ibid., 97.

19 Christine Kozlov, "Information: No Theory," accessed at http://www.ubu.com/papers/kozlov_information.html.

20 "Interview (October 12, 1969): Robert Barry," accessed at http://www.ubu.com/papers/barry_interview.html.

21 Alexander Alberro, *Conceptual Art and the Politics of Publicity* (Cambridge MA: MIT Press, 2003), 118.

22 Ibid., 115.

23 Catherine Moseley ed., *Conception. Conceptual Documents 1968 to 1972*, exhibition catalogue (Norwich: Norwich Gallery, 2001), 18.

24 Quoted in Arthur Rose "Four Interviews with Arthur Rose," *Arts*, February 1969; excerpted in Lucy Lippard, *Six Years: The Dematerialization of the Art Object from 1966 to 1972* (New York: Praeger, 1973), 72.

25 Johnson, "Laurie Anderson at the Holly Solomon Gallery," in *The Voice of New Music: New York City 1972–1982* (Eindhoven: Het Apollohuis, 1989), 271.

26 Ibid., 272.

27 Bill Viola, "The Sound of One Line Scanning," in *Sound by Artists*, ed. Dan Lander and Micah Lexier (Toronto/Banff: Art Metropole/Walter Phillips Gallery, 1990), 43–44.

28 Ibid., 46.

29 Bill Viola, "David Tudor: The Delicate Art of Falling," *Leonardo Music Journal* Vol. 14 (2004), 52.

30 Marcella Beccaria, "Bill Viola," in *Video Art: The Castello di Rivoli Collection*, ed. Ida Ginarelli and Marcella Beccaria (Milan: Skira Editore, 2005), 242–243.

31 Ian McMillan, "Wednesday on the Ranch with Bruce," *Modern Painters*, December 2004, 72.

32 The other performers were artists Michael Snow and Richard Serra, Reich, and composer James Tenney. "Pendulum Music" involved letting a microphone swing over a loudspeaker placed on its back, creating feedback squeaks that settle into a continuous tone when the microphone stops moving. Reich has termed it "audible sculpture," because of the foregrounding of the equipment in the piece, although given the swinging of the microphone one is tempted to consider it as a form of Kinetic art as well as a music composition.

33 See Joan Simon, "Hear Here," *Frieze.com*, October 10, 2004.

34 Quoted in an interview with Bob Smith in *Please Pay Attention Please: Bruce Nauman's Words, Writings, and Interviews*, ed. Janet Kraynak (Cambridge, MA: MIT Press, 2003), 303.

35 Ibid., 328.

36 Lucia Cerizza, "The Gallerist: René Block and Experimental Music, 1965–1980," www.art-agenda.com December 15, 2015, accessed at http://www.art-agenda.com/reviews/the-gallerist-rene-block-and-experimental-music-1965–1980-part-iiiii/.

37 Ibid.

38 Ibid.

39 Seth Cluett, "Ephemeral, Immersive, Invasive: Sound as Curatorial Theme, 1966–2013," in *The Multi-Sensory Museum: Cross-Disciplinary Perspective on Touch, Sound, Smell, Memory, and Space*, ed. Nina Levent and Alvaro Pascual-Leone (New York: AltaMira Press, 2013), 114.

40 Don Goddard, "Sound/Art: Living Presences," in *Sound/Art* exhibition catalogue (New York: The Soundart Foundation, 1983), unpaginated.

41 Bernd Schulz, introduction to *Resonances: Aspects of Sound Art*, ed. Schulz (Heidelberg: Kehrer Verlag, 2002), 18.

42 Helga de la Motte-Habe, "Site-Specific Art: Ten Years of the Singuhr Sound Gallery," in *Singuhr-Hoergalerie in Parochial: Sound Art in Berlin 1996—2006*, ed. Carsten Seiffarth and Markus Steffens (Heidelberg: Kehrer Verlag, 2010), 21.

43 Ibid.

44 Ibid., 23.

45 Panel discussion with Carsten Seiffarth and Bernd Schulz, Sense of Sound Symposium, z33, Hasselt Belgium, May 22, 2014, accessed at https://www.youtube.com/watch?v=49Lor893O-A&list=PLC6kdaOAsRYLak1pmZIdLFbkDGI5oG65N.

46 "Pierre Berthet Extended Drops July 2 2010—September 12 2010," at www.singhur.de, accessed at http://singuhr.de/page.php?ID=690&language=ENG.

47 Carsten Seiffarth, "Sound Art in Germany: A Look at a Young Genre," www.goethe.de January 2009, accessed at https://www.goethe.de/en/kul/mus/gen/neu/str/4090690.html.

48 Panel discussion, Seiffarth and Schulz.

49 Jørgen Larsson, "Sound Art in 2012," *Kunstjournalen B-post* No. 1_12 Sound (2012), accessed at https://b-post.no/en/12/larsson.html.

50 Carsten Seiffarth, "About Sound Installation Art," *Kunstjournalen B-post* No. 1_12 (2012), accessed at https://b-post.no/en/12/seiffarth.html.

51 Helga de la Motte-Haber, *Klangkunst: Tönende Objekt und klingende Räume (Handbook of Twentieth Century Music)* (Laaber: Laaber Verlag, 1999), 95, cited in Seiffarth, "About Sound Installation Art."

52 Kersten Glandien, "… Too Wide a Field: Sound Art in Berlin," www.seisomgraf.org May 5, 2015, accessed at http://seismograf.org/artikel/too-wide-a-field-sound-art-in-berlin.

53 Carsten Seiffarth lecture on Singuhr in Berlin, a project for sound art installations, Sweden, 2015, accessed at https://www.youtube.com/watch?v=OttN2w3gE5U.

54 Ibid.

55 Andrew McLennan, "A Brief Topology of Australian Sound Art and Experimental Broadcasting," 1994, accessed at http://soundartarchive.net/articles/ McLennan-1994-%20A%20Topology%20of%20Australian%20Radio%20&%20 Sound%20Art.pdf; Warren Burt, "Some Musical and Sociological Aspects of Australian Experimental Music," *Resonate*, July 31, 2007, accessed at https://www. australianmusiccentre.com.au/article/some-musical-and-sociological-aspects-of- australian-experimental-music.

56 Rebecca Coyle, "Sound in Space: A Curatorial Perspective," in *Sound in Space: Adventures in Australian Sound Art* exhibition catalogue (Sydney: Museum of Contemporary Art, 1995), accessed at http://www.sounddesign.unimelb.edu.au/ web/biogs/P000451b.html.

57 Ros Bandt, "Sound Sculpture Chapter 3 in full," excerpt from Bandt, *Sound Sculpture: Intersections in Sound and Sculpture in Australian Artworks* (North Ryde, NSW: Craftsmen House, 1999), accessed at http://www.digital-music-archives.com/ webdb2/application/Application.php?fwServerClass=ProductDetail&ProductCode =BKE0003.

58 Burt, "Some Musical and Sociological Aspects of Australian Experimental Music."

59 Ibid.

60 Ibid.

61 Linda Ioanna Kouvaras, *Loading the Silence: Australian Sound Art in the Post- Digital Age* (Burlington: Ashgate Publishing, 2013), 79–90.

62 Douglas Kahn, "The Arts of Sound and Music," accessed at http://www. douglaskahn.com/writings/douglas_kahn-sound_art.pdf.

Part Four

1 Nauman made a three-channel video, *End of the World* (1996), which showed musician Lloyd Maines playing the titular song on dobro, pedal steel, and lap steel guitars. The channels' timings were staggered so the song overlapped on itself, creating static harmonies with chords stacked on top of each other. Notably, Nauman elected to have a professional musician perform the song, as opposed to his own attempts at violin playing in his earlier films.

2 Charlotte Higgins, "Susan Philipsz: Lament for a Drowned Love," *The Guardian*, April 4, 2010, accessed at https://www.theguardian.com/artanddesign/2010/apr/04/ susan-philipsz-glasgow-international-interview.

3 Video embedded online in Charlotte Higgins, "Susan Philipsz: Sonic Boom," *The Guardian*, December 7, 2010, accessed at https://www.theguardian.com/ artanddesign/2010/dec/07/susan-philipsz-turner-prize.

4 Lisa Kosan, "Sculpting with Sound: Susan Philipsz," interview for Peabody
 Essex Museum website, accessed at http://staging2.pem.org/writable/resources/
 document/sculpting_with_sound_susan_philipsz_interview.pdf.

5 Anna Savitskaya, "'Sound Has Always Been My Primary Tool'—Interview with
 Susan Philipsz About Her Sound Installations and More," artdependence.com,
 January 9, 2015, accessed at https://www.artdependence.com/articles/sound-has-
 always-been-my-primary-tool-interview-with-susan-philipsz-about-her-sound-
 installations-and-more/.

6 Unidentified contributor, "Reverberations: In Conversation with Susan Philipsz,"
 fourbythreemagazine.com, accessed at http://www.fourbythreemagazine.com/
 issue/silence/susan-philipsz-interview.

7 Higgins, "Susan Philipsz: Lament for a Drowned Love."

8 Peter Coffin and Jen De Nike, "WSP1 Venice Interviews: Susan Philipsz," video 2005,
 accessed at http://clocktower.org/show/wps1-venice-interviews-susan-philipsz.

9 Savitskaya, "'Sound Has Always Been My Primary Tool'—Interview with Susan
 Philipsz About Her Sound Installations and More."

10 "Turner Prize 2010: Susan Philipsz" video at Tate Modern website, October 22,
 2010, accessed at https://www.tate.org.uk/context-comment/video/turner-prize-
 2010-susan-philipsz.

11 Jessica Feldman, "The Trouble with Sounding: Sympathetic Vibrations and Ethical
 Relations in 'Soundings: A Contemporary Score' at the Museum of Modern Art,"
 Ear / Wave / Event Issue One, Spring 2014, accessed at http://earwaveevent.org/
 article/the-trouble-with-sounding-sympathetic-vibrations-and-ethical-relations-in-
 soundings-a-contemporary-score-at-the-museum-of-modern-art/.

12 Savitskaya, "'Sound Has Always Been My Primary Tool'—Interview with Susan
 Philipsz About Her Sound Installations and More."

13 Quoted in Linda Yablonsky, "Haroon Mirza: Acoustic Space," in *Flash Art*, no. 286,
 (October 2012), accessed at https://www.flashartonline.com/article/haroon-mirza/.

14 Quoted in Nicole Cone, "Kevin Beasley's Moment Is Yours/Studio Visits," in
 Creators/Vice.com, May 13, 2016, accessed at https://creators.vice.com/en_us/
 article/qkw5dp/sound-sculptor-kevin-beasley-studio-visits.

15 Quoted in Alicia Zuckerman, "Max Neuhaus' Times Square," *Arts Electric*, 2002,
 accessed at http://www.arts-electric.org/articles0203/020530.neuhaus.html (no
 longer available online).

16 Nicholas Forrest, "Ryoji Ikeda: Artistic Genius or Maths Magician?" in
 BluoinArtInfo Australia, June 28, 2013, accessed at http://au.blouinartinfo.com/
 news/story/922562/ryoji-ikeda-artistic-genius-or-maths-magician.

17 Quoted in Michael H. Miller, "Infinite Quest: Ryoji Ikeda Wants to Disappear," *The
 New York Observer*, May 18, 2011, accessed at http://observer.com/2011/05/infinite-
 quest-ryoji-ikeda-wants-to-disappear/.

18 Brian Eno, liner notes to *Ambient #1: Music for Airports LP*, Editions E.G., 1978.

19 Sam Adams, "Sounds on the Fringe," *Philadelphia City Paper*, August 28–September 4, 1997.

20 Ibid.

21 Russell Ferguson, "The Variety of Din," in *Christian Marclay* exhibition catalogue (Los Angeles, CA: UCLA Hammer Museum, 2003), 19.

22 Jim Drobnick, "Listening Awry," in *Aural Cultures*, ed. Drobnick (Toronto/Banff: YYZ Books/Walter Phillips Gallery, 2004), 10.

23 Marcel Cobussen, Vincent Meelberg, and Barry Truax, General Introduction to *The Routledge Companion to Sounding Art*, ed. Cobussen, Meelberg and Truax (New York: Routledge, 2017), 5.

24 R. Murray Schafer, "The Soundscape, 1977," in *Sound*, ed. Caleb Kelly (London/ Cambridge: Whitechapel Gallery/MIT Press, 2011), 111.

25 Emily Ann Thompson, "Sound, Modernity, and History, 2002," in *Sound*, 117.

26 Chloë Bass, "When Institutional Critique Doesn't Go Far Enough," in *Hyperallergic*, March 8, 2016, accessed at https://hyperallergic.com/281630/when-institutional-critique-doesnt-go-far-enough/.

27 Ultra-Red, "Organizing the Silence," in *Audio Culture Revised Edition*, ed. Christoph Cox and Daniel Warner (New York: Bloomsbury, 2017), 161.

28 Feldman, "The Trouble with Sounding: Sympathetic Vibrations and Ethical Relations in 'Soundings: A Contemporary Score' at the Museum of Modern Art."

29 Michael Glasmeier, "Music of the Angels," in *Broken Music: Artists Recordworks*, ed. Ursula Block and Glasmeier (Berlin: DAAD/Gelbe Musik, 1989), 27.

30 Jøran Rudi, "*Norge—et lydrike, Norway Remixed*: a sound installation," in *Organised Sound* 8, no. 2 (2003): 152.

31 Brenda Hutchinson, "Sound, Listening, and Public Engagement," in *Ear/Wave/ Event Issue 2*, 2015, accessed at http://earwaveevent.org/article/sound-listening-and-public-engagement/.

32 Viv Corringham, talk at Deep Listening Institute about "Shadow-Walks," accessed at http://vivcorringham.org/shadow-walks.

33 Joshua Reiman, "The Shape of Sound: A Conversation with Julianne Swartz," in *Sculpture* 36, no. 4 (May 2017): 47.

34 Quoted in Unidentified contributor, "Sonic Arcade: Interview with Julianne Swartz," Museum of Arts and Design website, December 6, 2017, accessed at https://madmuseum.org/views/sonic-arcade-interview-julianne-swartz.

35 Artist's statement accessed at http://fonik.dk/works/wall.html.

36 Anne Hilde Neset, "Q &A: Interview with Christina Kubsich," in *Her Noise* exhibition catalogue, ed. Neset and Lina Džuverović (Newcastle upon Tyne: forma, 2005), 38.

37 Email to the author, October 6, 2018.

38 Andy Warhol and Pat Hackett, *Popism: The Warhol 60s* (New York: Harper & Row, 1980), 291.

39 Brandon LaBelle, *Background Noise: Perspectives on Sound Art* (New York: Continuum, 2006), x.

40 Leigh Landy, "But Is It (Also) Music?" in *The Routledge Companion to Sounding Art*, 19.

41 Andrew Raffo Dewar, "Handmade Sounds: The Sonic Arts Union and American Technoculture," (DR diss, Wesleyan University, Middletown CT, 2009), 53.

42 Corbussen, Meelberg, and Truax, General Introduction to *The Routledge Companion to Sounding Art*, 2.

43 Ibid.

44 Seth Kim-Cohen, *In the Blink of an Ear: Towards a Non-Cochlear Sonic Art* (New York: Continuum, 2009), xxi.

45 Gerald Hartnett, "Ballast Reduction & the Audio Arts," in *Leonardo Music Journal* 6 (1996): 5.

46 Kim-Cohen, *In the Blink of an Ear*, 157.

47 Ibid., 179.

48 Luc Ferrari, "I Was Running in So Many Different Directions," trans. Alexandra Boyle, *Contemporary Music Review* 15, part 1 (1996): 100; quoted in ibid., 178.

49 Alan Licht, *Sound Art: Beyond Music, Between Categories* (New York: Rizzoli, 2007), 218.

50 LaBelle, *Background Noise*, x.

51 Christopher Y. Lew, "Low End Theory," accessed at https://whitney.org/essays/kevin-beasley.

52 Ted Loos, "Firing Up Weird Science at the Whitney," *New York Times*, December 12, 2018.

53 Christopher Willes, "Christine Sun Kim Explores the Politics of Sound," *Musicworks*, no. 123, accessed at https://www.musicworks.ca/featured-article/sound-notes/christine-sun-kim-explores-politics-sound.

Index